YOUNG ASIAN
FASHION
DESIGNERS

daab

Introduction 4

INTRODUCTION

Like a train moving in full speed, Asia is hurtling towards new social, political and economic realities with staggering momentums. To catch up with the rest the world, Asian designers have to move fast, carry heavy loads with ever briefer stops to recharge their creative batteries. Amidst this chaos of ambitious developments, wrought with a constant cultural struggle torn between the East and the West, remaining true to oneself is no easy task. This book presents a new generation of gutsy and driven designers who are attempting to rise above the challenge.

As creative expressions overtake textile mills and clothing factories as the engine of growth and pride of nations, Asian cities are competing hard to become the premier fashion capitals of the region. To boost exposure to international press and buyers, governments everywhere are producing ever-bigger and glitzier fashion events; some even fund designers to go West with sponsored entrance to fashion and trade shows abroad. Add the thriving growth of the media, on-line or off, and a surge of international fashion bibles landing in the region, young designers in Asia have no lack of channels for creative expression. Yet throwing a show is one thing; sustaining a fashion business that's truly innovative is a different test altogether.

The struggle to survive is particularly rife for young designers from the more developed countries such as Japan, Korea, Australia and New Zealand. Despite better education, battles against rising labour costs and sky-high shop rent are relentless. In tiny city-states such as Hong Kong and Singapore, minute domestic markets and a perpetual predominance of commercial ideals are additional threats for fashion newcomers.

Long considered a world leader of progressive fashion, Japan has other issues at heart. For years, young Japanese designers have been torn between the impenetrable brilliance of the avant-garde—laid down by 80s fashion revolutionaries such as Yohji Yamamoto and Rei Kawakubo—and an ever flightier code of consumerism and fickle street aesthetics. One generation forward, young creators are finally freeing themselves from all fads and dogmas, and finding new meanings in their rich diversity of culture, from highbrow to low, east to west, manga to kimono.

In other less-developed economies, such as China, India and Thailand, the tremendous pressure to change aboard the superhighway of industrialization, consumer revolution and rapid urbanization have spurred a heedless amount of fashion imitations. But that same force has also jolted certain hungry visionaries to go completely against the system. The result is a new class of pure, daring and highly progressive creations that neither seek to break nor bond the rift between the East and the West.

As globalization intensifies, the line defining what is and isn't Asian fashion is progressively blurred. While certain phenomena—such as the preference of a fashion degree in the West and a rife penchant for Caucasian models—still hint a latent crush on western orders and aesthetics, traditional references haven't altogether disappeared; they simply reveal in a context that is far more unconscious, illusive, and less overtly fusion. But wherever the cognitions are rooted, and however they shape or inform the works, the final goal for the new generations is to create new ideas that will eventually break all cultural and geographical barriers.

Asked if she considered herself an international designer or a Japanese designer, Rei Kawakubo once replied, "Just a designer. Place of birth is an accident." Ultimately, it's the clothes that matters.

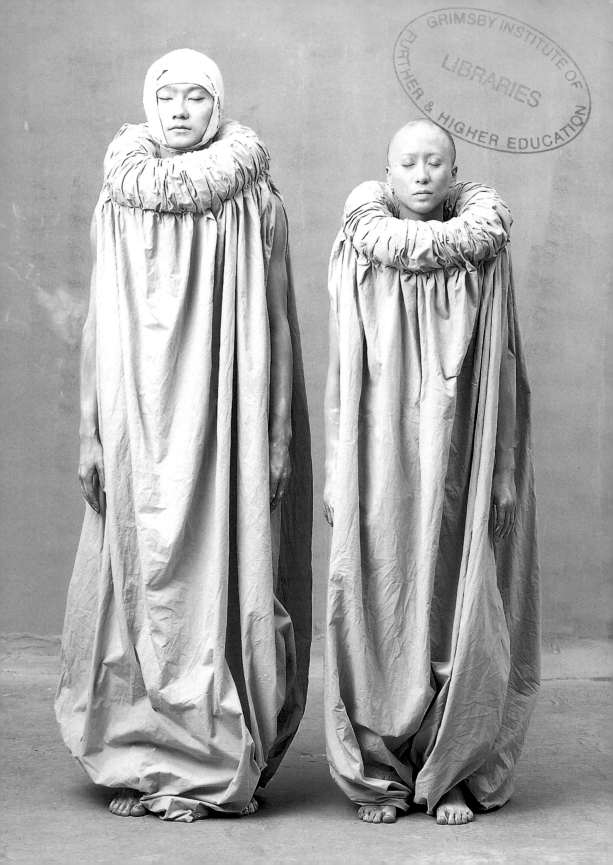

Wie ein Hochgeschwindigkeitszug rast Asien mit atemberaubender Geschwindigkeit auf neue soziale, politische und ökonomische Gegebenheiten zu. Um die restliche Welt einzuholen, müssen asiatische Designer schnell reagieren, viele Bürden auf sich nehmen und kürzeste Verschnaufpausen nutzen, um ihre kreativen Akkus aufzuladen. Inmitten dieses Chaos der ambitionierten Entwicklungen, geprägt von einem ständigen kulturellen Kampf, der sie zwischen Ost und West hin und herreißt, ist es für sie keine einfache Aufgabe, sich selbst treu zu bleiben. Dieses Buch stellt eine neue Generation mutiger und umtriebiger Designer vor, die versuchen, die Herausforderung anzunehmen, um an die Spitze der Haute Couture zu gelangen.

Da kreative Ausdrucksformen die Tuchfabriken und Bekleidungsfirmen als Motoren für Wachstum und Patriotismus längst übernommen haben, treten asiatische Städte in einen Konkurrenzkampf untereinander; jede von ihnen will die Nummer Eins unter den Modemetropolen der jeweiligen Region werden. Um in den Fokus der internationalen Presse und Käufer zu gelangen, organisieren Regierungen überall immer größere und schillernde Modeschauen; einige sponsern sogar Designer, damit sie dank ihrer Unterstützung in den Westen gehen können und dort Zutritt zu Modenschauen und Messen erhalten. Wenn man darüber hinaus die aufstrebende Macht der Medien nimmt sowie eine Flut internationaler Modebibeln, fehlt es jungen Designern in Asien nicht an Kanälen für kreative Ausdrucksformen. Eine Show zu initiieren ist eine Sache, eine viel größere Aufgabe und Herausforderung ist es jedoch, ein wirklich innovatives Modebusiness zu schaffen und zu erhalten.

Mit dem Überlebenskampf werden insbesondere junge Designer aus den stärker entwickelten Ländern wie Japan, Korea, Australien und Neuseeland konfrontiert. Trotz der besseren Ausbildung herrscht der unerbittliche Kampf gegen die steigenden Lohnkosten und extrem hohen Ladenmieten. In winzigen Stadtstaaten wie Hongkong und Singapur stellen die kurzlebigen Binnenmärkte sowie das immer während Vorherrschen der kommerziellen Ideale zusätzliche Bedrohungen für Newcomer in der Modewelt dar.

Obwohl Japan seit langem als Weltführer der progressiven Mode gehandelt wird, liegen dem Land andere Probleme am Herzen. Seit Jahren fühlen sich junge japanische Designer zwischen der unerreichbaren Glorie der Avantgarde – geprägt von Moderevolutionären der Achtziger Jahre wie Yohji Yamamoto und Rei Kawakubo – und dem sogar noch unbeständigeren Kodex des Konsumverhaltens und der launischen Straßenästhetik hin und her gerissen. Eine Generation weiter befreien sich junge Kreative endlich von all diesen Modetrends und Dogmen, indem sie neue Bedeutungsnuancen in ihrer reichen Kulturvielfalt finden, hochintellektuelle oder einfache, aus Ost oder West stammend, mit Einflüssen von Manga bis Kimono.

In anderen, weniger stark entwickelten Ökonomien, wie zum Beispiel China, Indien und Thailand, herrscht ein wahnsinniger Druck, die Industrialisierung voranzutreiben; das Verhalten der Verbraucher in den rasch urbanisierten Regionen verändert sich revolutionär, was eine Welle von rücksichtslosen Modeimitationen in Gang gesetzt hat. Dieselbe Macht hat aber auch gewisse hungrige Visionäre zusammengeschweißt, die gemeinsam gegen dieses System vorgehen. Das Ergebnis ist eine neue Kategorie klarer, gewagter und äußerst progressiver Kreationen, die die Kluft zwischen Ost und West weder brechen noch kitten sollen.

Mit zunehmender Globalisierung wird die Definition dessen, was asiatische Mode ist, fortschreitend unklar. Während bestimmte Phänomene – wie zum Beispiel die Bevorzugung eines westlichen Modediploms und eine starke Vorliebe für kaukasische Models – immer noch eine starke Affinität zu den Anforderungen und der Ästhetik des Westens andeuten, sind traditionelle Bezüge dennoch nicht gänzlich verschwunden; sie offenbaren sich in einem eher unbewussten und trügerischen Kontext und weniger als offene Fusion. Aber wo auch immer die Erkenntnisse verwurzelt sind und in welcher Form sie die Arbeiten prägen beziehungsweise beeinflussen, das Ziel für die neuen Generationen ist letztendlich, Ideen zu finden, die vielleicht alle kulturellen und geographischen Barrieren durchbrechen werden.

Als Rei Kawakubo einmal gefragt wurde, ob Sie sich selbst als eine internationale oder japanische Designerin betrachte, antwortete sie: „Nur als Designerin. Ich bin zufällig dort geboren, wo ich geboren bin." Letztendlich geht es nur um die Bekleidung.

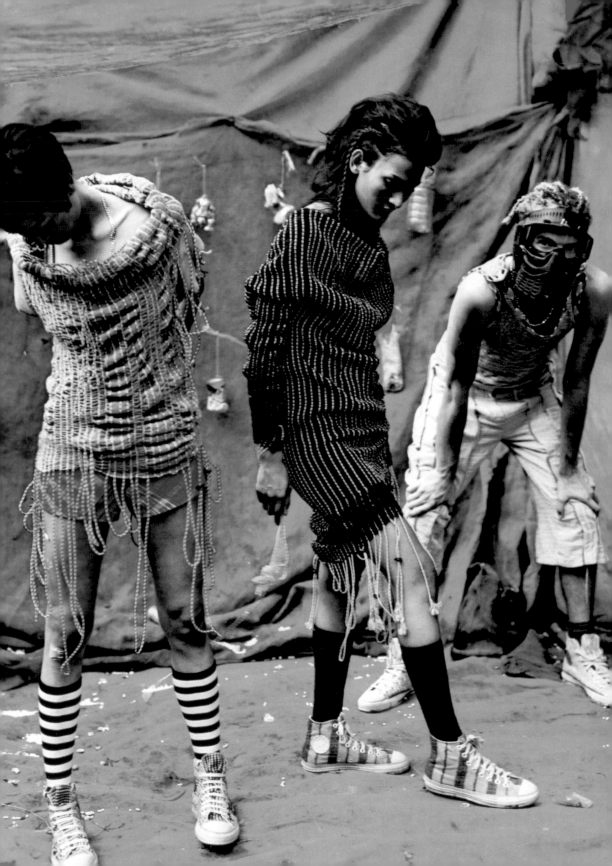

Al igual que un tren que avanza a toda velocidad, Asia se está lanzando en pos de una nueva realidad social, política y económica con un ímpetu asombroso. Para alcanzar al resto del mundo, los diseñadores asiáticos han de moverse con rapidez llevando consigo cargas muy pesadas e incluso con menos tiempo para detenerse que el resto y recargar las baterías creativas. Entre todo este caos de ambiciosos progresos que lleva aparejada una constante pugna cultural entre Oriente y Occidente, permanecer fiel a sí mismo no es tarea fácil. Este volumen presenta una nueva generación de diseñadores valientes y decididos cuyo objetivo es superar este reto.

Conforme la expresión creativa supera a los telares y a las fábricas de ropa y pasa a ser el motor del crecimiento y el orgullo de una nación, las ciudades asiáticas están luchando por convertirse en capitales de la moda de primera magnitud en la zona. Para conseguir una presencia mayor entre la prensa internacional y los compradores, todos los gobiernos se encargar de organizar certámenes de moda, a cual más grandioso y rutilante, llegando a financiar a algunos diseñadores para que se presenten en desfiles y ferias en el extranjero. Si a esto se le añade el floreciente progreso de los medios de comunicación, tanto tradicionales como on-line, y la oleada de biblias de la moda internacional que inunda la zona, a los jóvenes diseñadores asiáticos no les faltan vías de expresión creativa. No obstante, organizar un desfile es una cosa, y mantener el negocio de la moda, negocio del todo innovador, es algo bien distinto.

La lucha por la supervivencia es particularmente notoria entre los jóvenes diseñadores de los países más desarrollados como Japón, Corea, Australia y Nueva Zelanda. Si bien cuentan con una mejor educación, son encarnizados los conflictos contra la subida de los costes salariales y los desorbitados alquileres de las tiendas. En pequeñas ciudades-estado como Hong-Kong y Singapur, sus insignificantes mercados internos y la preponderancia perpetua de los ideales comerciales constituyen amenazas adicionales para los recién llegados al mundo de la moda.

Considerado largo tiempo líder de la vanguardia en moda, a Japón en el fondo le preocupan otros asuntos. Durante años, los jóvenes diseñadores japoneses se han batido entre el impenetrable fulgor de la vanguardia –con revolucionarios de la moda de los años 80 como Yohji Yamamoto o Rei Kawakubo, que sentaron las bases– y unos códigos de consumo más frívolo y una estética urbana siempre cambiante. Una generación después, ha llegado la hora de que los jóvenes creadores se liberen de todas las modas pasajeras y los dogmas para encontrar nuevos significados en su rica diversidad cultural, para personas cultas y no tan cultas, de Este a Oeste y del manga al quimono.

En otras economías no tan desarrolladas, como la de China, la India o Tailandia, la tremenda presión que se ejerce para subirse al tren de la industrialización, de la revolución del consumidor y la veloz urbanización ha dejado una cantidad ingente de imitaciones de moda. Sin embargo, esa misma fuerza ha sacudido a unos cuantos ávidos visionarios que han ido frontalmente contra el sistema. El resultado es una nueva clase de creaciones puras, atrevidas y de lo más vanguardista que no pretenden ni abrir aún más la brecha entre Oriente y Occidente ni tampoco suprimirla.

A medida que la globalización se intensifica, la línea que diferencia lo que es moda asiática de lo que no lo es se va difuminando. Paralelamente, ciertos fenómenos como son la preferencia en Occidente por un título en moda y la manifiesta tendencia hacia los modelos caucásicos, siguen dejando entrever un dominio latente de los estilos y estéticas occidentales; las referencias tradicionales no han desaparecido del todo, lo que evidencia simple y llanamente un contexto más inconsciente e ilusorio, con una fusión no tan patente. Pero sin importar dónde se encuentren las raíces o la manera en la que las obras toman cuerpo o forma, el objetivo final de estas nuevas generaciones es crear nuevas ideas que terminen rompiendo todas las barreras culturales y geográficas.

Se le preguntó en una ocasión a Rei Kawakubo si se consideraba un diseñador internacional o japonés, a lo que replicó lo siguiente: "Simplemente un diseñador. El lugar de nacimiento es accidental". A fin de cuentas, la ropa es lo que importa.

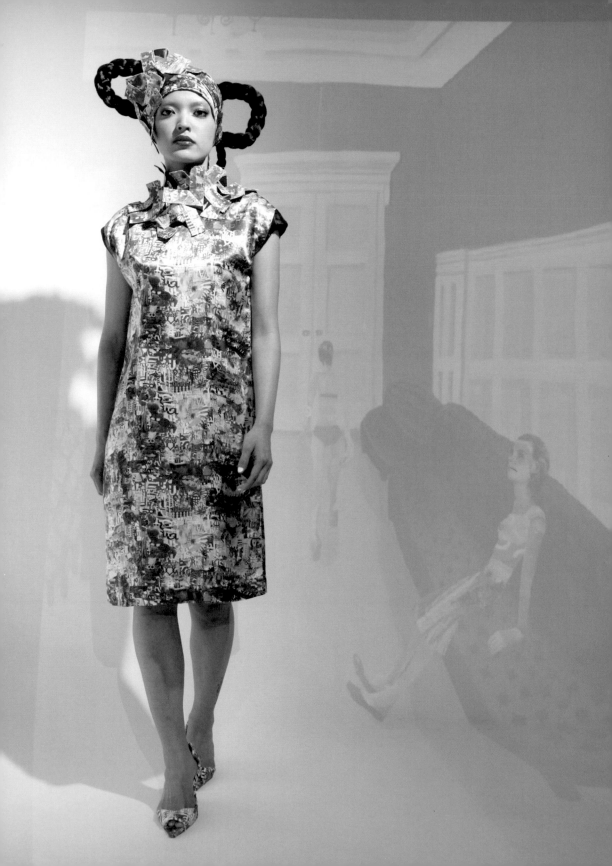

Comme un train filant à toute vitesse, l'Asie est lancée dans un élan surprenant vers de nouvelles réalités sociales, politiques et économiques. Pour rattraper le reste du monde, les créateurs asiatiques doivent se déplacer vite et porter de lourdes charges en faisant des pauses toujours plus brèves pour recharger leurs batteries créatives. Dans ce chaos de progressions ambitieuses, forgé au cours d'une lutte culturelle constante entre l'Est et l'Ouest, rester fidèle à soi-même n'est pas chose facile. Cet ouvrage présente une nouvelle génération de créateurs audacieux et impliqués qui tentent de relever haut la main ce défi.

Alors que l'expression créative prend la place des filatures et des usines de vêtements en tant moteur de croissance et fierté des nations, les villes asiatiques rivalisent fortement pour devenir LA capitale de la mode de cette région du globe. Pour augmenter leur exposition vis-à-vis de la presse internationale et des acheteurs, les gouvernements créent partout des événements mode toujours plus grands et prestigieux ; certains subventionnent même les créateurs pour qu'ils aillent en Occident en leur offrant l'entrée dans des défilés et salons commerciaux à l'étranger. Ajoutez à cela la croissance fabuleuse des médias, en ligne ou non, et le déferlement de bibles internationales de la mode arrivant dans la région, et les jeunes créateurs d'Asie ne manquent pas de voies d'expression créative. Mais organiser un défilé est une chose, faire vivre durablement une industrie de la mode réellement innovante en est une autre.

La lutte pour survivre est particulièrement rude pour les créateurs des pays les plus développés, comme le Japon, la Corée, l'Australie et la Nouvelle-Zélande. Malgré un meilleur niveau d'étude, ces pays doivent mener un combat acharné contre la hausse du coût du travail et les loyers vertigineux des boutiques. Dans les minuscules villes-états comme Hong-Kong et Singapour, les petits marchés intérieurs et l'éternelle prédominance des idéaux commerciaux traditionnels sont des menaces supplémentaires pour les nouveaux venus dans la mode.

Longtemps considéré comme le leader mondial de la mode moderne, le Japon a d'autres problèmes à résoudre. Pendant des années, les jeunes créateurs japonais ont été déchirés entre l'éclat impénétrable de l'avant-garde – initiée par des révolutionnaires de la mode des années 80 comme Yohji Yamamoto et Rei Kawakubo – et un code de consumérisme toujours plus frivole associé à une esthétique des rues inconstante. Une génération plus tard, les jeunes créateurs se libèrent finalement de tous les fanatismes et de tous les dogmes, et voient de nouvelles significations dans la riche diversité de leur culture, des sommets aux bas-fonds, de l'est à l'ouest, du manga au kimono.

Dans d'autres économies moins développées comme celles de la Chine, de l'Inde et de la Thaïlande, l'énorme pression pour rejoindre la super autoroute de l'industrialisation, la révolution de la consommation et l'urbanisation rapide ont conduit à une quantité insensée d'imitations dans le domaine de la mode. Mais cette même force a aussi permis à certains visionnaires ardents d'aller à l'encontre totale du système. Le résultat : une nouvelle classe de créations pures, audacieuses et extrêmement contemporaines, qui ne cherchent ni à combler ni à creuser le fossé entre Est et Ouest.

Avec l'intensification de la mondialisation, la ligne définissant ce qui fait partie ou non de la mode asiatique s'efface progressivement. Alors que certains phénomènes – comme la préférence accordée aux diplômes de mode occidentaux et un penchant marqué pour les mannequins caucasiens – indiquent toujours un goût latent pour les règles et l'esthétique occidentales, les références traditionnelles n'ont pas totalement disparu : elles révèlent simplement un contexte relevant beaucoup de l'inconscient, de l'illusoire et moins exagérément de la fusion. Mais quelles que soient les racines des connaissances, ou la manière dont elles forment ou informent les œuvres, l'objectif final des nouvelles générations est de proposer de nouvelles idées qui finissent par briser les barrières géographiques et culturelles.

A la question de savoir si elle se considérait comme une créatrice internationale ou japonaise, Rei Kawakubo a un jour répondu : « Simplement comme une créatrice. Le lieu de naissance n'est qu'un hasard. » A la fin, ce sont les vêtements qui comptent.

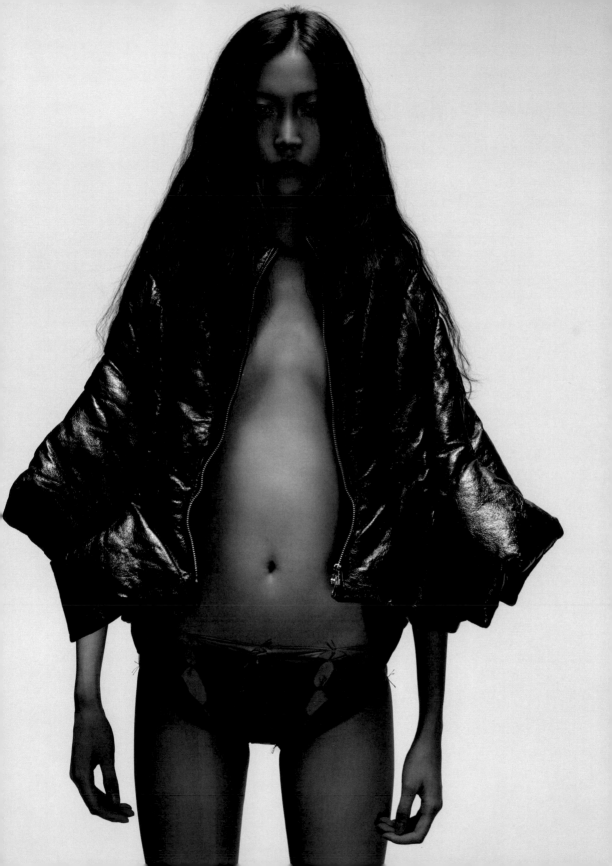

Come un treno lanciato ad alta velocità, l'Asia si sta dirigendo verso nuove realtà sociali, politiche ed economiche con momenti barcollanti. Per stare al passo con il resto del mondo, i designer asiatici devono muoversi velocemente, portare dei pesanti fardelli con pause più brevi per ricaricare le loro batterie creative. In mezzo a questo caos di sviluppi ambiziosi, turbati da una costante battaglia culturale tra Oriente e Occidente, rimanere fedeli a se stessi non è una impresa facile. Questo libro presenta una nuova generazione di designer coraggiosi e lanciati che cercano di emergere dalla sfida.

Mentre le espressioni creative superano le fabbriche tessili e gli stabilimenti di abbigliamento come la crescita dell'energia e l'orgoglio delle nazioni, le città asiatiche competono duramente per diventare le più importanti capitali della moda in tutta la regione. Per aumentare la visibilità sulla stampa e gli acquirenti internazionali, ovunque le amministrazioni producono degli eventi di moda sempre più grandi e più sfavillanti; alcuni addirittura finanziano i designer per andare in Occidente con un ingresso sponsorizzato nelle sfilate di moda e nelle fiere all'estero. Se si aggiunge la vigorosa crescita dei media, in diretta o in differita, e un'ondata di icone della moda internazionale nella regione, i giovani designer in Asia non mancano di canali per l'espressione creativa. Ma fare uno spettacolo è una cosa; sostenere un'impresa di moda veramente innovativa è una prova completamente diversa.

La battaglia per la sopravvivenza è particolarmente pesante per i giovani designer di paesi più sviluppati come il Giappone, la Corea, l'Australia e la Nuova Zelanda. A dispetto della migliore istruzione, le battaglie contro i costi crescenti del lavoro e gli affitti dei negozi alle stelle sono inflessibili. In piccole città-stato come Hong Kong e Singapore, minuscoli mercati locali e una perpetua predominanza di ideali commerciali costituiscono delle minacce aggiuntive per i nuovi arrivati nel settore della moda.

Considerato per molto tempo un leader mondiale nella moda progressista, il Giappone ha in fondo altri problemi. Per anni i giovani designer giapponesi sono stati combattuti tra l'impenetrabile intensità dell'avanguardia – stabilita da rivoluzionari della moda anni '80 come Yohji Yamamoto e Rei Kawakubo – e il codice di consumismo sempre più volubile e gli estetici capricciosi da strada. Una generazione più avanti, i giovani creatori si liberano finalmente di tutte le tendenze e i dogmi, ritrovando nuovi significati nella loro ricca diversità di cultura, dall'accademico al semplice, dall'oriente all'occidente, dal manga al kimono.

In altre economie meno sviluppate, come la Cina, l'india e la Tailandia, l'enorme pressione per cambiare all'estero la mega-autostrada dell'industrializzazione, la rivoluzione del consumatore e la rapida urbanizzazione hanno spronato una sbandata quantità di imitazioni della moda. Ma questa stessa forza ha anche sbalzato certi visionari affamati ad andare completamente contro il sistema. Il risultato è una nuova classe di creazioni pure, audaci e altamente progressive che non cercano né di rompere né di colmare il divario tra Oriente e Occidente.

Mentre la globalizzazione si intensifica, la linea che definisce cos'è e cosa non è moda asiatica viene progressivamente offuscata. Mentre alcuni fenomeni – come la preferenza per un diploma di moda in Occidente e una marcata inclinazione verso modelli caucasici –danno ancora una pressione latente sugli ordini e gli estetismi occidentali, i riferimenti tradizionali ancora non sono completamente scomparsi; si rivelano semplicemente in un contesto che è molto più inconscio, illusorio e meno apertamente fuso. Ma ovunque siano radicate le cognizioni, e in qualunque modo diano forma ai prodotti, lo scopo finale per le nuove generazioni è quello di creare nuove idee che alla fine romperanno tutte le barriere culturali e geografiche.

Una volta le venne chiesto se si considerasse una designer internazionale o una designer giapponese, e Rei Kawakubo ha risposto "Solo una designer. Il luogo di nascita è un incidente." Infondo, sono i vestiti che contano.

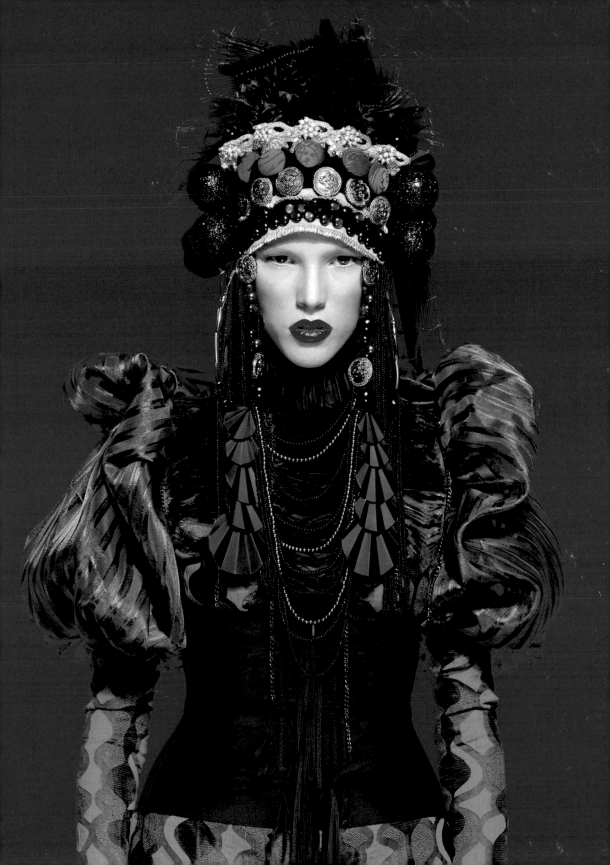

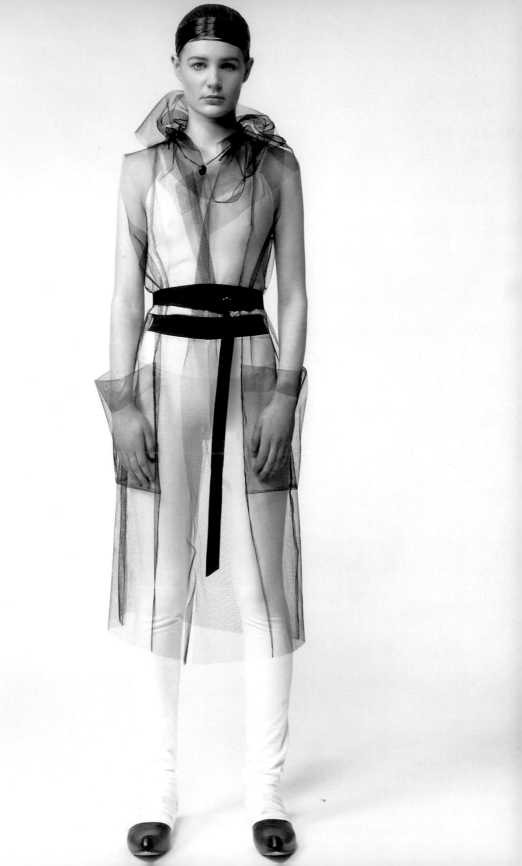

ALEXANDRA OWEN | WELLINGTON, NZ
Alexandra Owen

Set up in 2004 after graduating from Massey University, Wellington, New Zealand at the age of 23, Alexandra Owen's label is a focus on craft and innovation. Through experimental cutting techniques the Wellington designer attempts to perfect complex construction that appears effortless and ultra-wearable. Touted as one of the hottest newcomers in New Zealand, the label has alluded much attentions from a design scene reputed for its love for dark and intellectual designs. Her latest designs, a triumphant retro-futurist collection of streaming silver silk and wool cashmere, was debuted at the aw 2007 Air New Zealand Fashion Week to rave reviews.

www.alexandraowen.co.nz

1 fall winter 2008
2 fall winter 2007

Photos: Amelia Handscomb

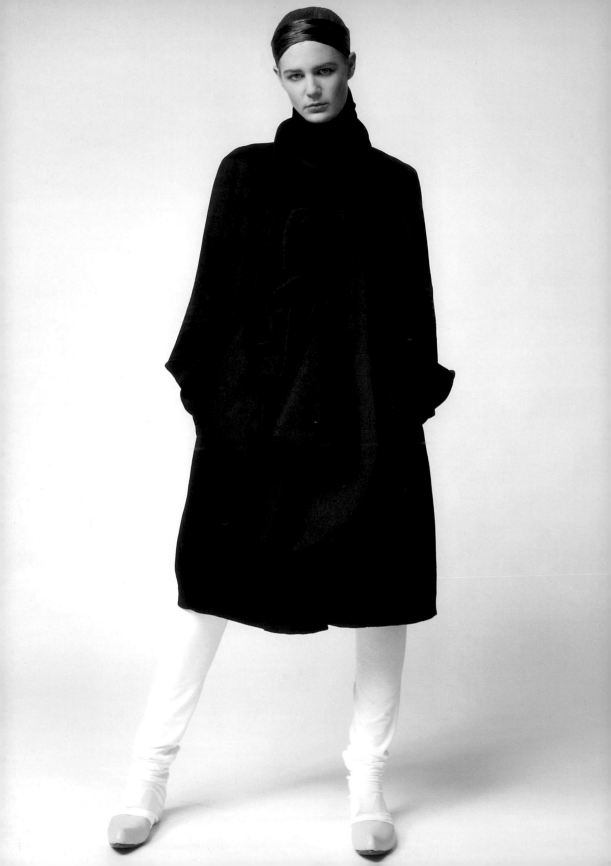

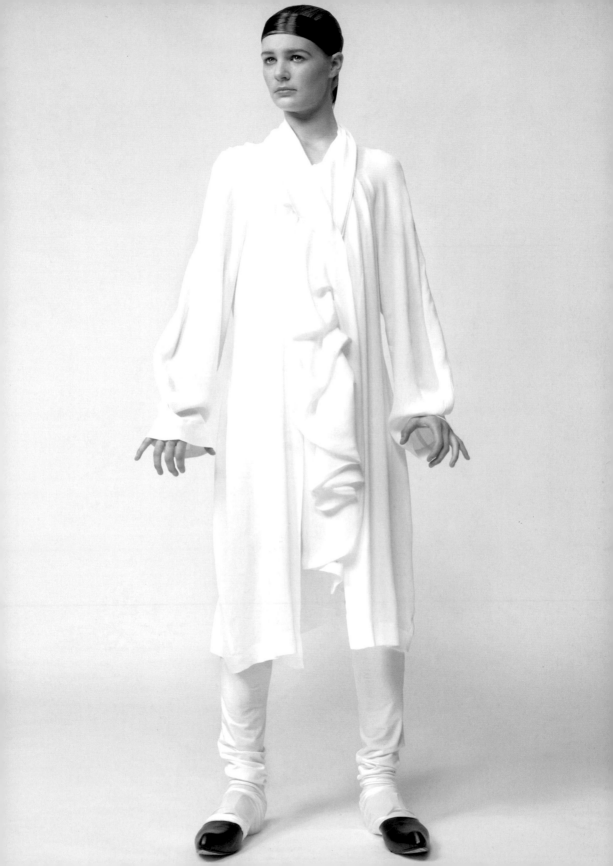

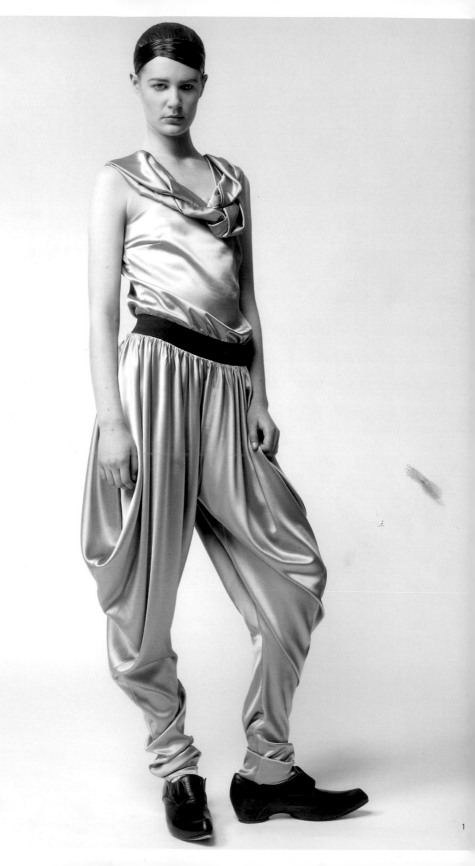

1

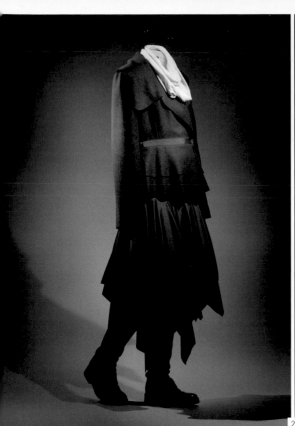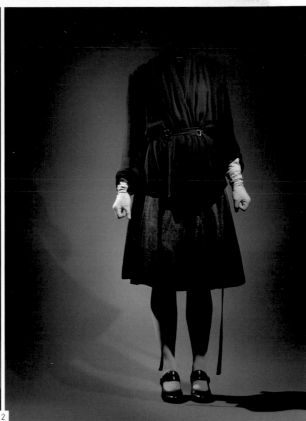

2

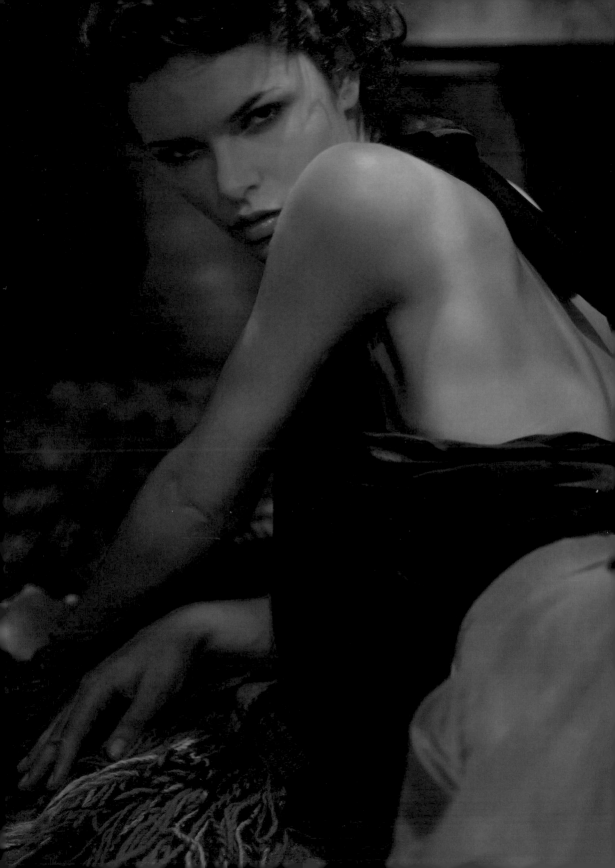

ALLDRESSEDUP | SINGAPORE
Sven Tan

Sven Tan is the principal designer for Singapore-based all-dressedup, the ready-to-wear brand conceptualised by the The Link group. Barely into its 6th seasons the fashion-forward brand had already reaped much international coverage and acclaims having already showcased for three consecutive seasons at the Paris Fashion Week. Widely adored for its forward-thinking yet utterly wearable silhouettes and forms evoking essence of modern romanticism, the brand won the Singaporean Label of the Year nod at the Cleo Awards in 2006, and again in 2007. The same year Tan, born 1979, was crowned the Singaporean Designer of the Year at the Elle Awards. Prior to taking the helm at alldressedup, the Raffles Fashion Institute graduate was the winner of the Mercedes-Benz Asian Fashion Award in 2004.

www.alldressedupintl.com

1 fall winter 2007
2 spring summer 2008

Photos: Ivanho Harlim, Him Him (1, page 27)

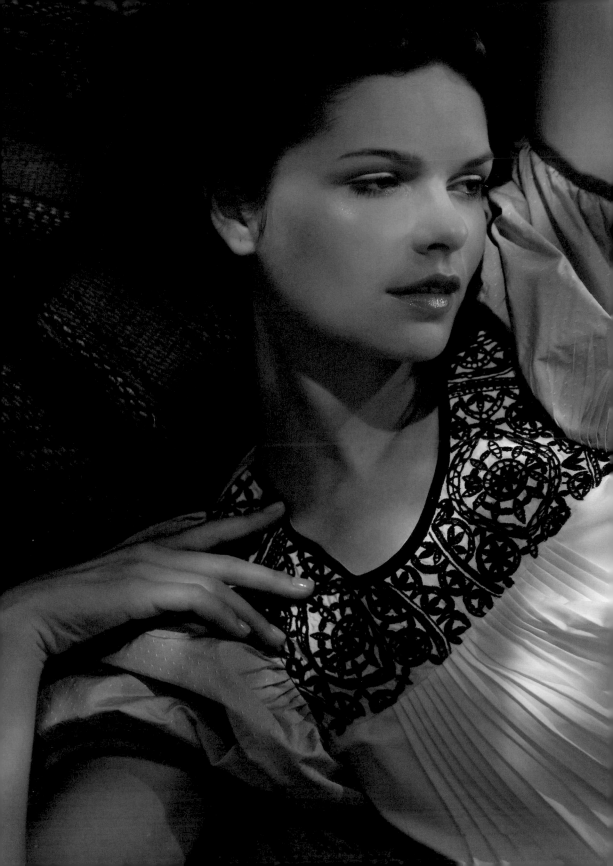

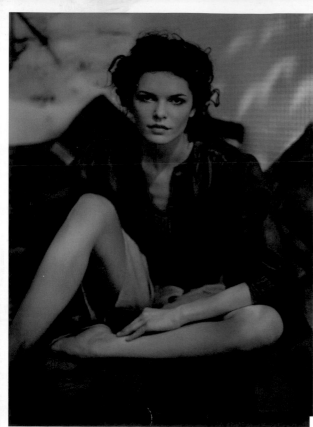
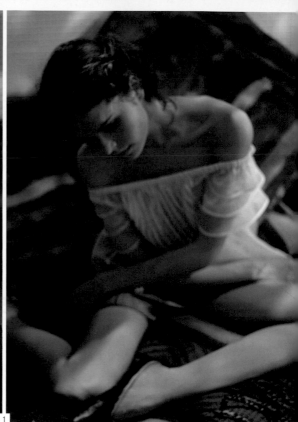

1

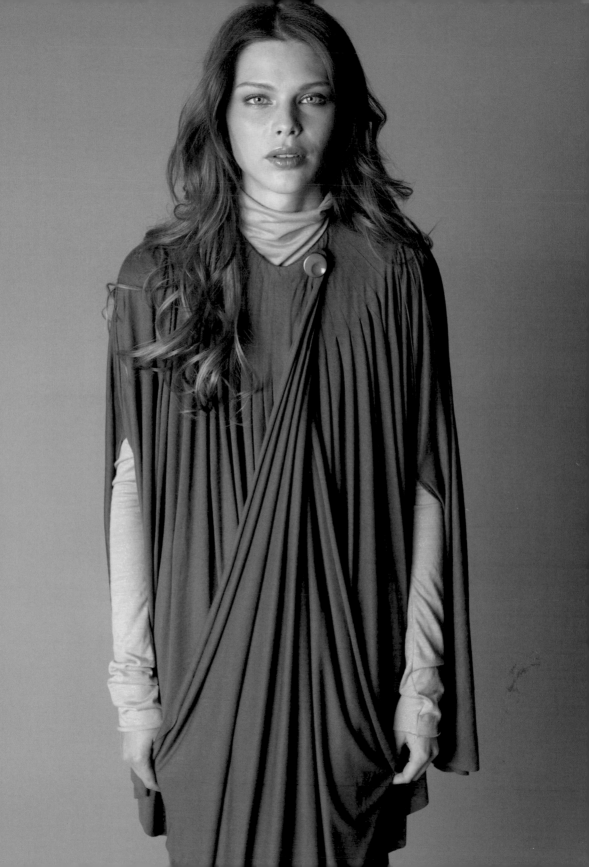

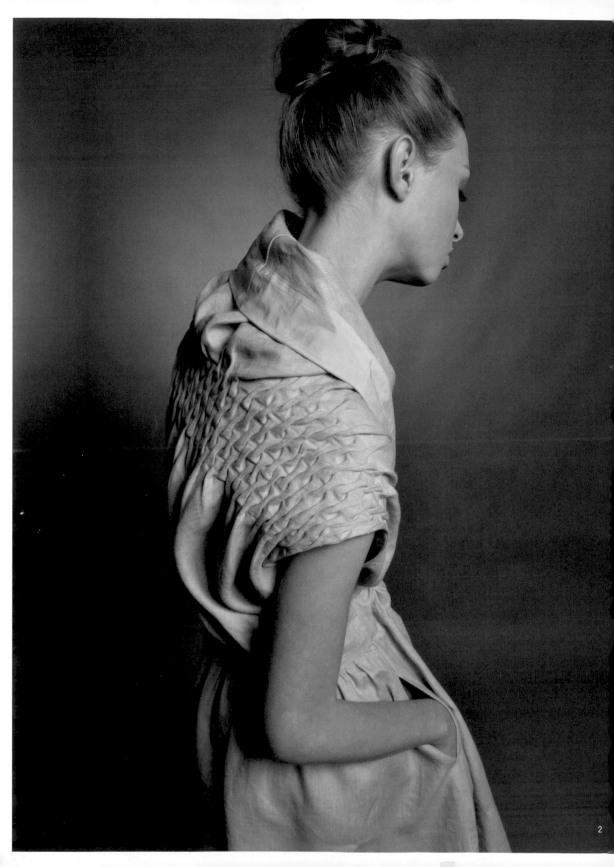

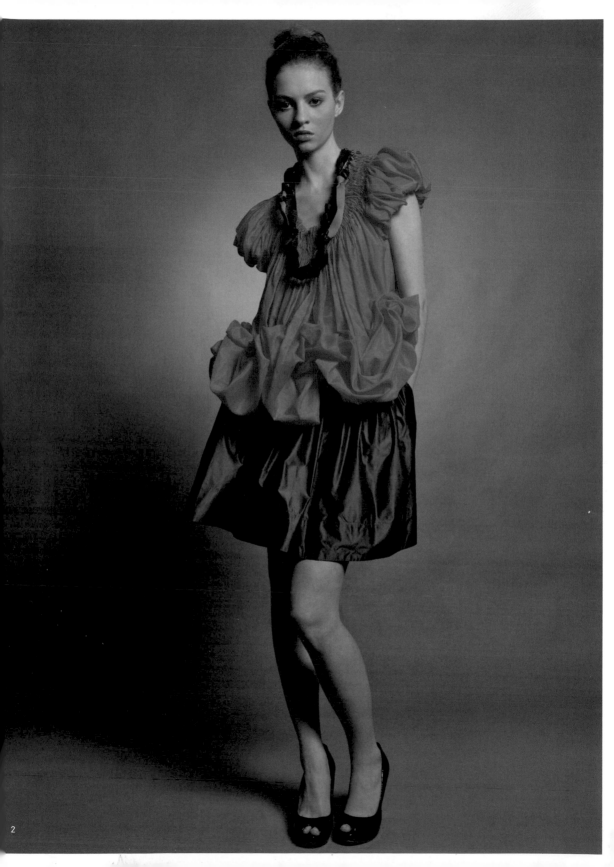

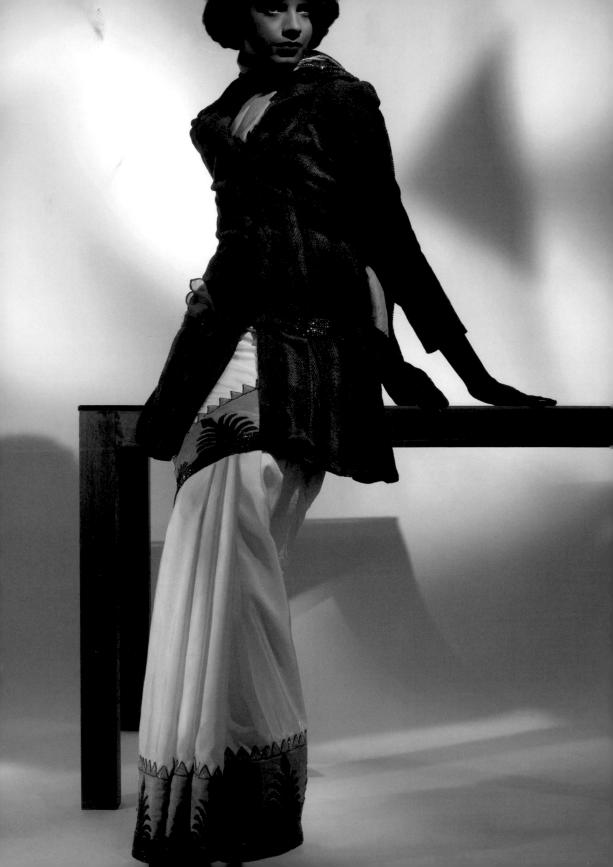

ANAND KABRA | HYDERABAD, INDIA
Anand Kabra

Returning from his London College of Design training to Hyderabad, India, Anand Kabra, born 1974, has been working quietly behind the scenes until he got his first break through in 1999 to create a trousseau for one of the largest industrial families in India, which won him both popularity and a large client base. His label was also launched the same year. Choosing the Indian market as his main priority, he set about establishing himself in Mumbai and Delhi. In 2006, he debuted at the Lakme Fashion Week with his spring summer 2007 collection, Hatsuhi: "First Sun". He has since showcased two more collections. His fall winter 2007 collection, The Orange Scarf, 1927, parallels contemporary times with the Art Deco period and finds inspiration from artist Tamara De Lempicka and the ethos of linearity, abstraction, simplification, geometry and intensity of color. His latest spring summer 2008 collection, "In Search of Duende", is about renewal and rebirth.

www.anandkabra.com

1 fall winter 2007
2 spring summer 2008

Photos: Jaideep Oberoi (1), Monika Ghurde (2)

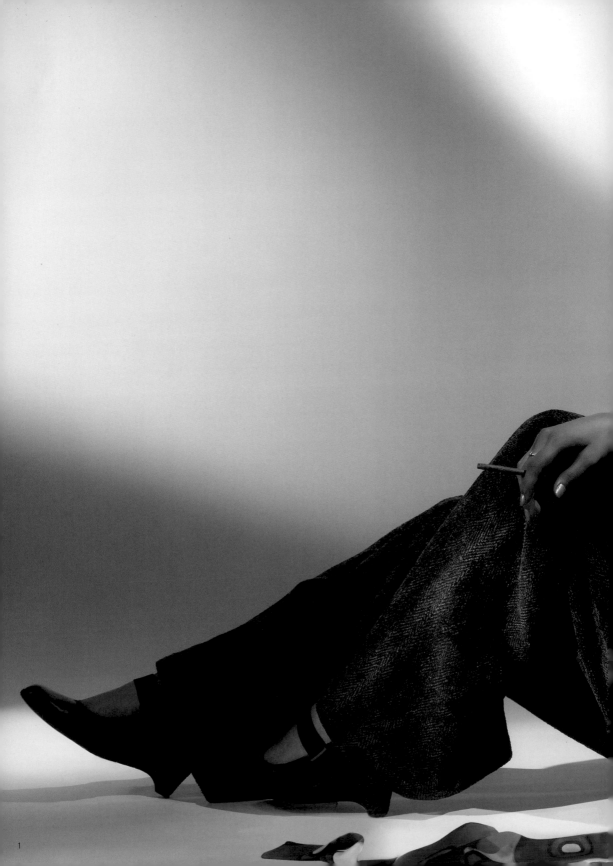

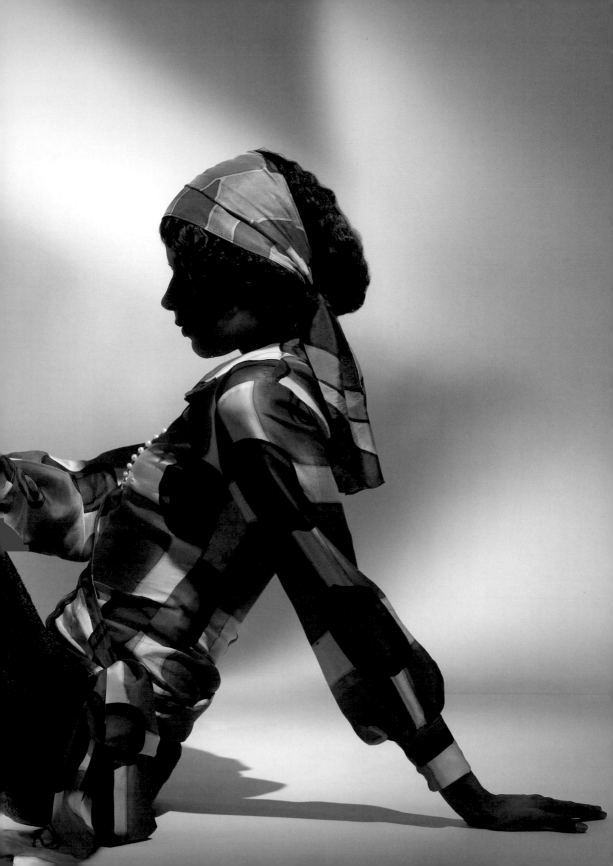

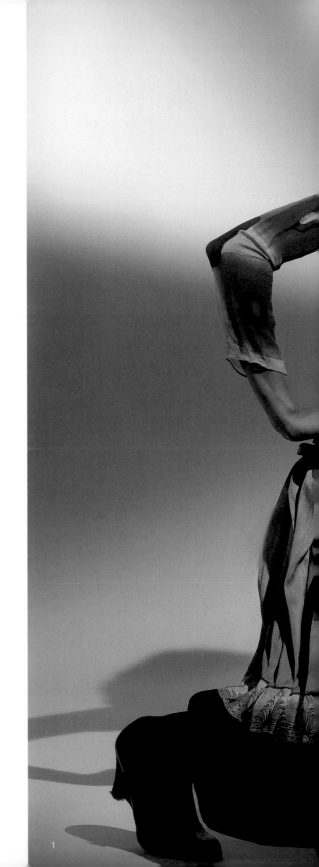

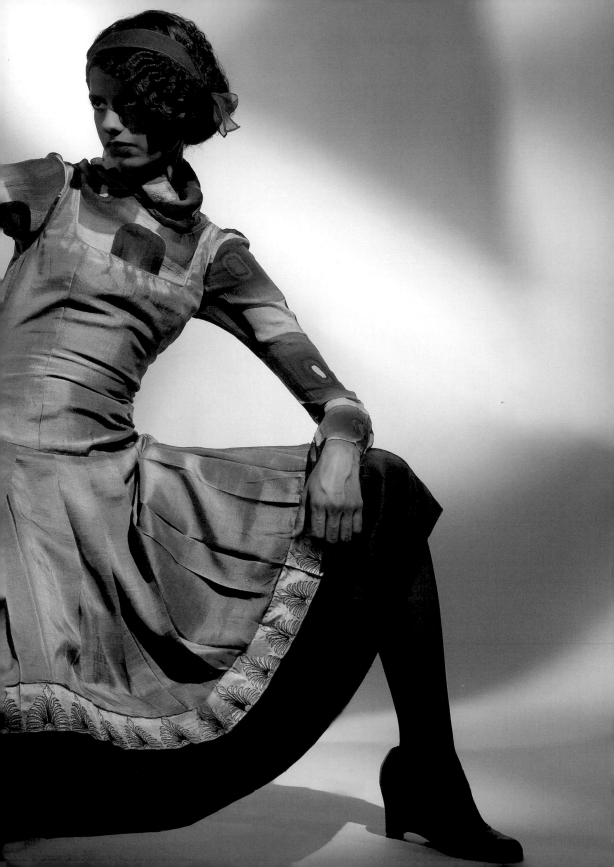

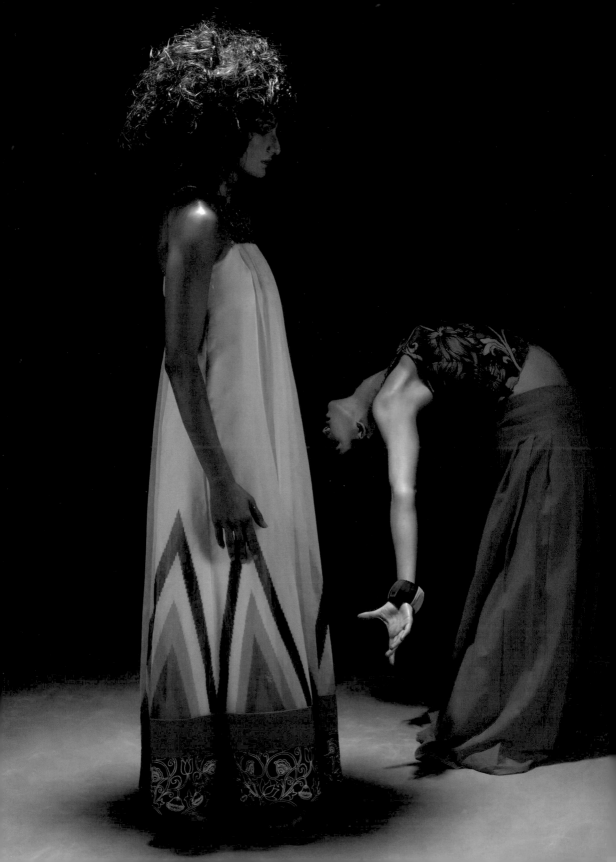

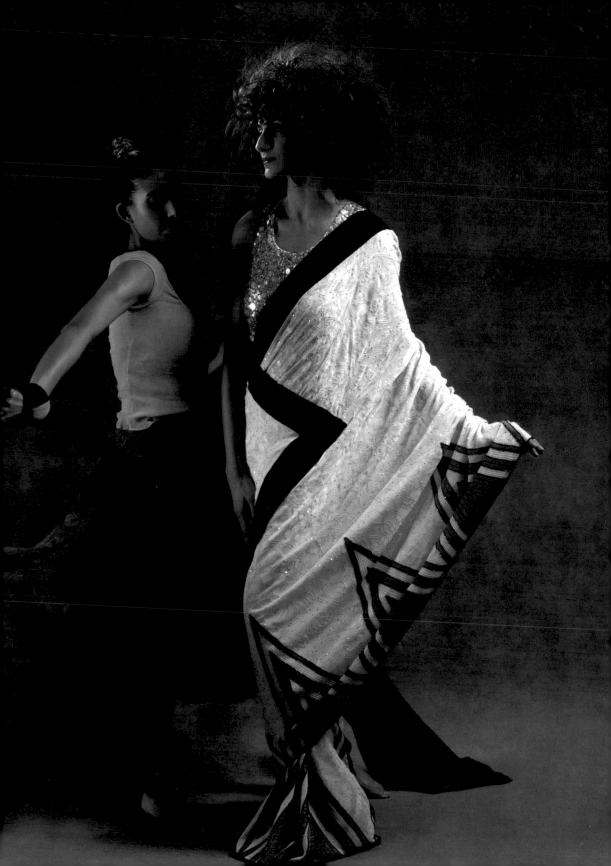

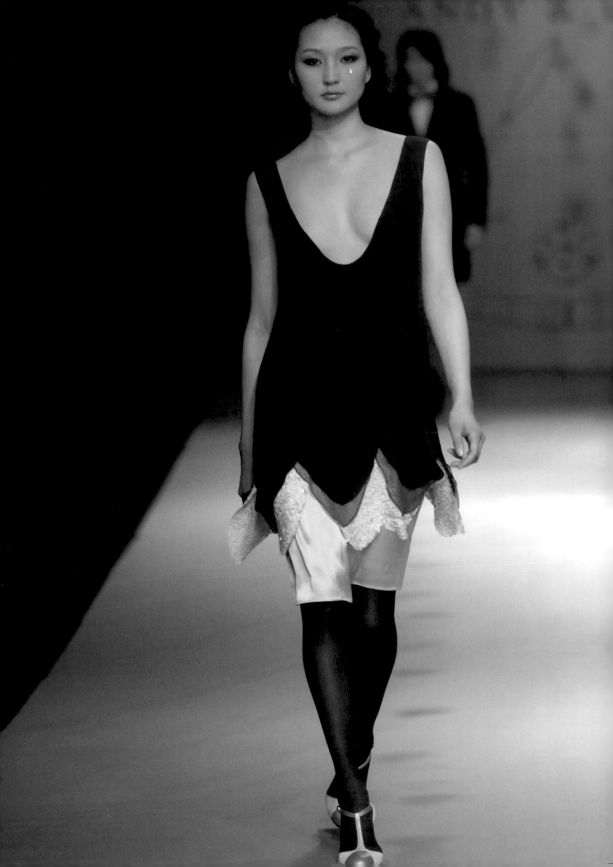

ANDY & DEBB | SEOUL

Seokwon Andy Kim, Wonjeong Debbie Yoon

Both born in 1970, the husband and wife team Andy Kim and Debby Yoon launched their eponymous brand in Seoul 1999 upon returning from New York, where they met as class mates at the Pratt Institute, began careers as fashion designers and subsequently got married. The brand's clean, fresh cuts and minimal silhouettes instantly caught the eyes of many, from editors and fashion trendsetters. Since opening their flagship in Seoul in 1999, Kim and Yoon has expanded their boutiques across all major department stores in Korea. In 2004, among their many other accolades, the couple received the Up and Coming Designer of the Year Award from the Fashion Association of Korea. Besides attending the Seoul Fashion Week regularly, Andy & Debb also showcased its collection at the White show in Milan recently.

www.andyndebb.com

1 fall winter 2006
2 fall winter 2007
3 spring summer 2008

Photos: Seon Young Do (1, 2), Jung Hee Bae (3)

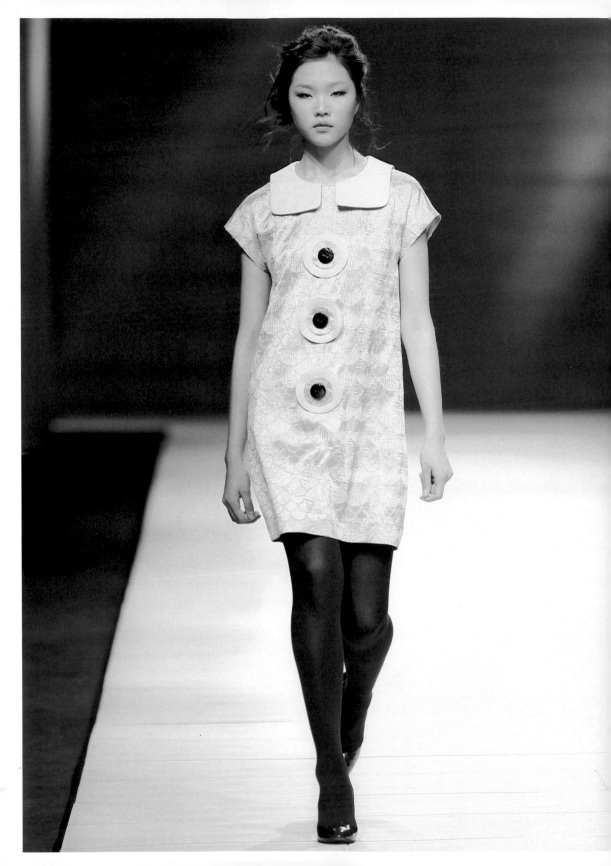

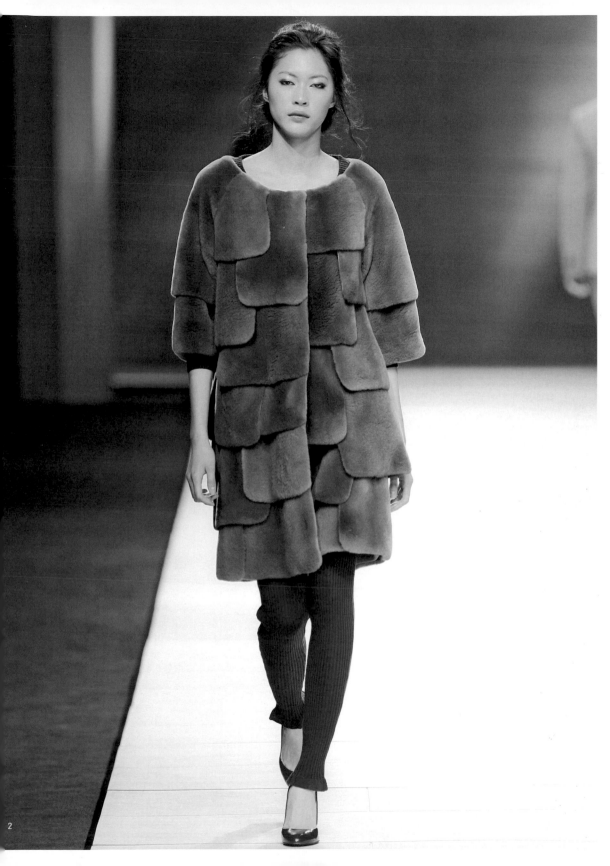

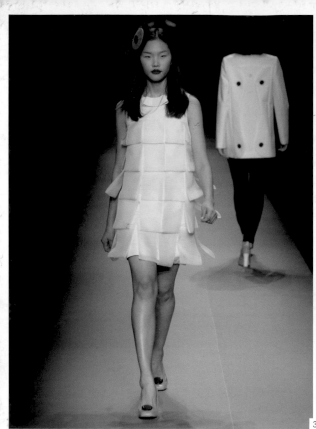
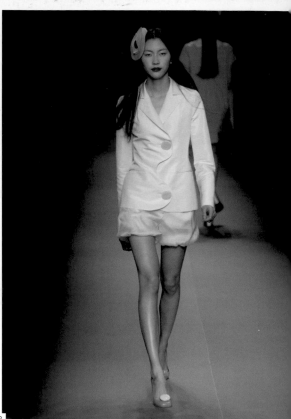

3

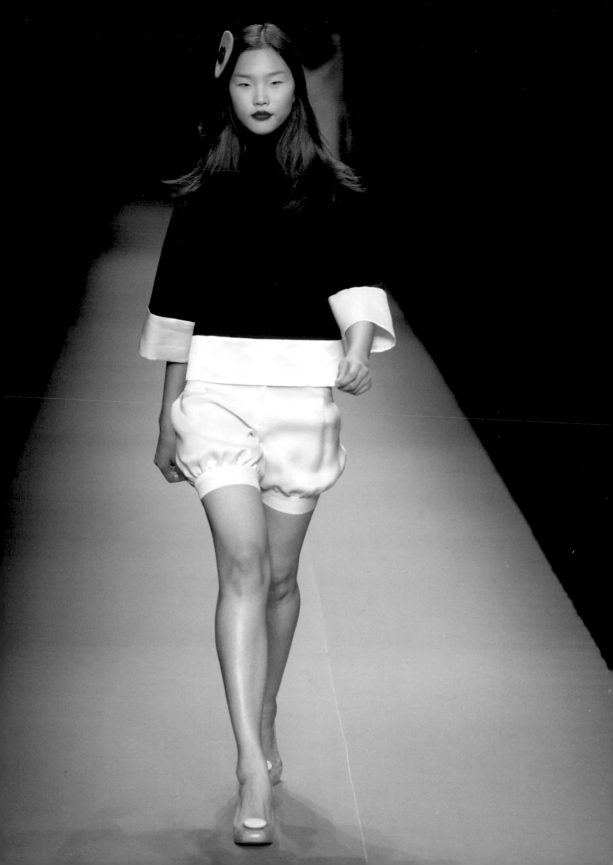

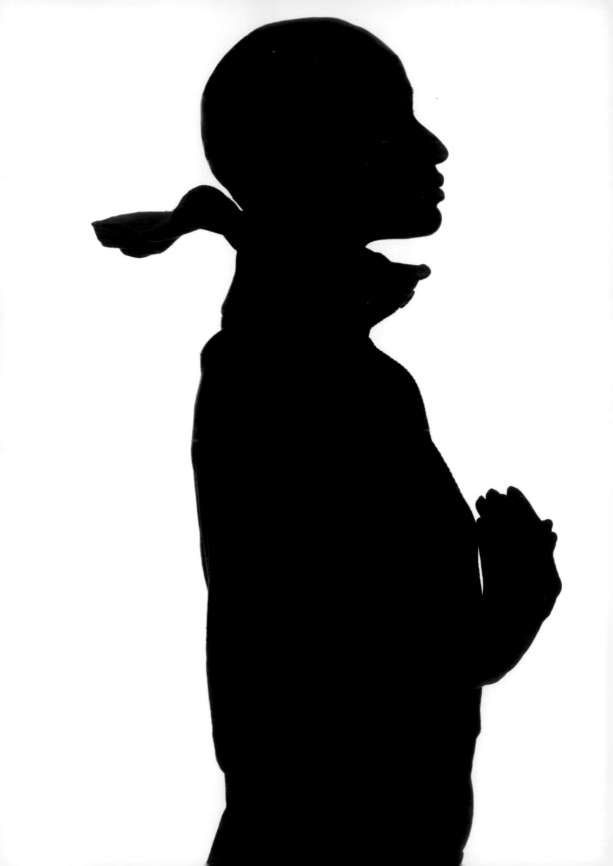

ASHISH N SONI | NEW DELHI
Ashish Soni

Launching his own label in 1993, Ashish Soni, born 1971, initially spent many quiet yet constructive years developing a strong language and design philosophy for his first label in his native town, New Delhi. As Soni's repertoire for strong designs began to gain grounds in his home country nation-wide, Soni took every opportunity to strut his collections to fashion weeks and festivals beyond India. The biggest international break came with the invitation as one of the ten 'future of fashion' designers to take part in the Olympus Fashion Week in New York. Focused and thoughtful, with embellishments used with great restraint to highlight form, his collection attracting unanimously favorable write-ups from the world's top critics and publications. Ashish n Soni is now a regular at New York fashion events and has since shown in London and Paris. The label is now found globally in select outlets across Japan, Europe, Middle East and the U.S.

www.ashishnsoni.com

1 fall winter 2006
2 spring summer 2006

Photos: Tarun Khiwal

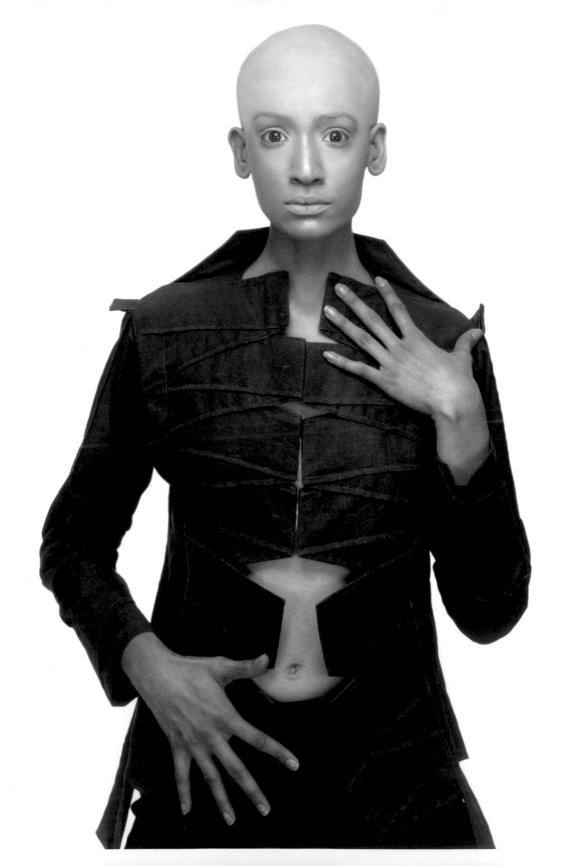

1

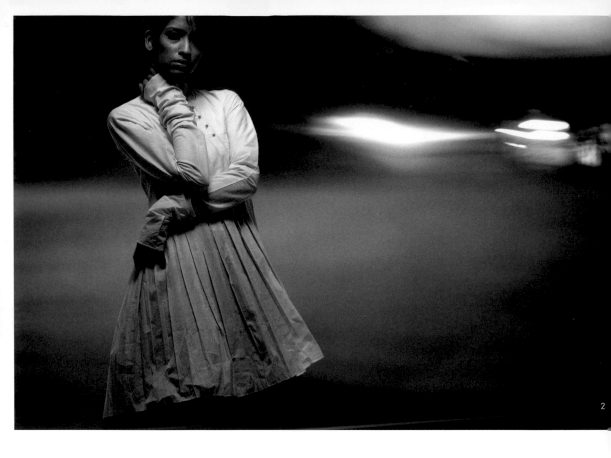

2

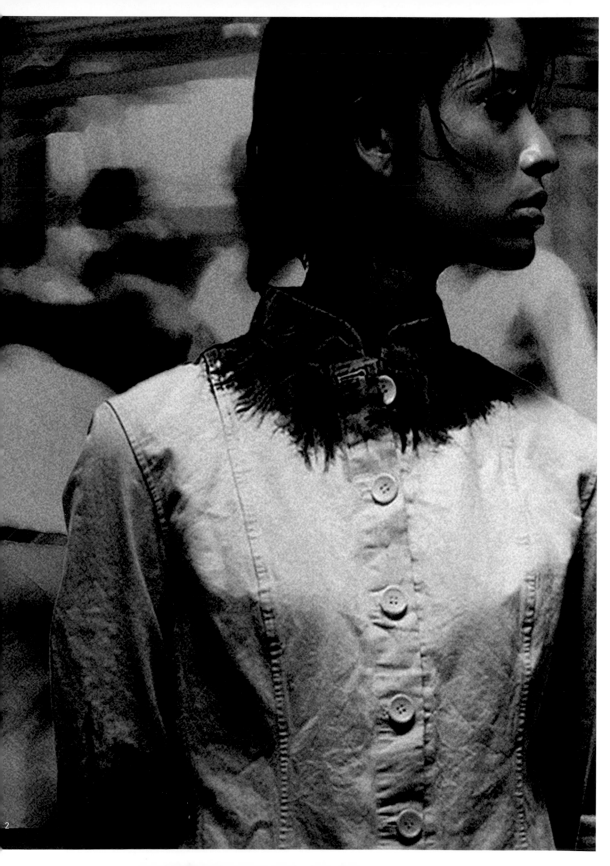

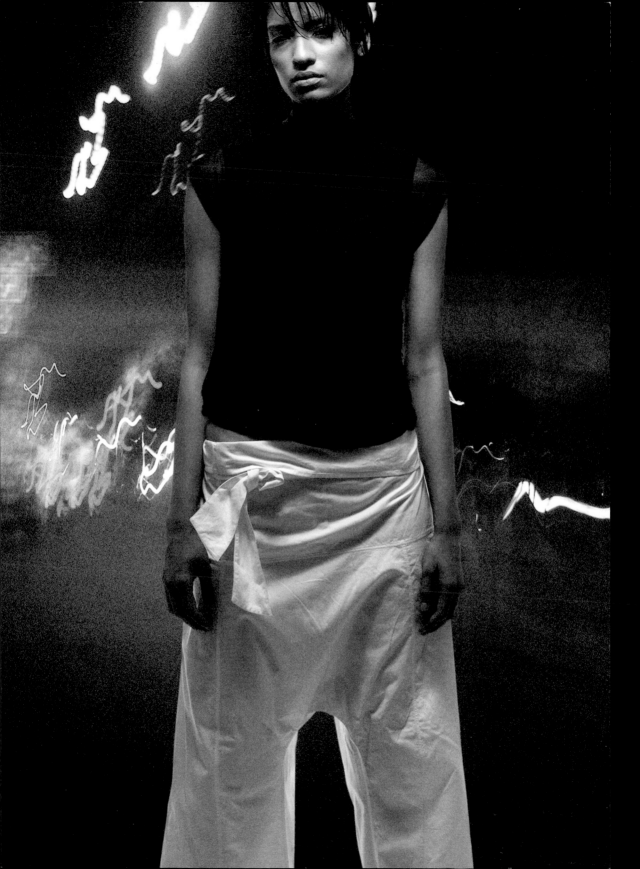

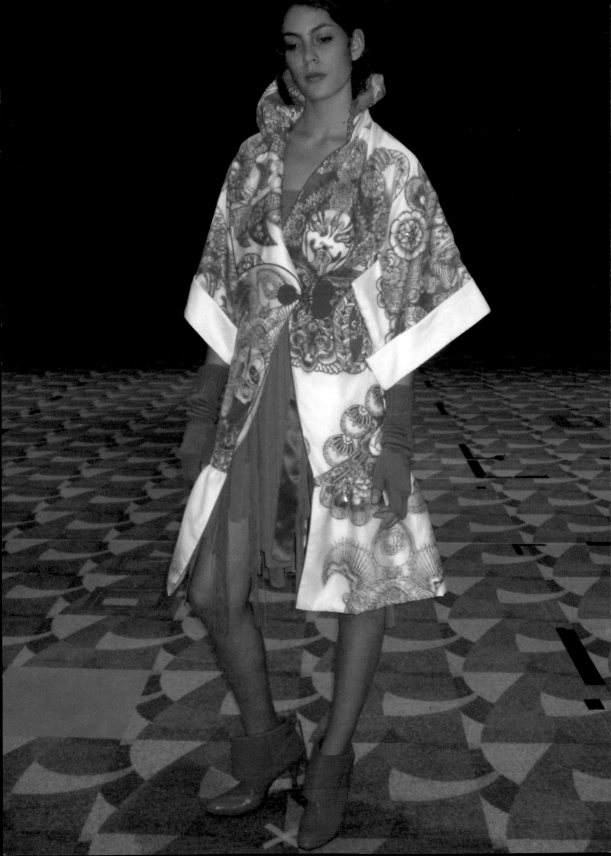

***ATELIER | HONGKONG**
Yeung Shiu Cheung

Eternally captured by the state of confusion, Yeung, born 1976, adores the fusion of antithetic elements, from the old and the new, the simple and the complex, to the body-conscious and the shape-driven. A graduate of the The School of Design of the Hong Kong Polytechnic, Yeung is a keen contestant on local fashion competitions, for which he won top awards on three occasions. He was the recipient of the 1999 Young Talent Award from the Hong Kong Fashion Design Association, the knitwear group winner at the 2002 Hong Kong Trade Development Council (HKTDC) Fashion Designer Contest, as well as the Overall Winner of the 2004 Hong Kong New Fashion Collection Award, also organised by the HKTDC. Besides working on his own collections, Yeung has held various designer positions for venerable local designers and renowned fashion companies, from Walter Ma, Gay Giano, to the Baleno Group. 2006 finally saw the birth of his own label *atelier.

www.jconceptlounge.com

1 fall winter 2007, *mask*
2 spring summer 2004, *ink illusion*

Photos: Yeung Shiu Cheung (1), Tim (2)

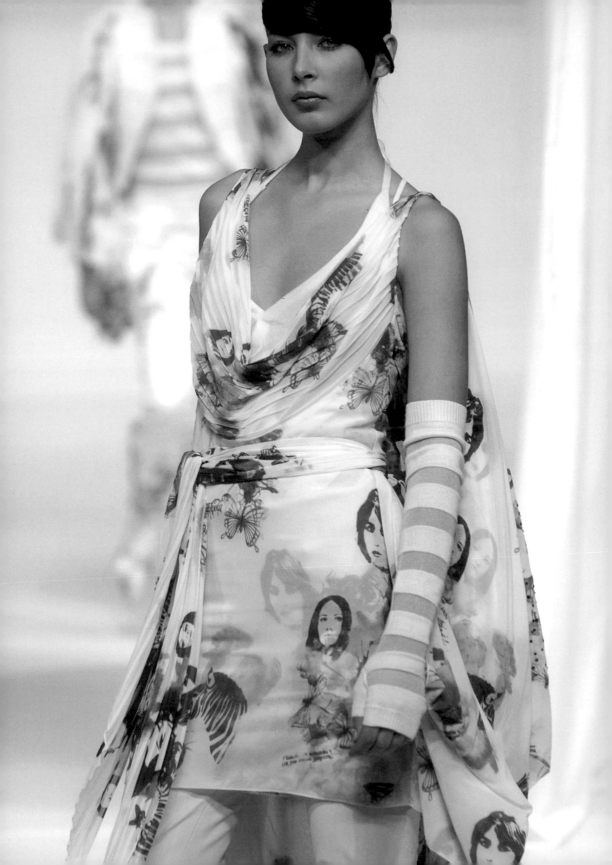

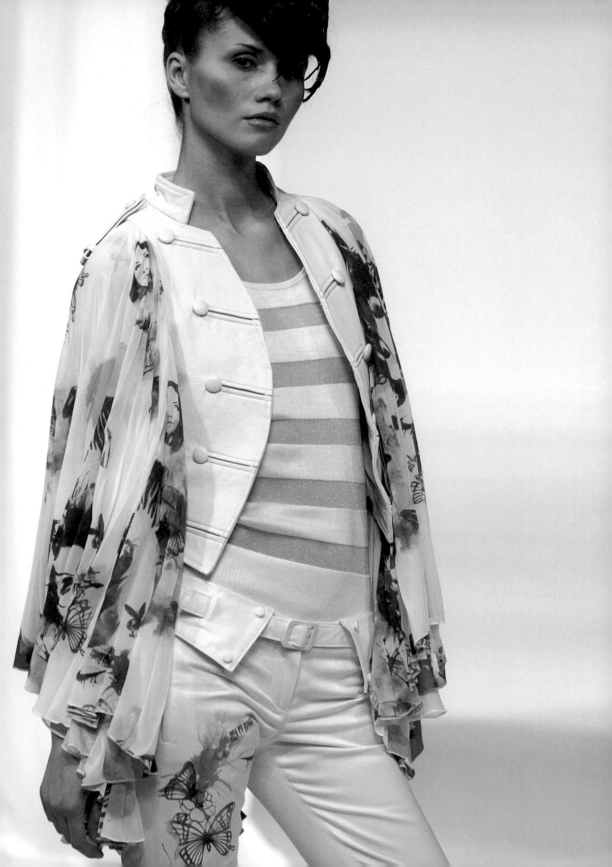

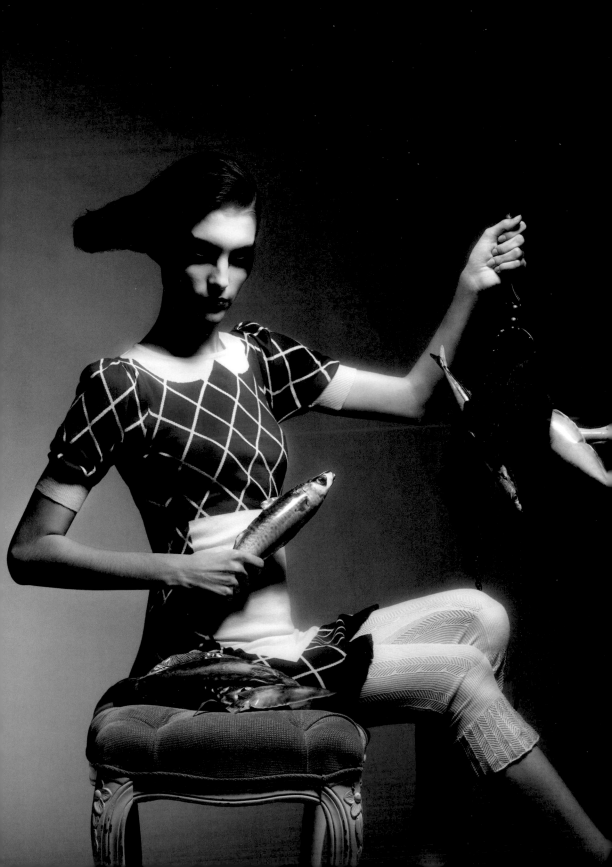

BALDWIN PUI | HONG KONG
Baldwin Pui

Graduated with a diploma in Design Studies and Fashion Design at the Hong Kong Polytechnic University in 2000, the Hong Kong-born designer is the winner of the Hong Kong Designer Association Award as well as several regional design contests. They include the 2002 Hong Kong Young Fashion Designer Contest, the 2002 Asian Young Fashion Designer Contest in Singapore and the 2005 Hong Kong Young Design Talent Award. Baldwin's startling and witty designs, which come alive especially through his knitted patterns, are inspired by objects, crafts and folk toys from local culture and everyday living. In 2007, Baldwin, born 1974, launched an accessories brand, hoiming, with partner Hoi Ming Fung. The label is now sold through Harvey Nichols and select shop Cocktail in Hong Kong.

www.hoiming.net

1 fall winter 2007 knitwear collection, *Hong Kong*
2 spring summer 2007 knitwear collection, *Hong Kong*
3 fall winter 2008 handbag collection, *„big pocket"*

Photos: Jacky Chee

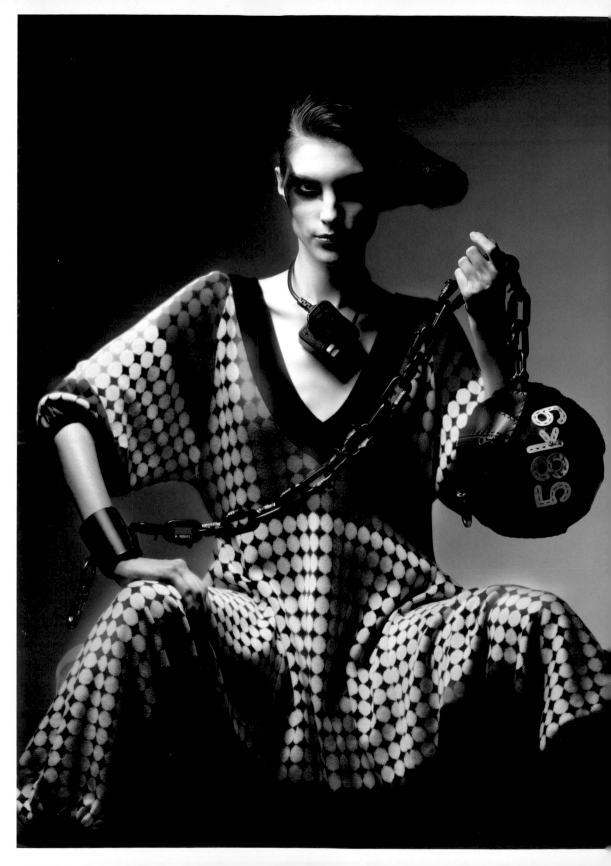

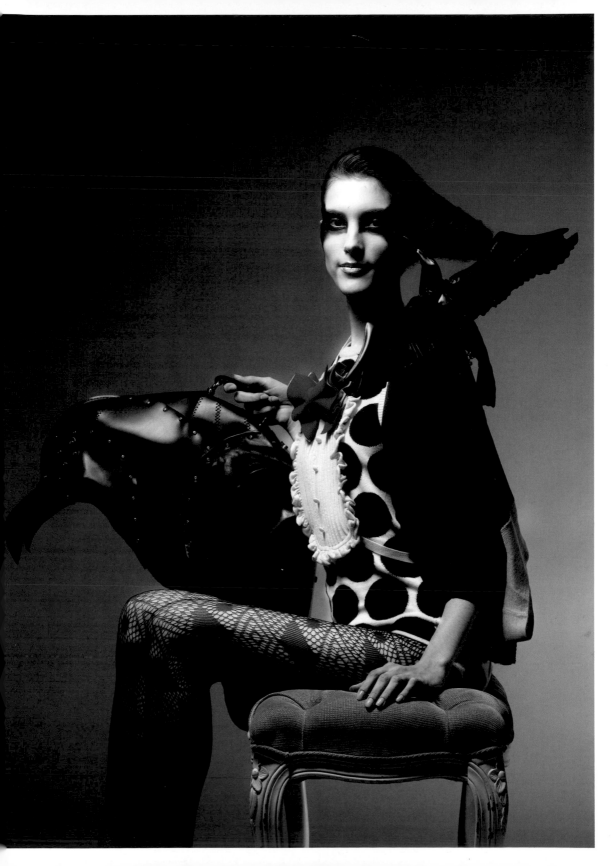

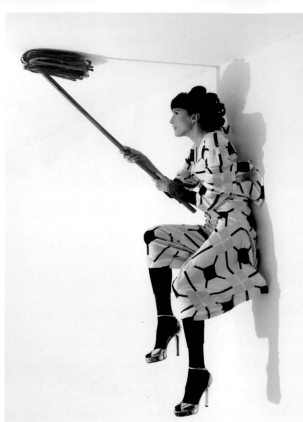
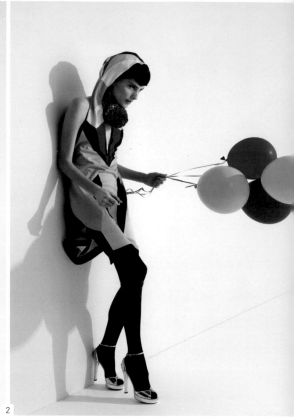

2

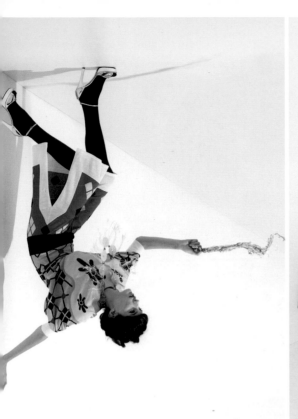

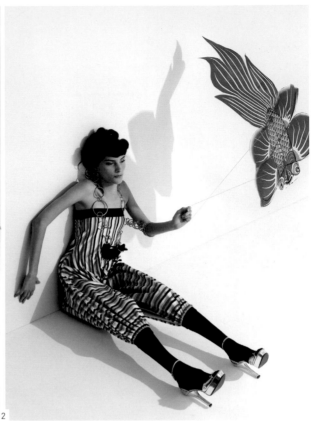

2

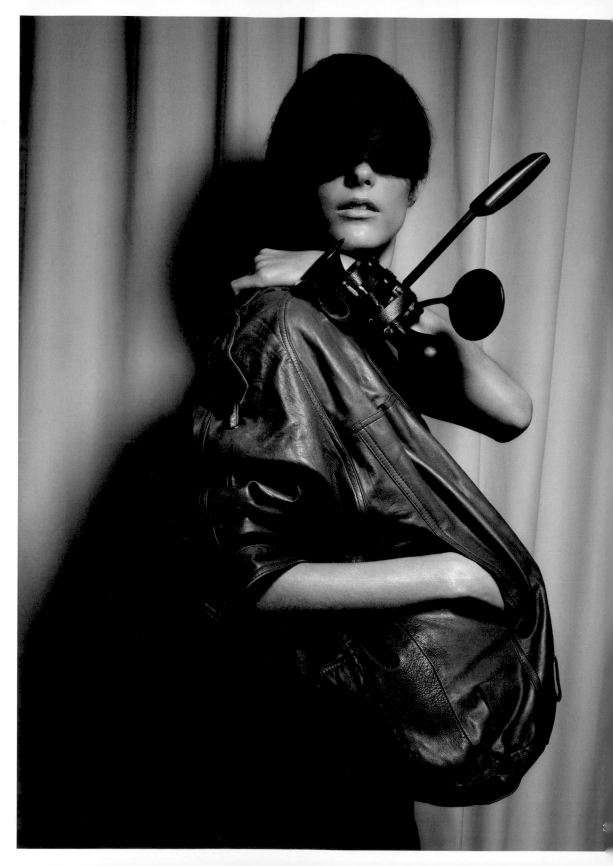

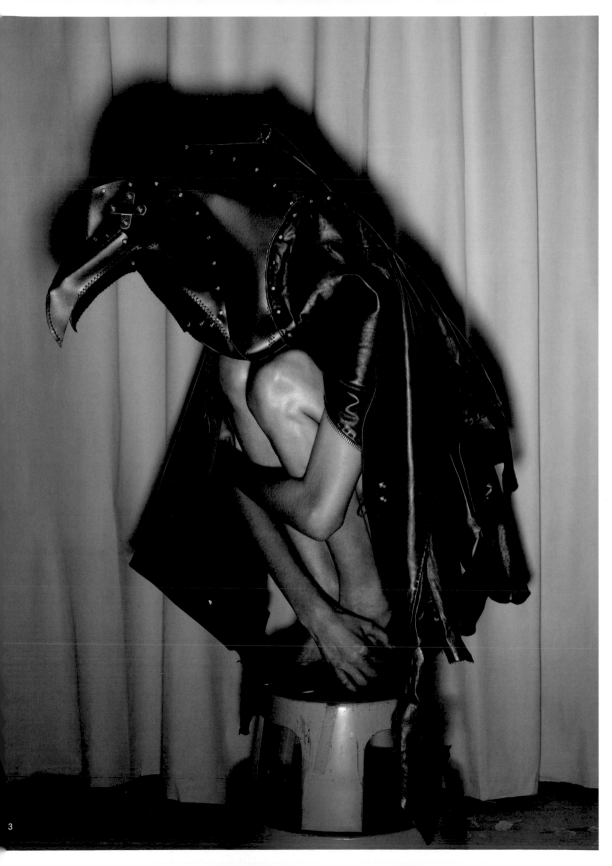

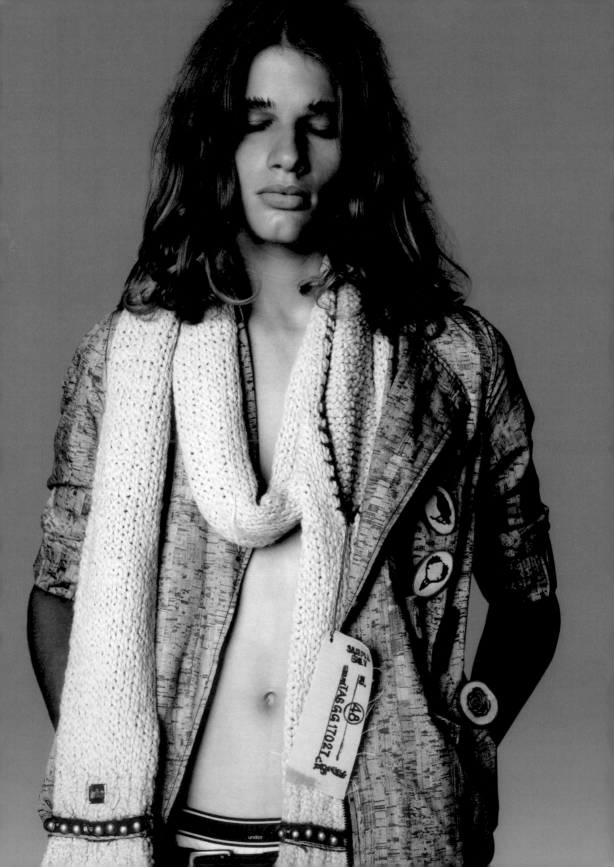

CHAI | BANGKOK
Chai Jaem-Amornrat

After graduating from Thailand's leading art school, Silpakorn University, Jaem-Amornrat, born 1973, headed to Europe to further hone his fashion skills at Norway's elite National College of Art and Design. Having completed his bachelor's and master's degrees in fashion design in 2000, the Thai designer returned home to launch his own label. It's tempting to read Chai's stylistic signature as autobiography. His celebration of streetwear reflects the teeming life of the tropical mega-city around him. His flair for sportswear influences recall the active Nordic lifestyle he knows from Oslo. And his gifted handling of color, pattern and prints, which benefits from his undergraduate study in graphic design, quickly attracted wide media attentions as well as a succession of collaboration opportunities from top Thai fashion houses, including the royal Thai project, Mae Fah Luang. It also won him numerous accolades including 1st Runner Up of the 1999 Smirnoff Fashion Design Award in Oslo, Norway, as well as the Designer of the Year Award 2004 from Silpakorn University. Since co-founding the fashion collective, Headquarter, with two other partners, Jaem-Amornrat now presents his collection bi-annually at the Elle Bangkok Fashion Week under the Headquarter umbrella. In 2007 Jaem-Amornrat presented Chai at Rendez-Vous Homme in Paris.

chai_jeam@yahoo.co.uk

1 fall winter 2006, *Bangkok Fashion week 2006*
2 2002, *Mae Fah Luang in ELLE Fashion Week 2002*
3 fall winter , *ELLE Fashion Week 2004*

Photos: Tada Varich (1), J.Surat (2), Nikar Greeprom (3)

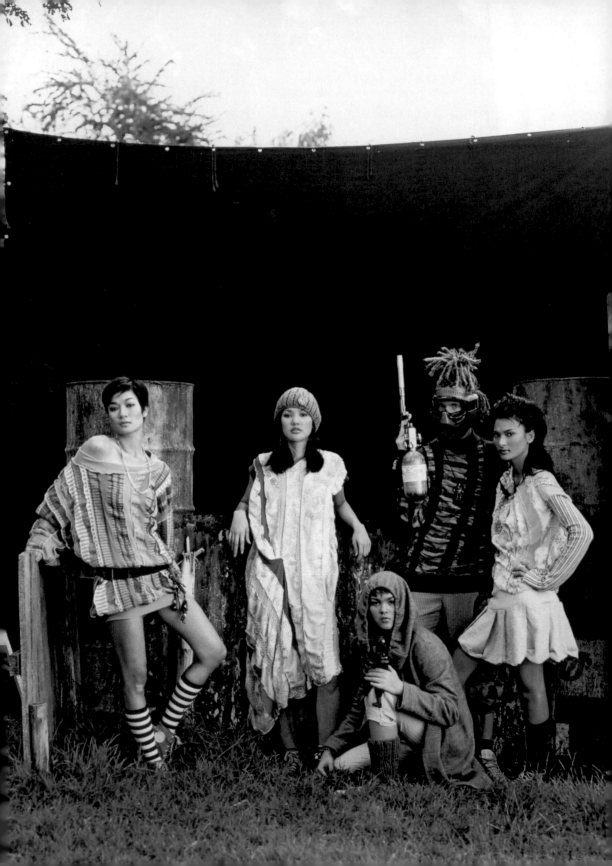

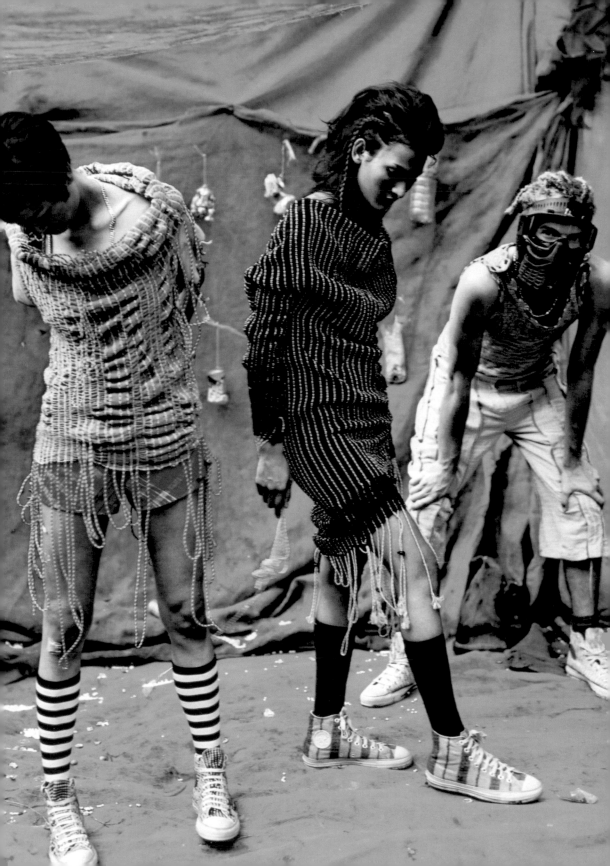

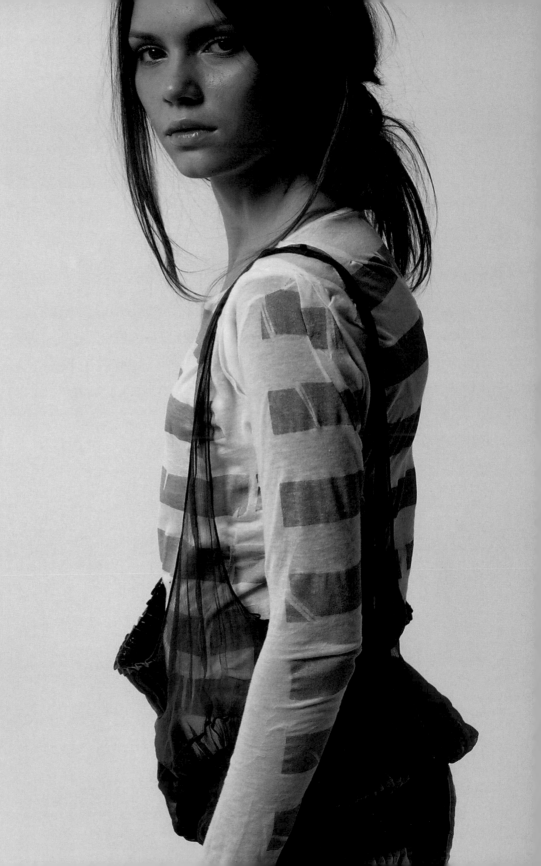

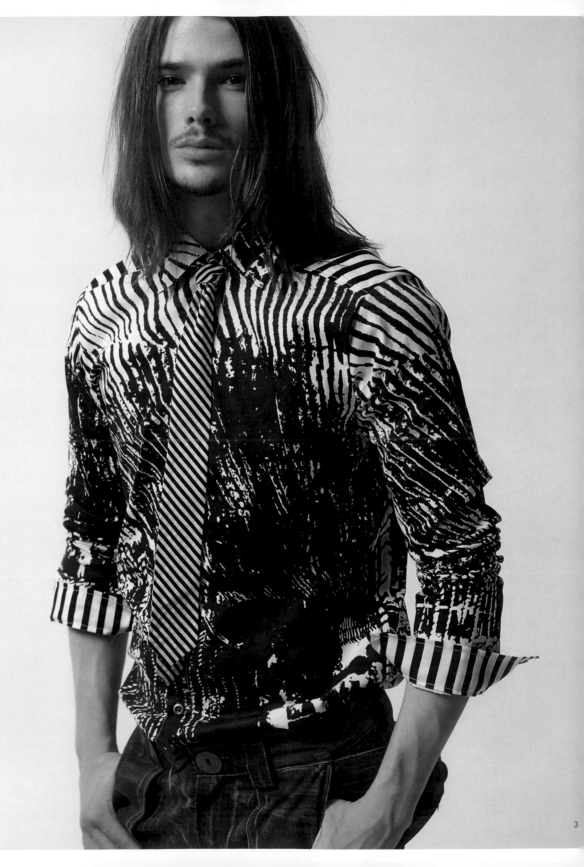

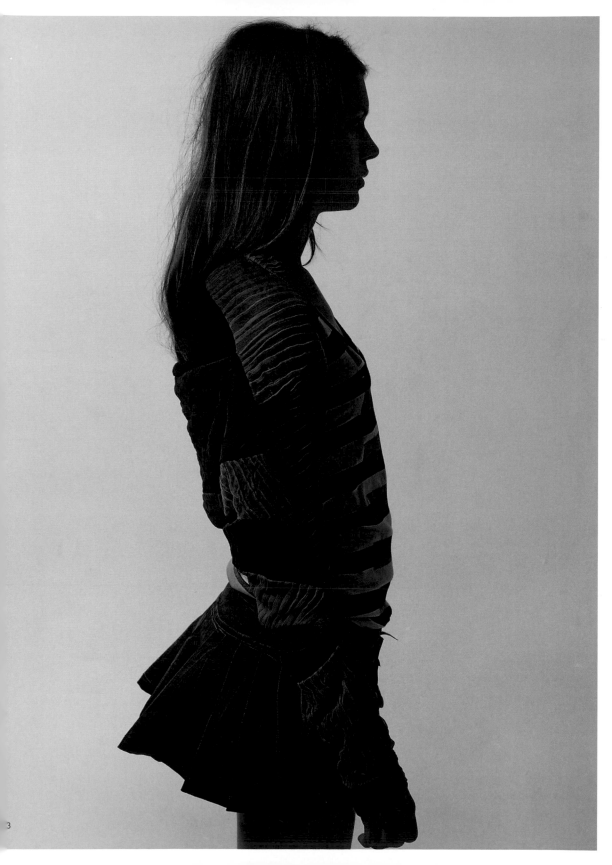

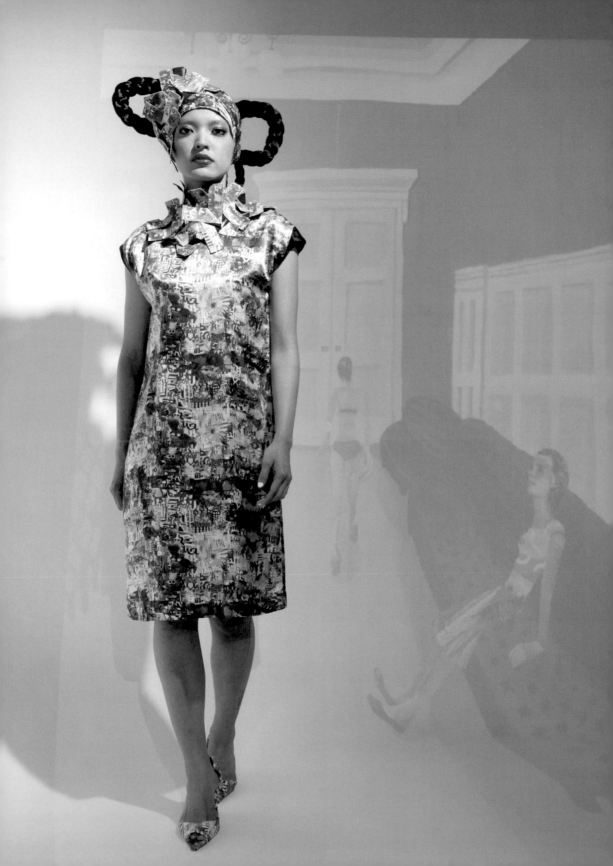

CHEESE-MONGER | TOKYO
Kumiko Iijima, Shinko Okuhara

The brainchild of stylist Kumiko Iijima and illustrator Shinko Okuhara is a unique collaboration effort which embraces their shared love of the bizarre, the cute and the comical. A graduate of an apparel design technique course at the Bunka Fashion College, Iijima, born 1974, was an assistant photo editor at Vogue Japan. In 2000, she switched to freelance styling and is now a talent represented by Cube Management. A graduate of Yokohama Art College, Okuhara, born 1973, is an award-winning freelance illustrator. In 2002, they launched the brand CHEESE-monger having collaborated successfully to turn Okuhara's popular print art into a series of fashion accessories for an exhibition. Now the brand is a fully-fledged clothing line available in department stores throughout Japan.

www.cheese-monger.com

1 spring summer 2007, „Collage"
2 cover photo SENKEN „h" of japanese Apparel news paper
3 fall winter 2007, „SOPO"

Photos: Humio Doi (1, 3), Noriyoshi Aoyagi (2)

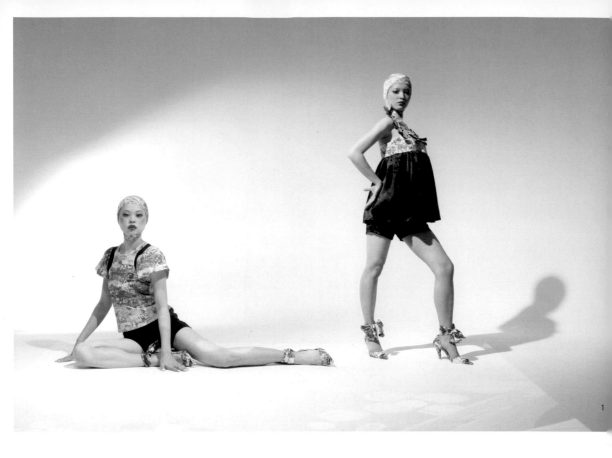

1

2

3

CHRONICLES OF NEVER | SYDNEY
Gareth Moody

Gareth Moody began his path in the fashion world with Tsubi (now Ksubi). After moving to Los Angeles to facilitate the initial set up of the growing global brand and phenomenon in America, Moody took a step back from Hollywood to come back down to earth. After leaving Ksubi as far as day-to-day actions were concerned, Gareth embarked on a journey of "self-indulgence" and traveled around the globe, during which he developed brand new conceptions for his future design direction. Gareth's first post-Ksubi solo creation, launched in 2006, was a collection of necklaces, bracelets and rings sculpted from real and old materials which was accompanied with a small clothing capsule, consisting mainly of graphic t-shirts. One year later a fully-fledged ready-to-wear range, "Water Will Burn", was launched for Spring Summer 2008, which was followed by "Another Slogan vs The World" for Winter 2008. Born from a whimsical desire to design with different mediums and new shapes, the brand is heavily influenced by architecture and geometrics, big manga dreams and a love for industrial materials.

www.chroniclesofnever.com

spring summer 2008

Photos: Marvin Scott Jarrett

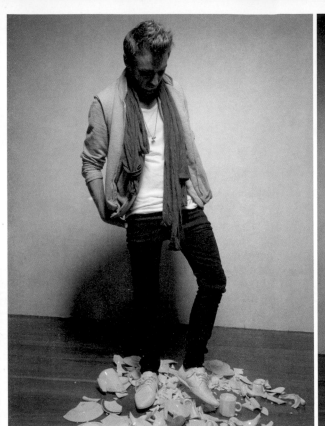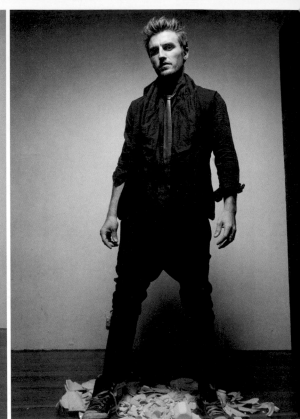

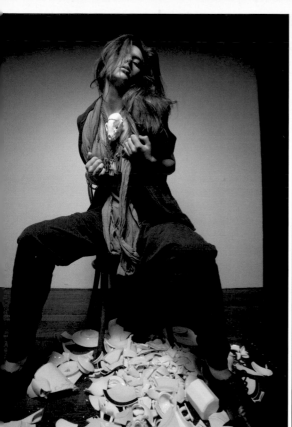
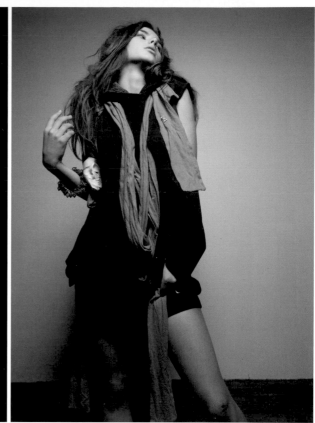

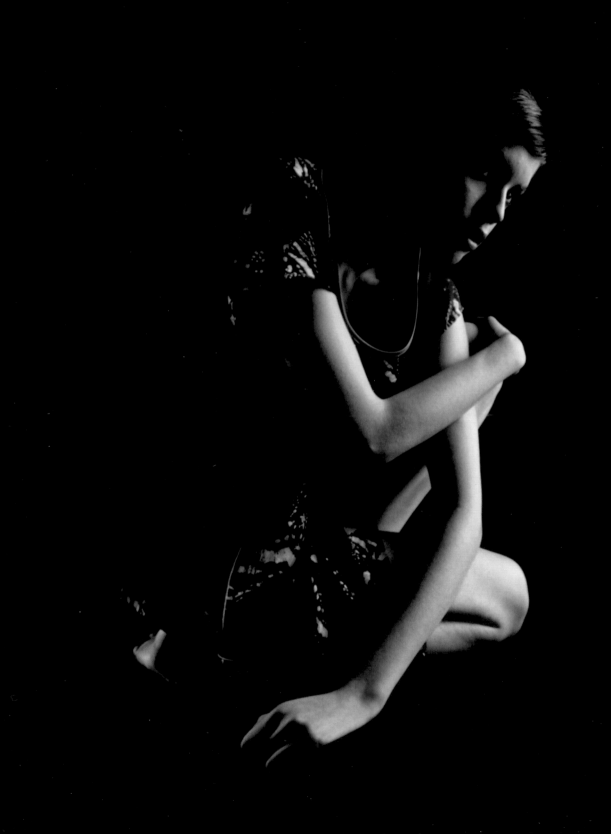

CYBÈLE | AUCKLAND
Cybèle Wiren

Graduating with a Bachelor of Visual Communications in 1999, designer Cybèle Wiren had worked in the Melbourne fashion industry for two years before returning to New Zealand and establishing the Cybèle label in 2003. Regarded as one of the country's foremost up-and-coming designers, Wiren, born 1976, has travelled to show as an invited designer at the Shanghai International Young Designer Showcase in 2006. The same year she presented successful showings of her summer collections at the Mercedes Australian Fashion Week. The label has since shown at the Rosemount Australian Fashion Week in April 2007, the Air New Zealand Fashion Week in September 2007, and in Tokyo during November 2007. Now in its 11th season, the bold and youthful brand, defined by distinctive custom prints designed in-house with innovative cuts and a striking use of patterns, is available in 30 boutiques throughout New Zealand, Australia, the U.S., UK and Japan.

www.cybele.co.nz

1 spring summer 2006/2007, *Fly Now*
2 fall winter 2007, *Blue Blood*
3 spring summer 2007/2008, *Hi-Fiction Science*

Photos: Brendan Callaghan (1, 2), Brad Hick Photography (3)

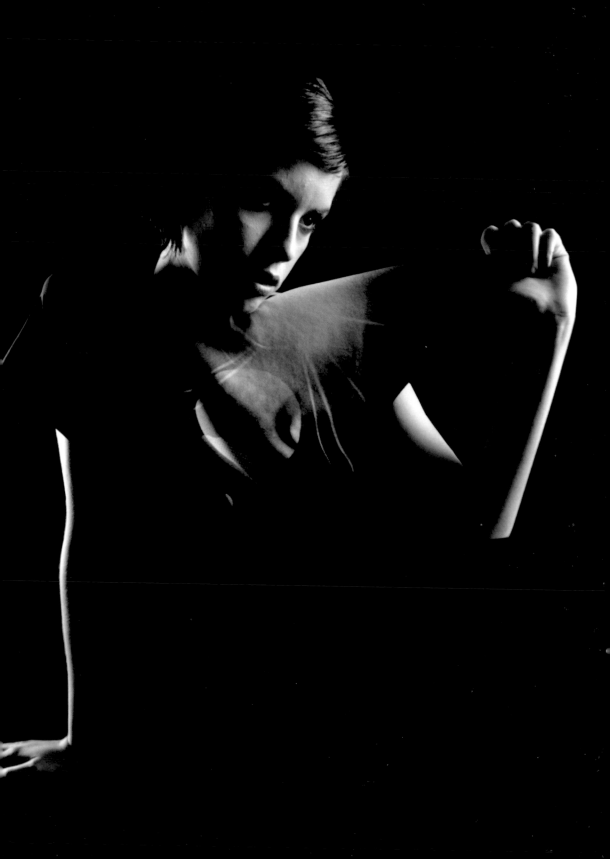

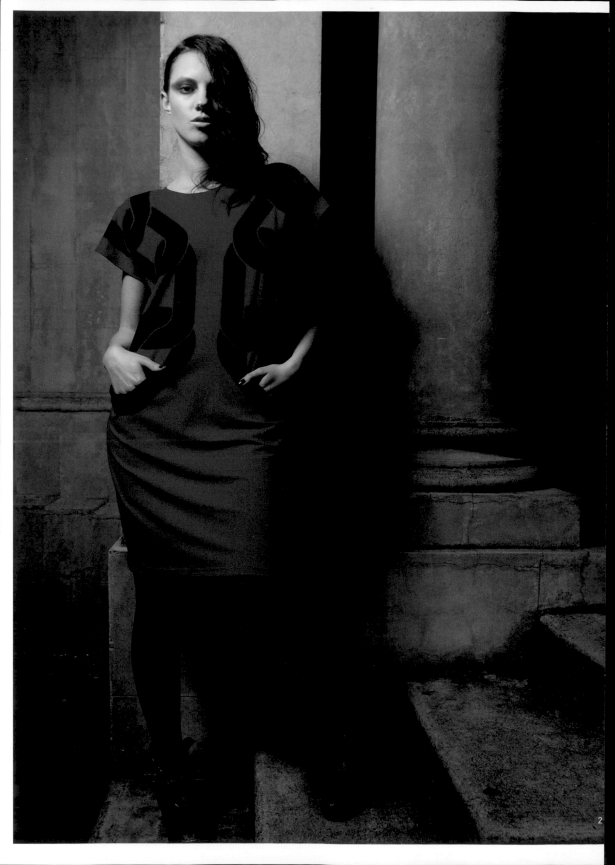

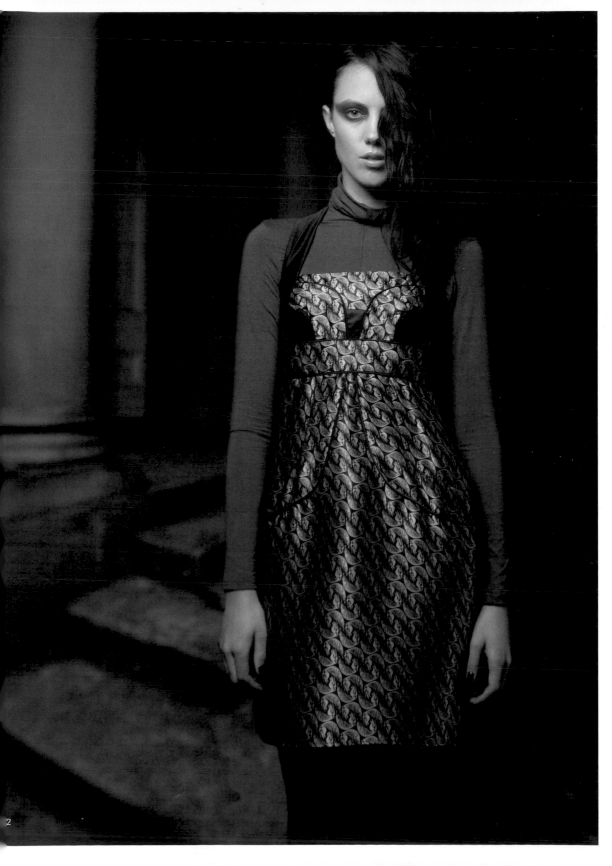

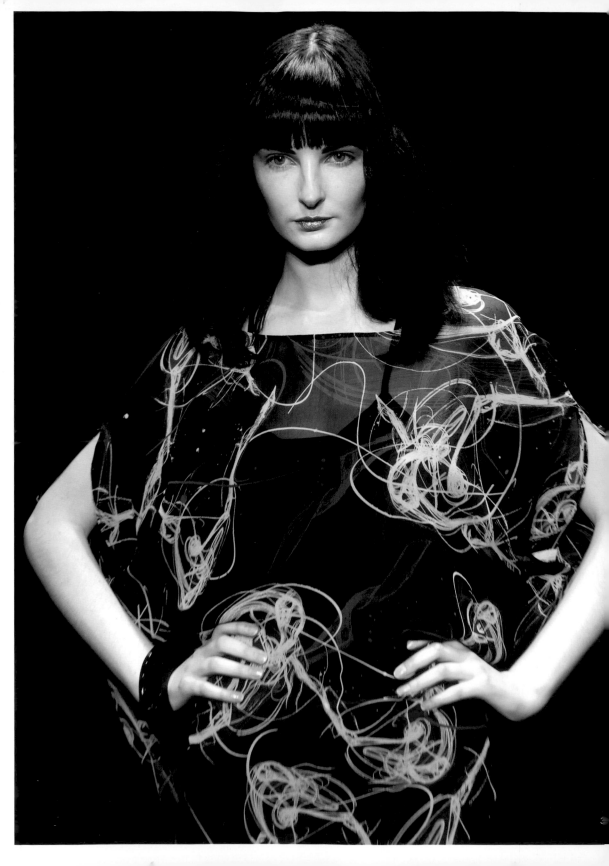

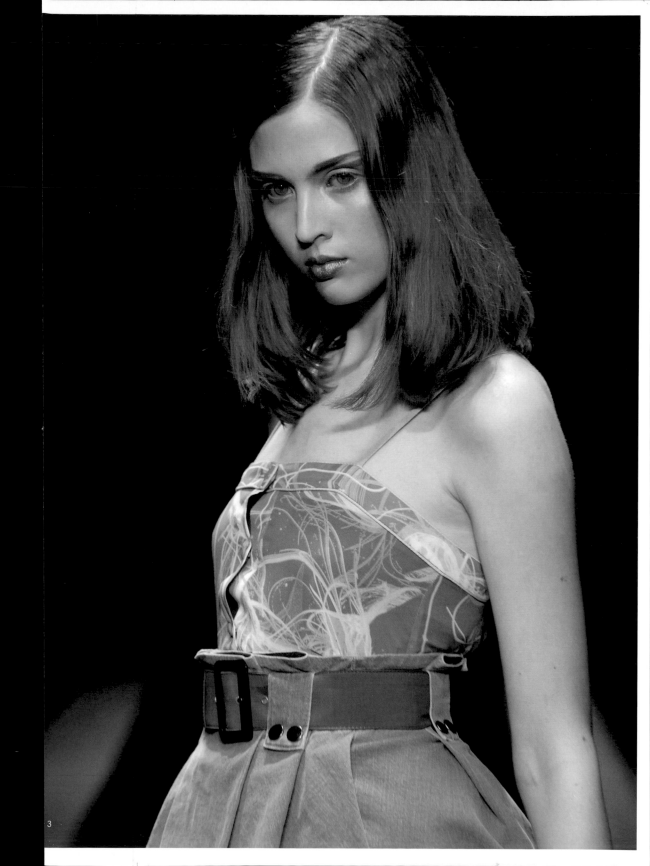

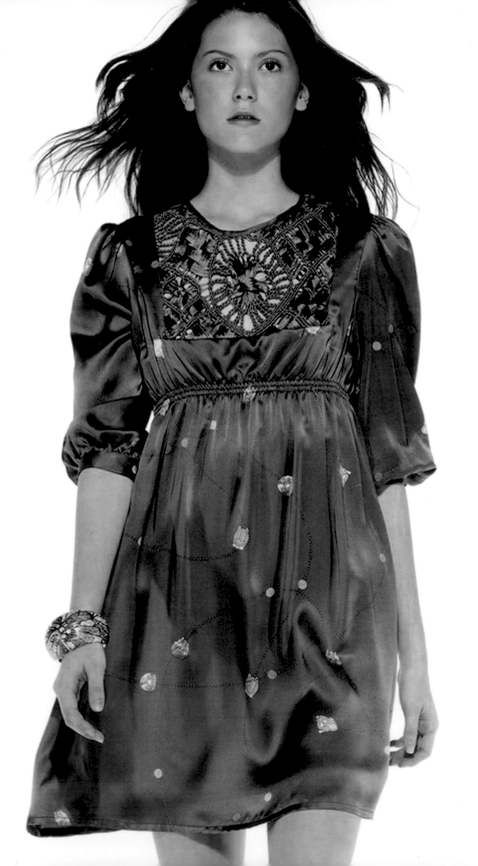

DISAYA | BANGKOK
Disaya Prakobsantisukh

Completing both undergraduate and postgraduate degrees at Central Saint Martins College of Art and Design with distinctions, Disaya Prakobsantisukh, born 1978, is highly influenced by London and the independent and creative element embedded within the city. With her works featured in magazines such as Dazed & Confused, Tank and Jalouse, including two of her V&A museum exhibits created for the 2001 "Curvaceous" project, the impetus to go solo was strong. Following a stint working with John Galliano, which came after winning the 2002 L'Oreal's Professional Total Look Award and Lancôme's Color Designs Award for Innovation in 2004, the Bangkok-born designer returned home to launch her first lingerie label, Boudoir by Disaya. The quirky and eccentric servings by Boudoir, debuting at the Bangkok Fashion Week in 2004, quickly caught a large following. Driven by the brand's successful launch, the designer has since widened her range to include an eponymous ready-to-wear line as well as a jewelry collection.

www.disaya.com

1 spring summer 2007
2 fall winter 2007
3 spring summer 2008

Photos: Nat Prakobsantisukh

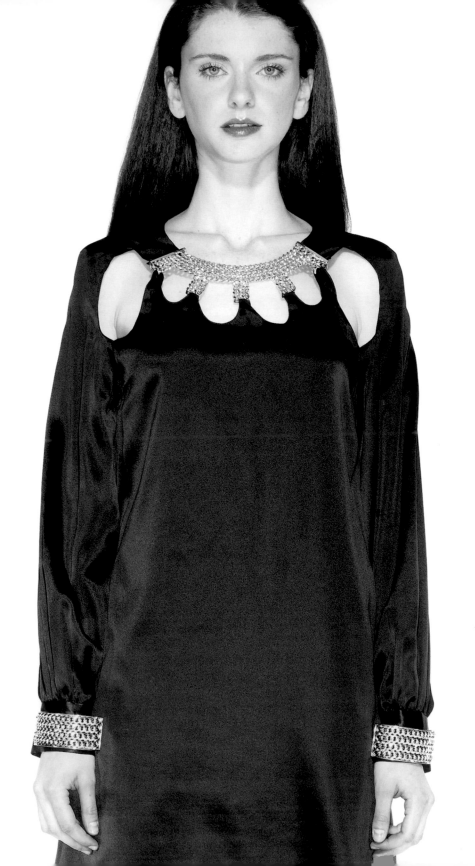

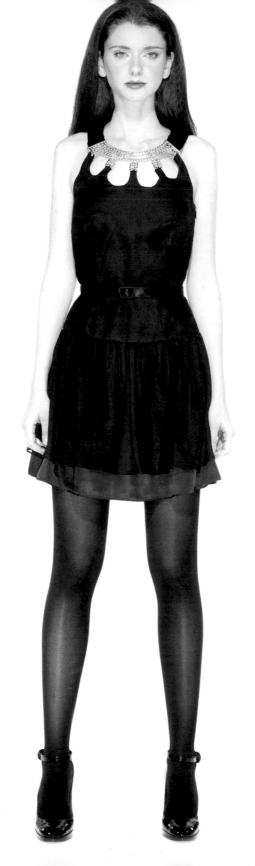

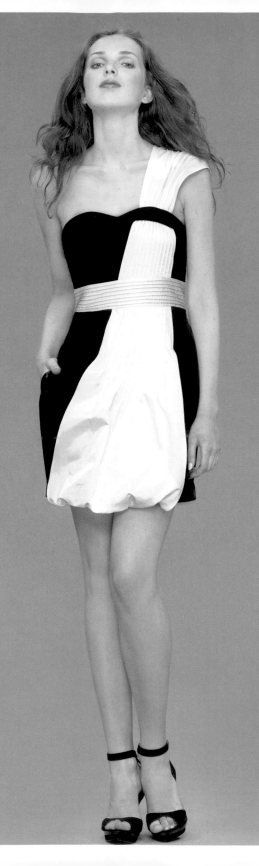

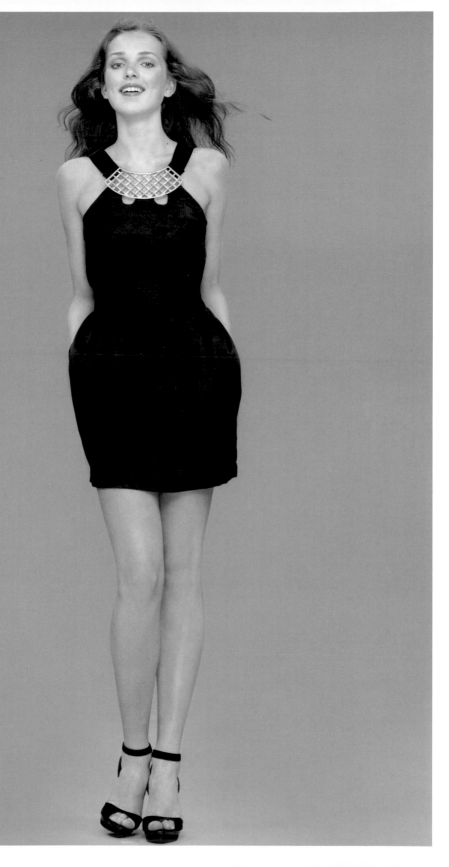

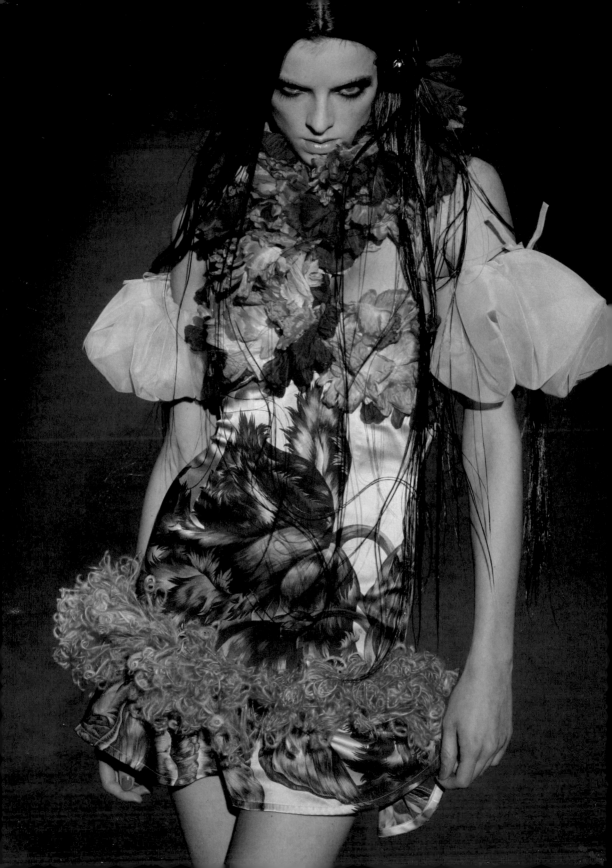

DRESSCAMP | TOKYO
Toshikazu Iwaya

Born 1974 and a graduate of Bunka Fashion College, Toshi-kazu Iwaya launched DRESSCAMP in 2003 with the support of the textile company, At One's , where he designed prints and patterns for seven years. Rejecting all mainstream aesthetics, which was still very much imbued in minimal-ism and spirituality, Iwaya brought in a whole new world of decorative flamboyance with his first collection, which stunt the audience and debuted to critical acclaims at the SS 2003 Tokyo Fashion Week. A year on he was announced the best newcomer at the 2004 Mainichi Fashion Awards as well as the winner of the Moet et Chandon New Designer Awards. In 2005 Iwaya opened the brand's first flagship in Aoyama, Tokyo and began several collaborations with inter-national luxury brands including Swiss watchmaker Piaget, the German leather label MCM and Italian fashion label Du-vetica. This year Iwaya's signature prints will make another debut in forms of DRESSCAMP Tablewear.

www.dresscamp.org

1 spring summer 2006
2 fall winter 2006/07
3 fall winter 2007/08
4 spring summer 2008

Photos: © DRESSCAMP

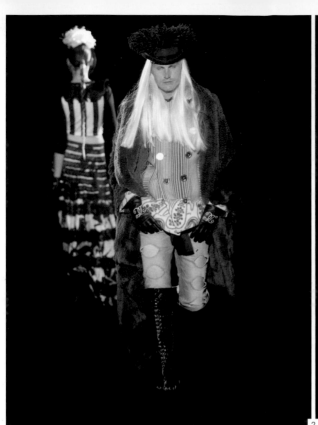
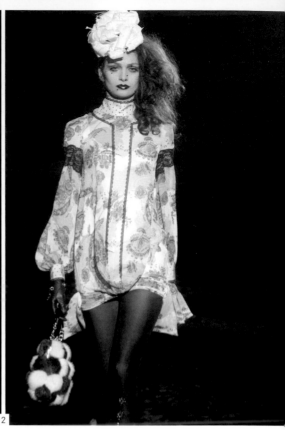

2

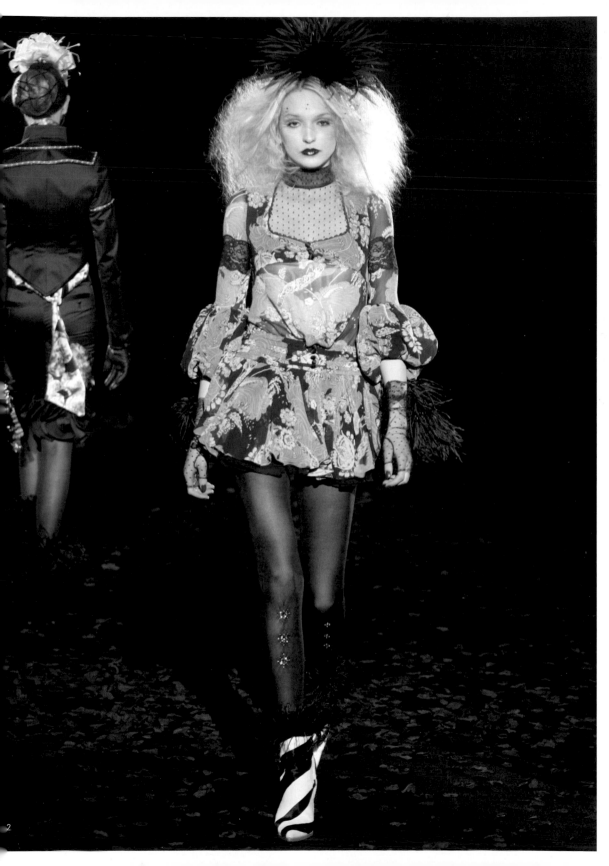

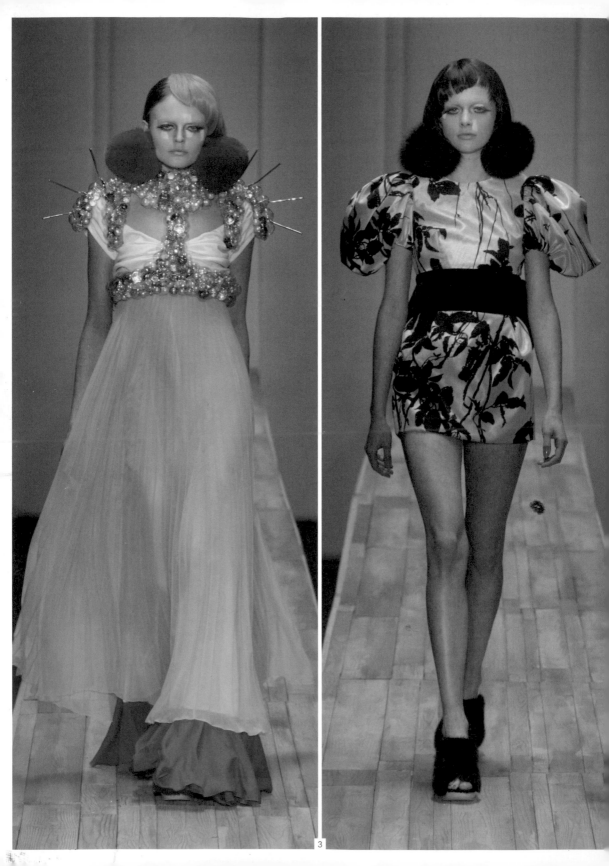

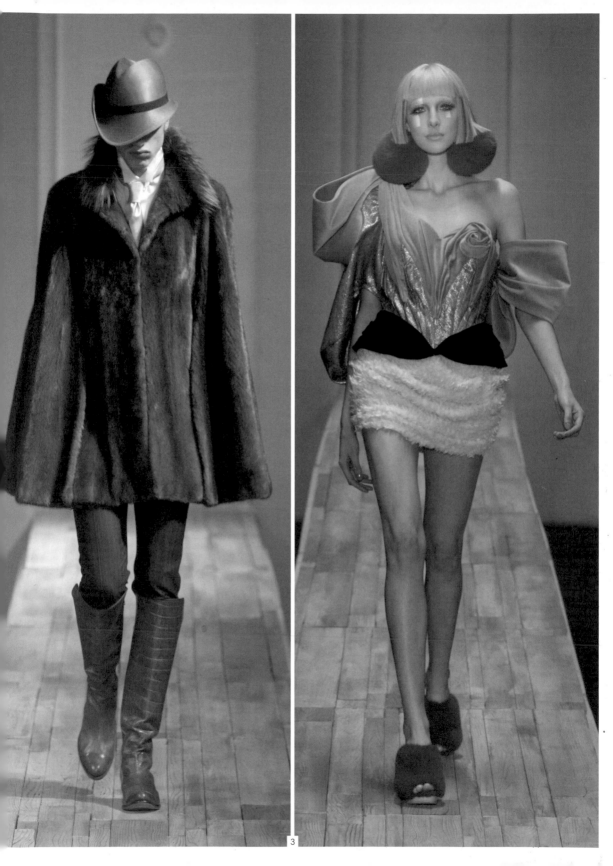

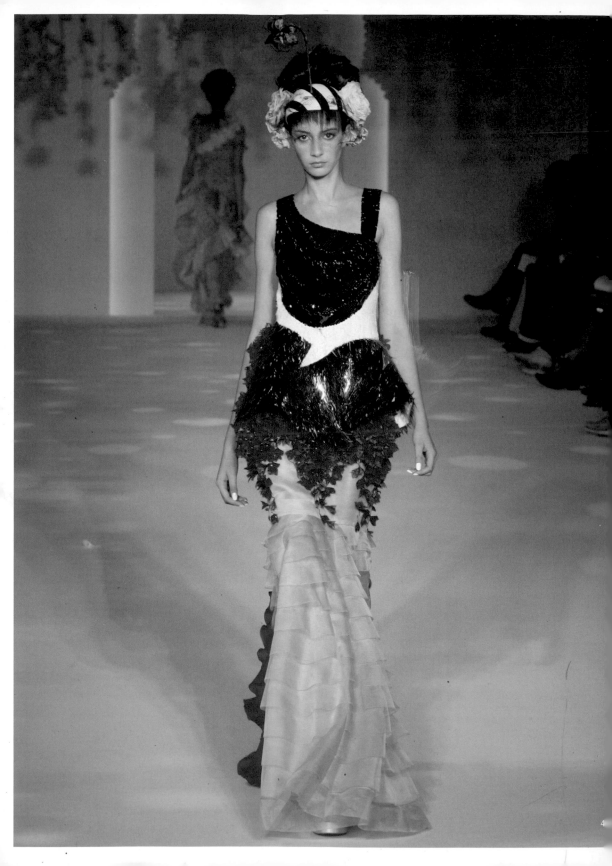

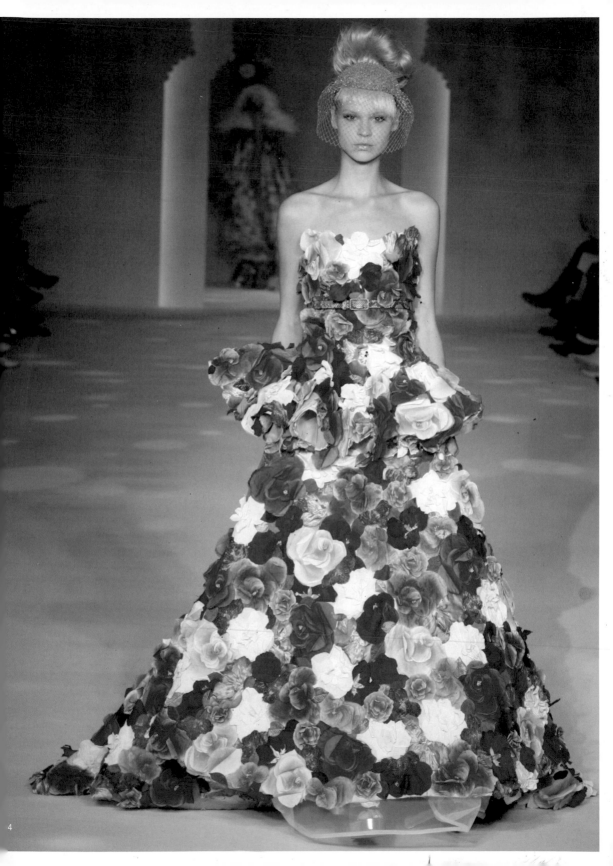

4

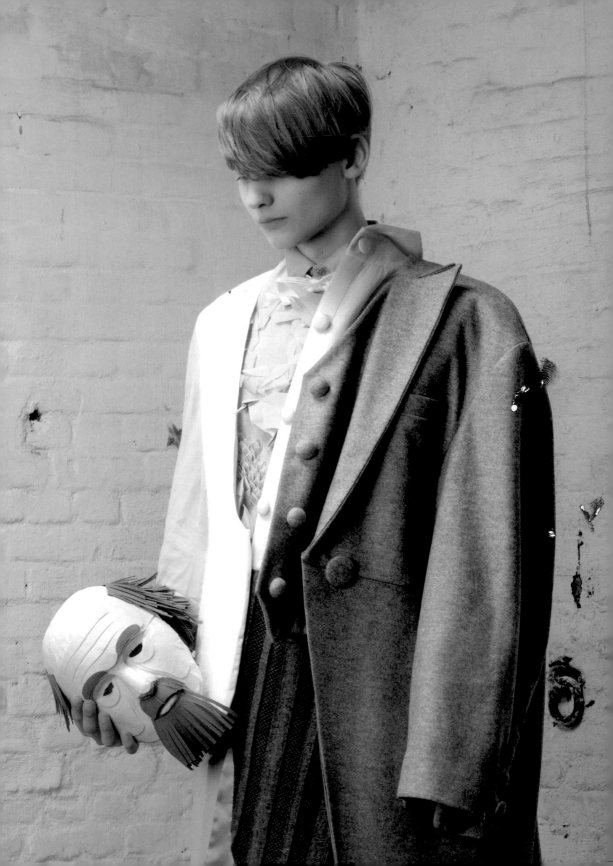

EK THONGPRASERT | BANGKOK
Ek Thongprasert

A Thai native born in 1981, Ek Thongprasert already showed a prominent passion and flair for fashion when he was studying architecture at the eminent Chulalongkorn University Bangkok. During his tenure there between 1999 and 2004, he represented Thailand for the Ferragamo International Shoes Competition in Milan, entered two local fashion competitions, came out top for one, and costume-designed for his university's theatre group. Once graduated, he headed to Belgium to cement his fashion knowledge. He enrolled at the Fashion Department of the Royal Academy of Fine Arts, Antwerp, after a brief internship with Christian Wijnants. In between working hard on his studies, which won him the Louise Award for the most remarkable third year student, the prolific designer collaborated on a Comme des Garçons project for Isabella de Borchgrave, and participated in the Pitti Imagine exhibition in Milan as well as the Fashion and Flavour fundraising event for Mode Museum, Antwerp. 2007 was the harvest year for his efforts when Thongprasert won two further recognitions: the first prize for the Fashion Weekend Festival by Weekend Knack Magazine, Belgium, and the Collection of the Year and Develon Award by the ITS#6 Competition in Trieste, Italy. Still a while to go before graduation in 2008, Thongprasert's work has been featured in numerous Thai and international magazines, including "ID" and "Dazed and Confuse".

www.ekthongprasert.com

1 Little Prince 2007, *Antwerp, Belgium*
2 Renaissance 2006, *Bangkok*
3 Little Prince 2007, *catwalk, Antwerp*
4 Little Prince 2007, *Mallorca, Spain*

Photos: by Bart (1), Jutarat Pornmuneesuntorn (2), Dominique Janssens (3), E. Thibault (4)

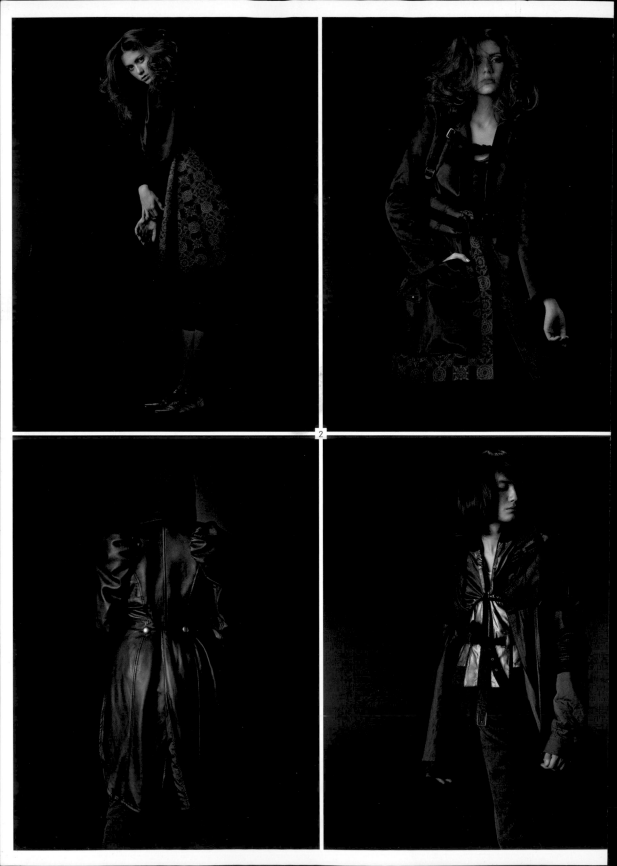

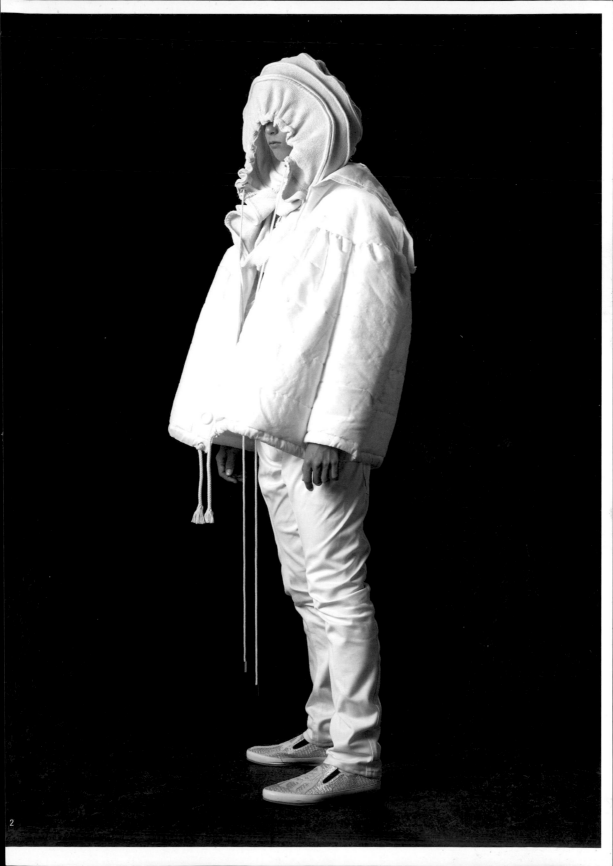

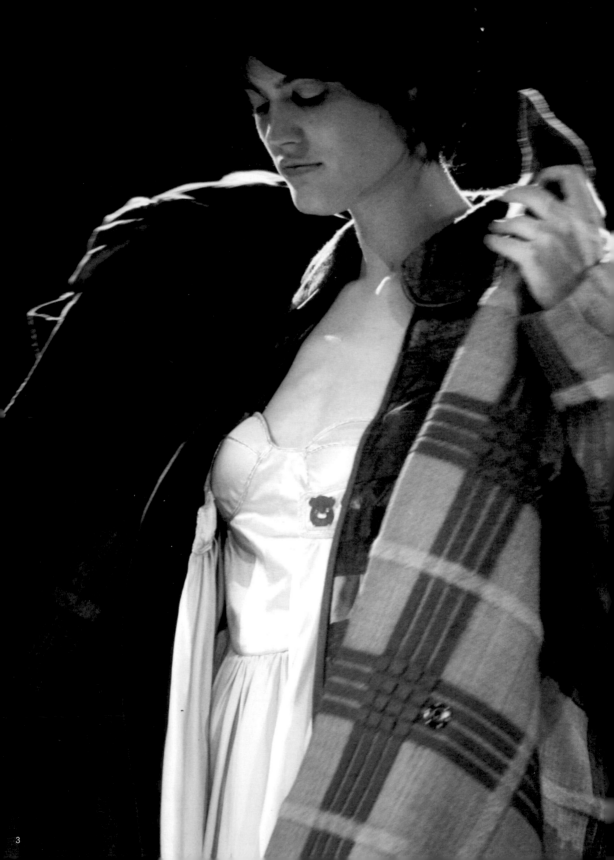

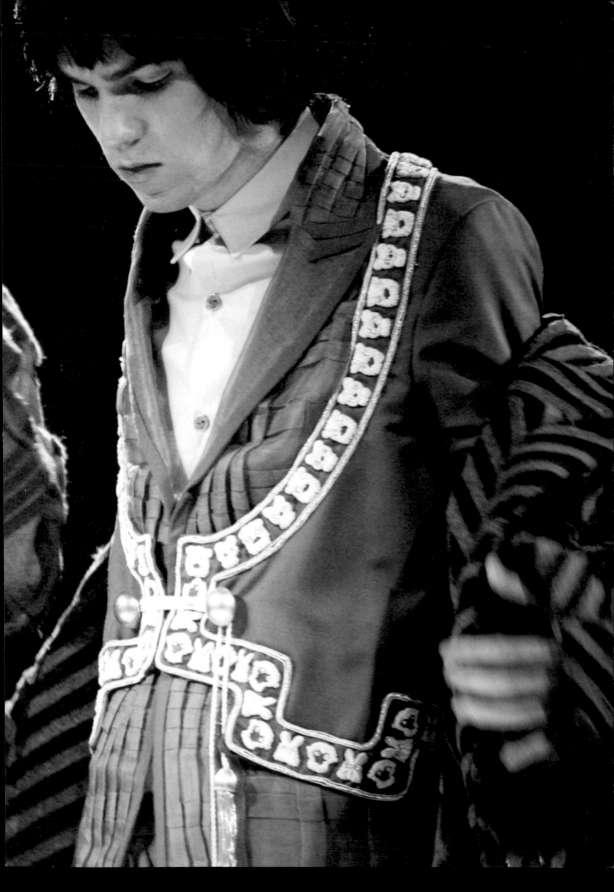

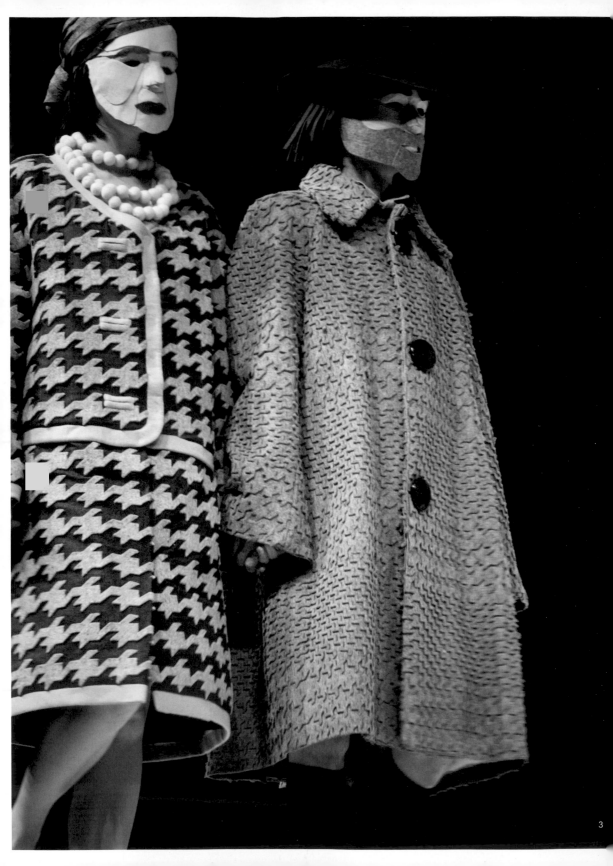

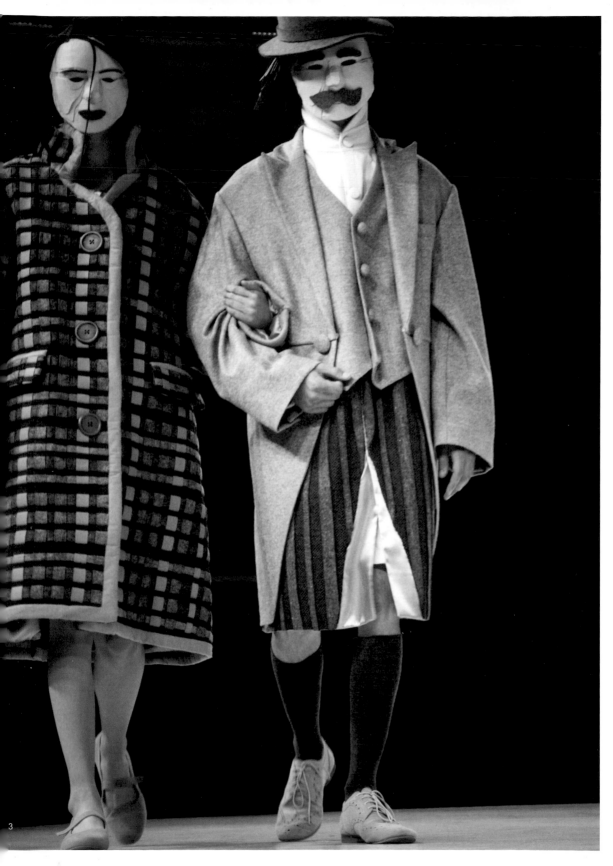

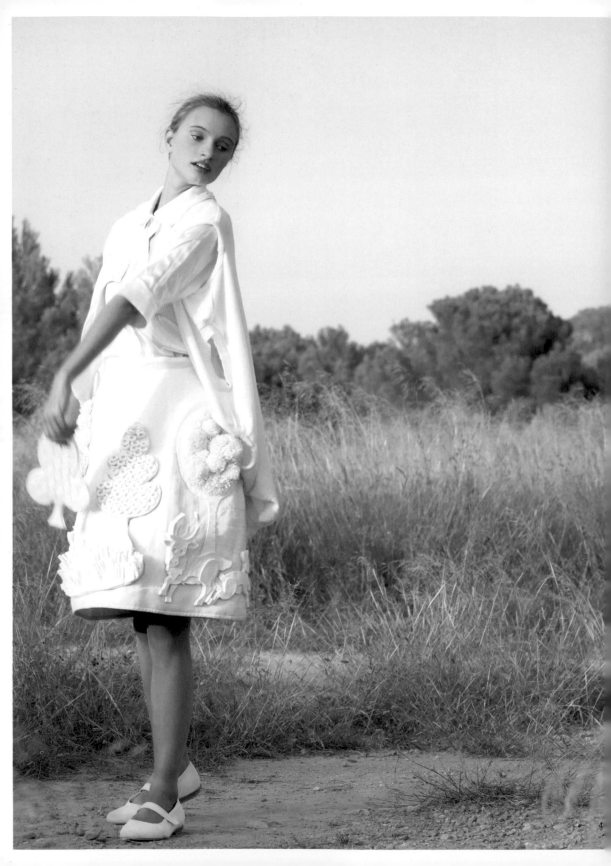

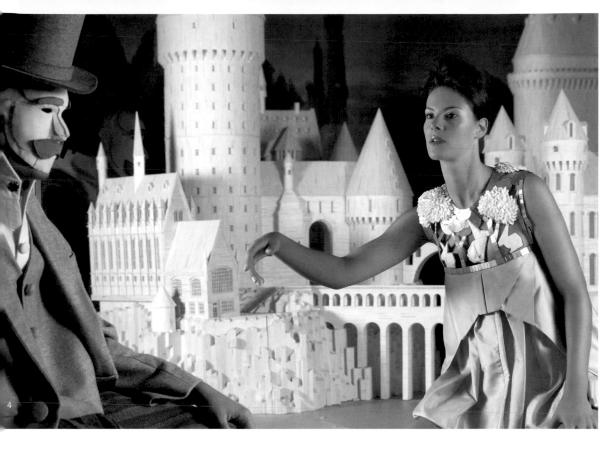

4

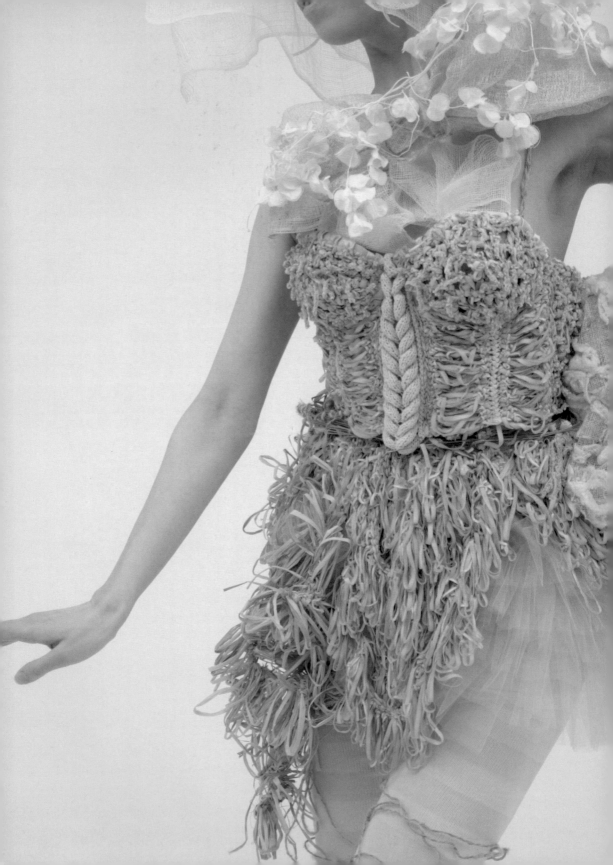

EVERLASTING SPROUT | TOKYO
Keiichi Muramatsu, Noriko Seki

After graduating from Bunka Fashion College in Tokyo, Keiichi Muramatsu and Noriko Seki, both born 1981, went their separate ways to pursue their fashion dreams. Muramatsu headed out to Florence, Italy to join a yarn company, the Lineapiu Group as their assistant designer, while Seki worked as a freelance designer in Tokyo. Once back home from Italy, Muramatsu hooked up with Seki again to found Everlasting Sprout, and immediately set about to sprout up their first knitwear spectacle for the Spring Summer 2005 Tokyo Fashion Week. In February 2006, their ever intricate and dreamy designs were presented at the leading yarns, wools and knit trade fair Pitti Filati in Italy. Besides showing their collections regularly in Tokyo, the pair also collaborates frequently with Japanese designers and foreign companies as specialist knitwear consultants.

www.everlasting-sprout.com

1 may 2005
2 spring summer 2008

Photos: Katsumi Fujii (1), Kazuya Aiba (2)

1

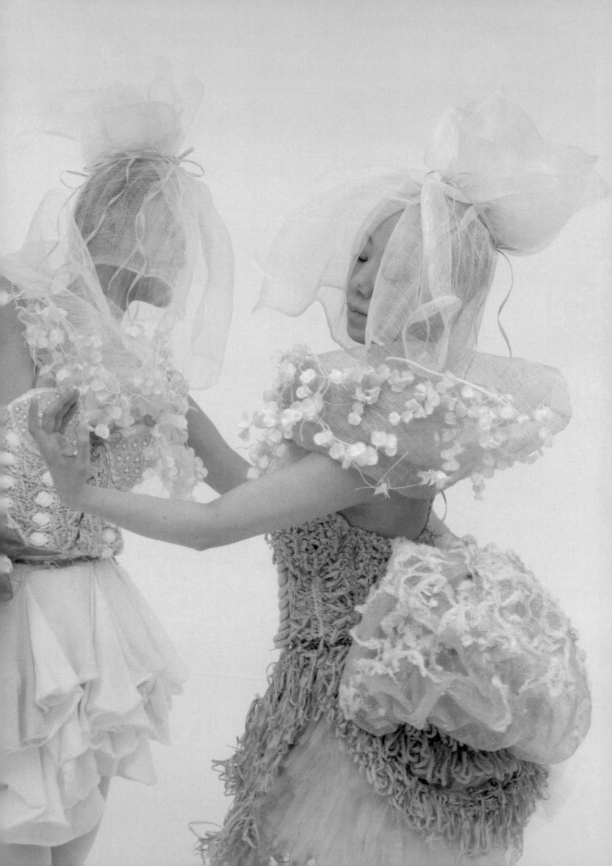

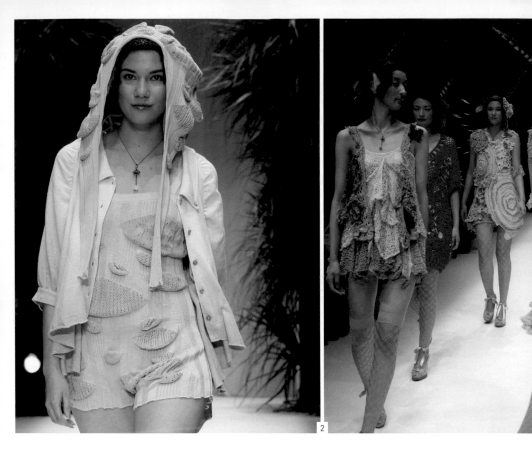

2

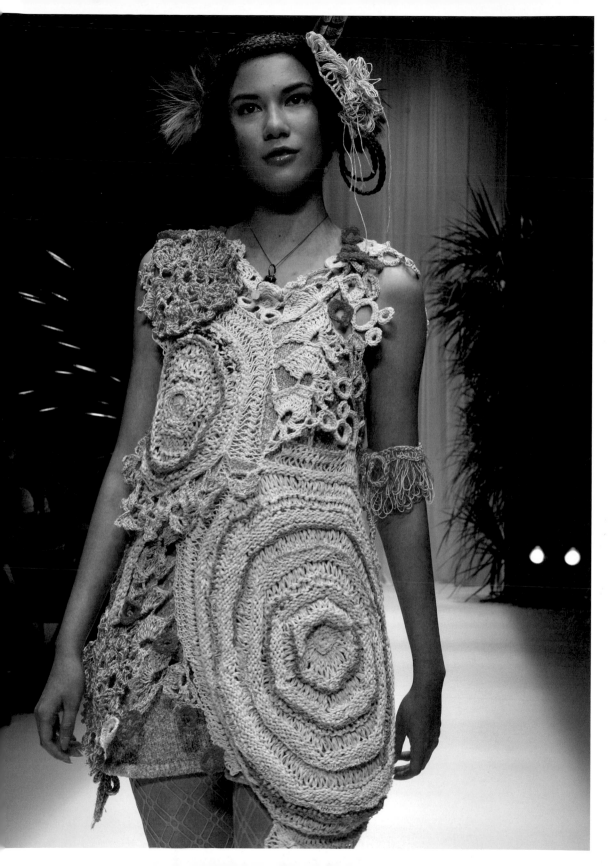

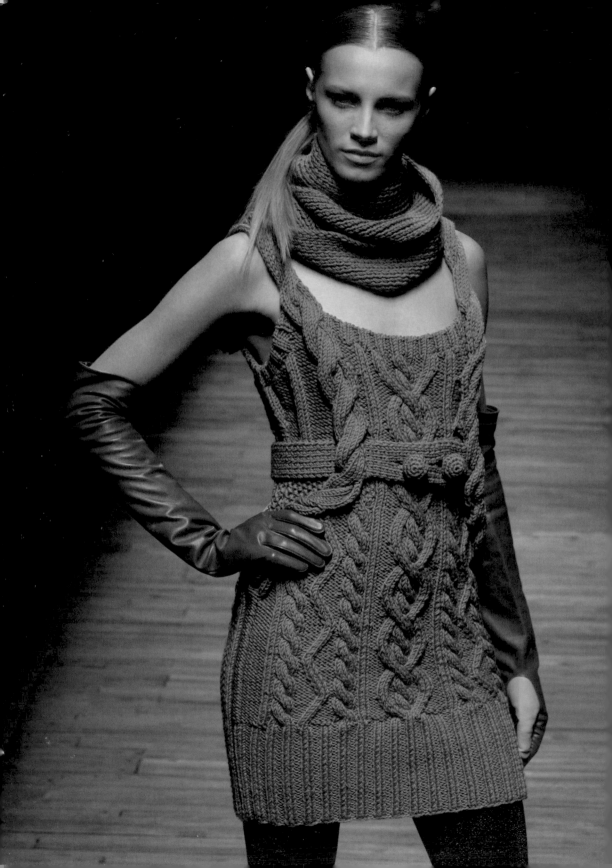

G.V.G.V. | TOKYO
MUG

Born 1971, the mononymous designer MUG is a graduate
of Kuwasawa Design Institute. Launched in 1999 with back-
ings by a cultish all-female fashion collective k3, G.V.G.V.
is famed for its menswear-inspired tailoring and carefully
considered silhouettes. For MUG each season is a fash-
ion-forward exploration of her unique vision of coexisting
masculinity and femininity in the modern word. Recently
that vision is bending evermore towards the feminine. Her
latest collection, Spring Summer 2008, conveys an urban,
minimalist silhouette and a witty use of synthetic-looking
fabrics that's in fact all natural.

info@k3coltd.co.jp

1 fall winter 2007
2 spring summer 2008

Photos: Nobuyoshi Yoneyama

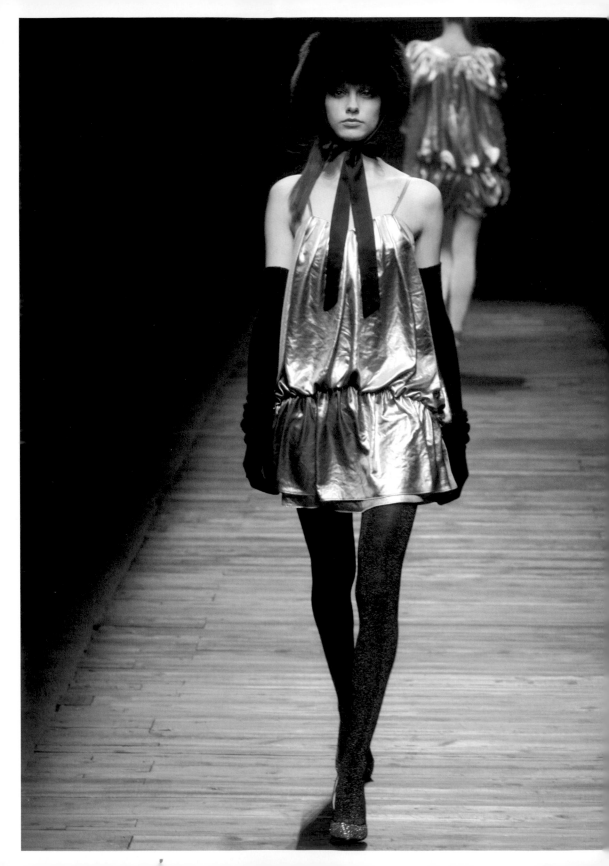

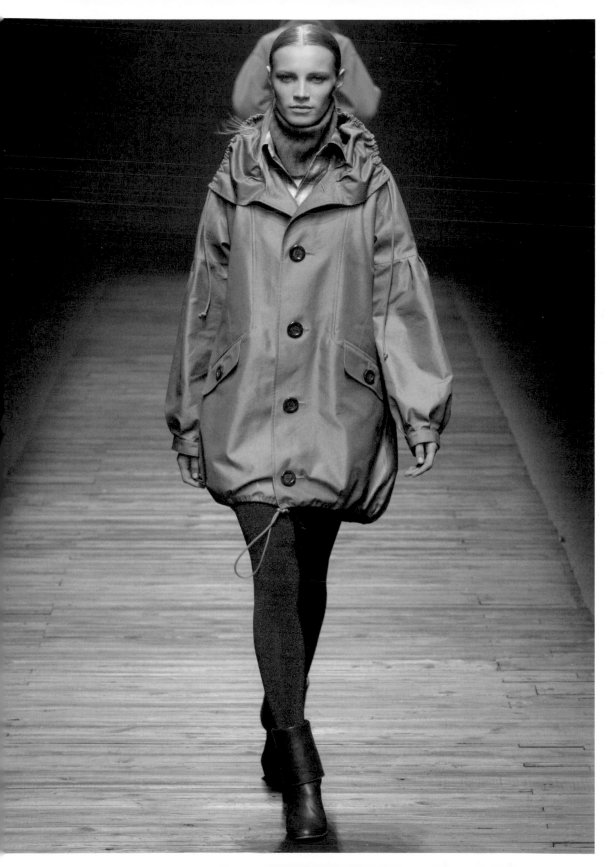

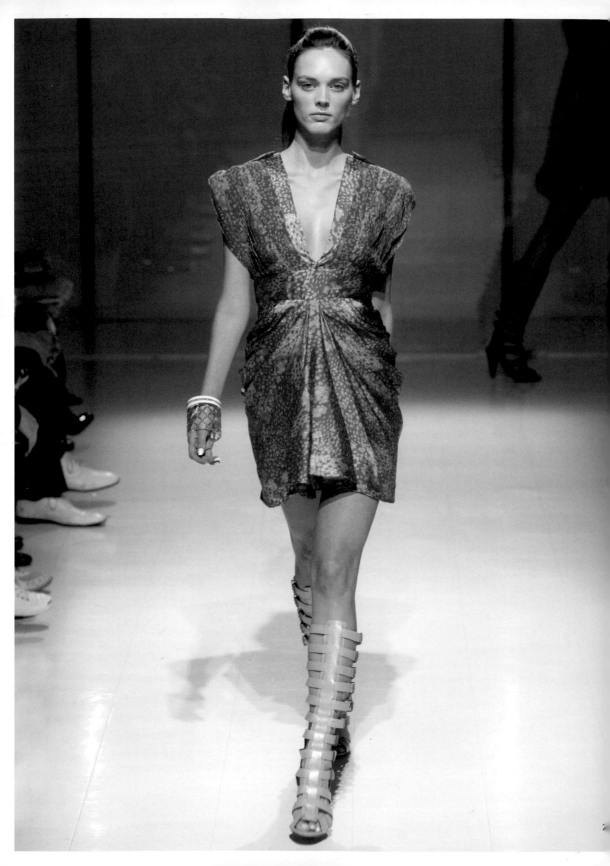

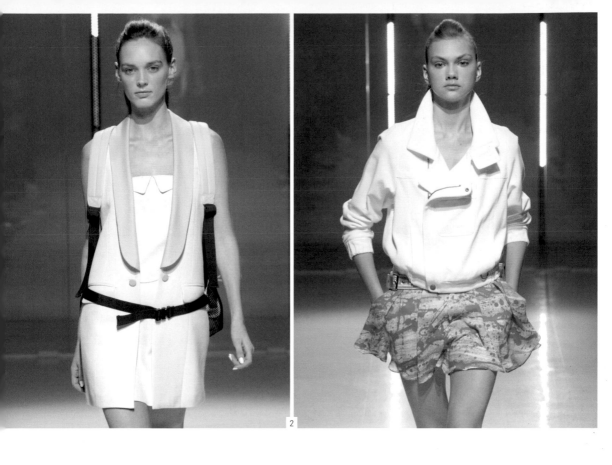

2

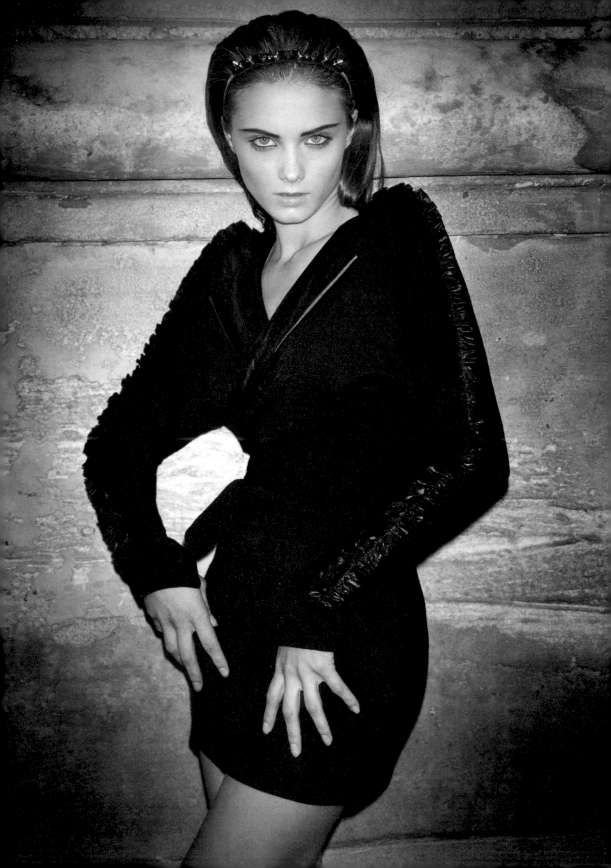

GAIL SORRONDA | BRISBANE
Gail Reid

Before launching her label in 2005, Reid worked as a model and a stylist prior to completing a bachelor's degree in Fine Arts (Fashion) in 2004. Prior to immersing herself in fashion, the Australian designer also studied Built Environment. Hence, a fascination with structure and perspective continues into her work today, which shows a focus on dramatic silhouettes eschewing color and print. After her debut collection, "Angel at my Table", which was awarded first place within its category at the Mercedes-Benz Start Up Awards, Reid has presented and sold her collections at fashion weeks from London and New York to Berlin and LA. In 2007, she presented her spring summer 2008 collection, Bird of Prey, at her debut solo show at the Rosemount Australian Fashion Week. Currently Reid is working on her debut at Paris Fashion Week and planning her first free-standing concept store.

www.gailsorronda.com

1 fall winter 2007/08, *White Knight*
2 spring summer 2008, *Bird of Prey*
3 spring summer 2007, *Angel At My Table*

Photos: Ezra @ The Artists Group

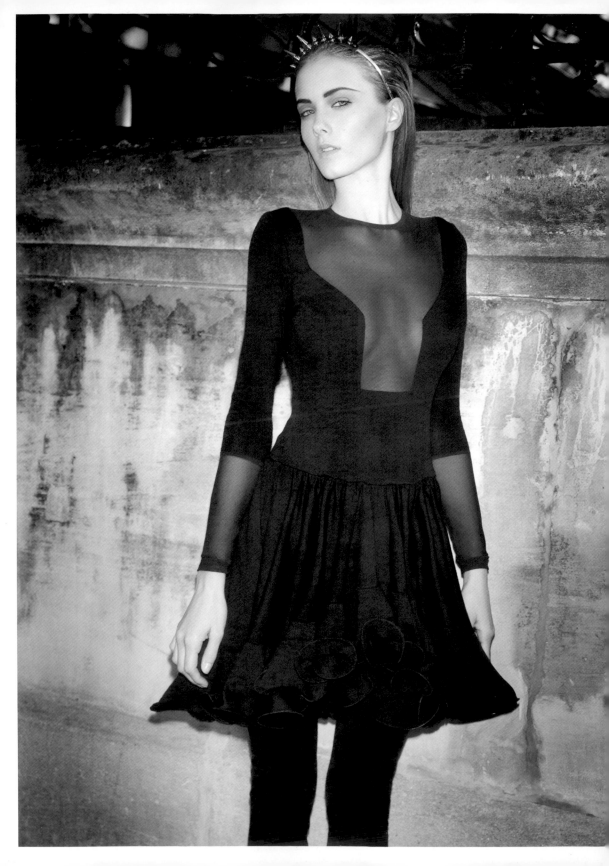

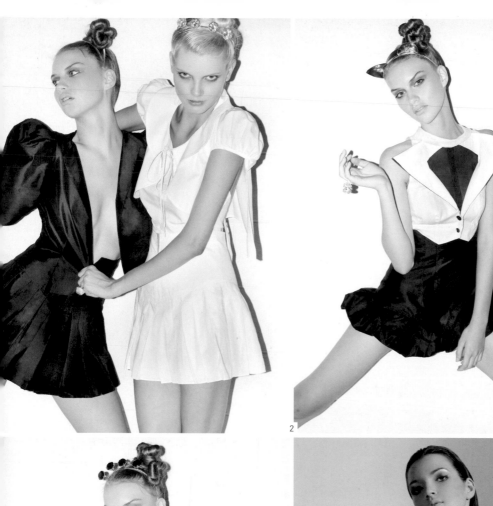

2

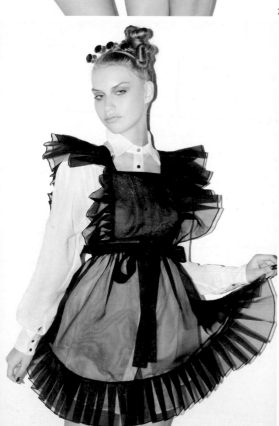

2

3

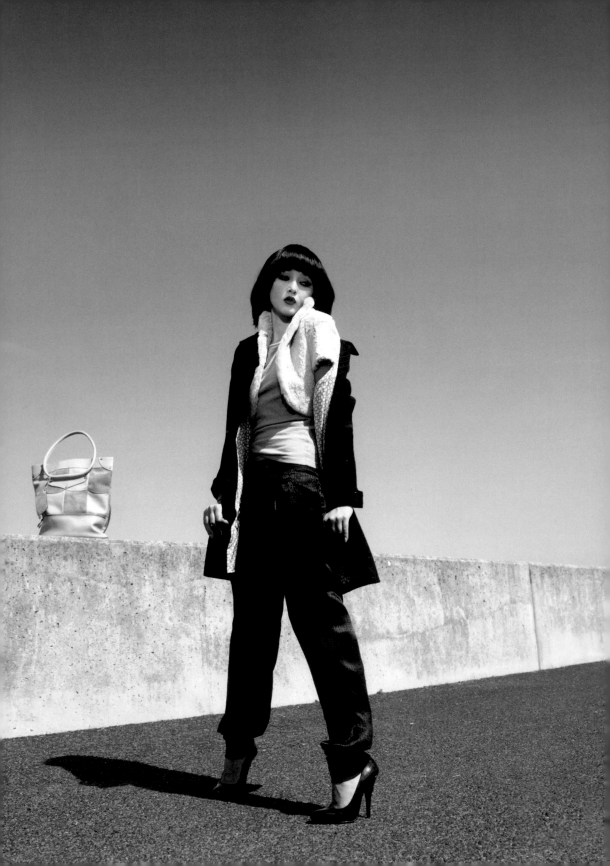

GINGER & SMART | SYDNEY
Genevieve Smart, Alexandra Smart

Ginger & Smart is the brainchild of two redhead sisters Alexandra and Genevieve Smart, who teamed up their fashion design and entrepreneurial talents to launch the brand in 2002. Prior to Ginger & Smart, Genevieve, born 1972, worked as the head designer for Lisa Ho for six years and Alexandra, born 1970, was a publisher in the magazine, book and internet industries. She was also the launching editor of Oyster Magazine. The brand signature is about luxury escapes: polished design chic, sexy dresses and accessories that are luxury accompaniments to an escape. Based in Sydney with a flagship store in Paddington, Ginger & Smart is now sold in more than 100 boutiques in Australia and 40 stores in UK, Europe, Hong Kong and Russia including Browns Focus and Harvey Nichols in London and Lane Crawford in Hong Kong.

www.gingerandsmart.com

1 fall winter 2007
2 fall winter 2008

Photos: David Mandelberg

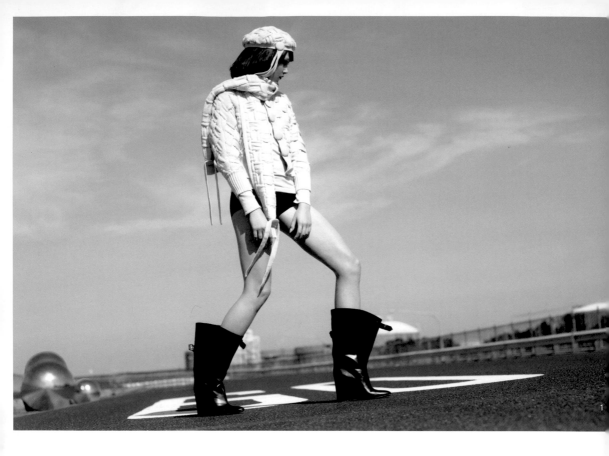

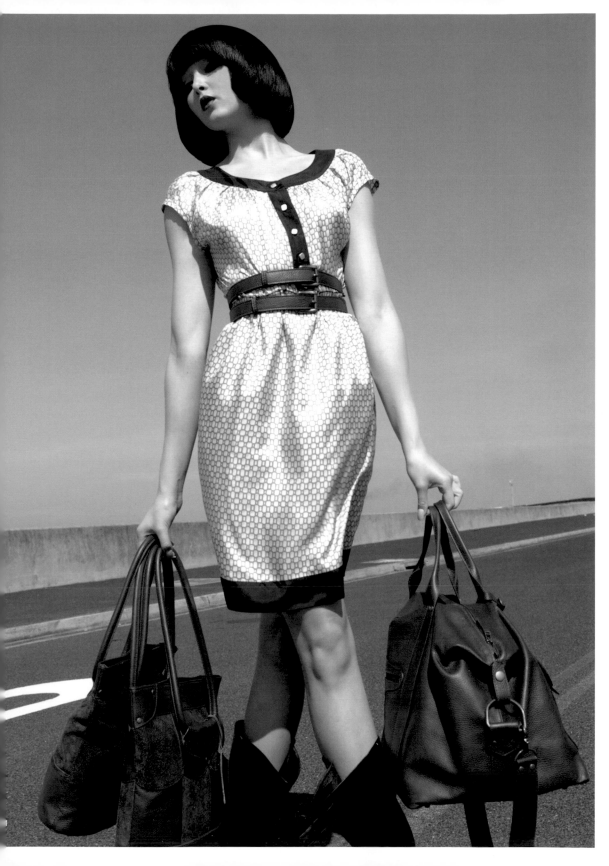

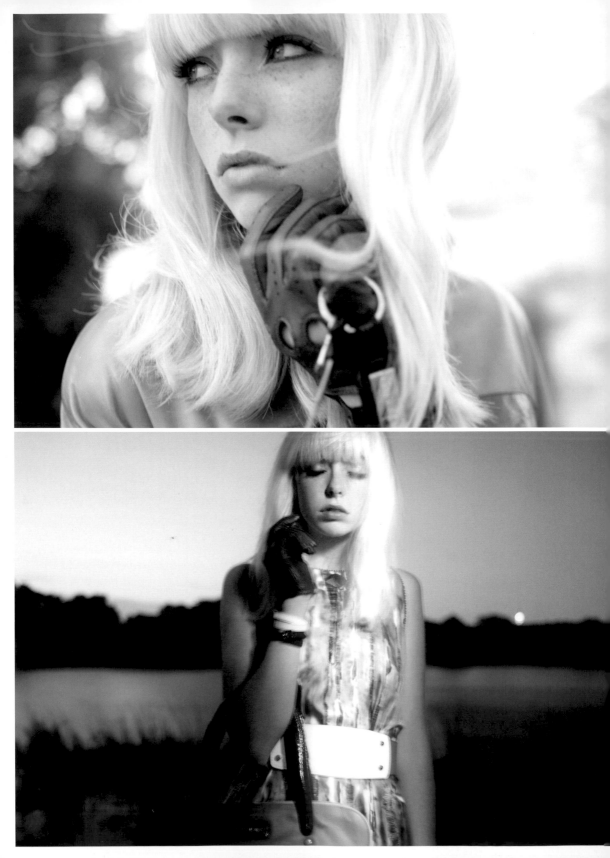

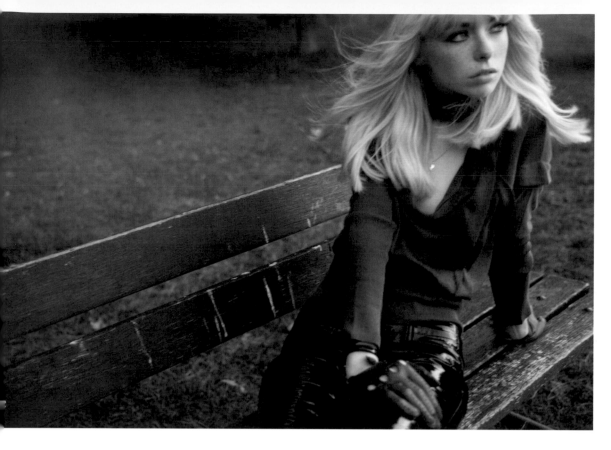

HABENORMAL | SEOUL
Yum Mi, Eun Hee Kim, So Young Park

Habenormal is born out of a meeting of minds between three Koreans who share a keen taste in deconstructionist beauty and who cherish the idiosyncrasies that cut the normal from the abnormal. Launched in 2004 not long after completing their fashion degrees in various countries—Yum Mi from the Academy of Art University in San Francisco, Eun Hee Kim from the Samsung Art and Design Institute in Korea and So Young Park from Drexel University in Philadelphia—Habenormal sent a breath of fresh air to the Korean fashion scene with their original styles. Since becoming a member of the Seoul Fashion Artist Association in 2006 and strutting their debut show at the Seoul Collection, the trio is now a regular seen every season.

www.habenormal.com

1 fall winter 2007, *moderate humorsomeness*
2 fall winter 2004, *an experiment of versatility*

Photos: Jimmy Bae (1), Jono Lee (2)

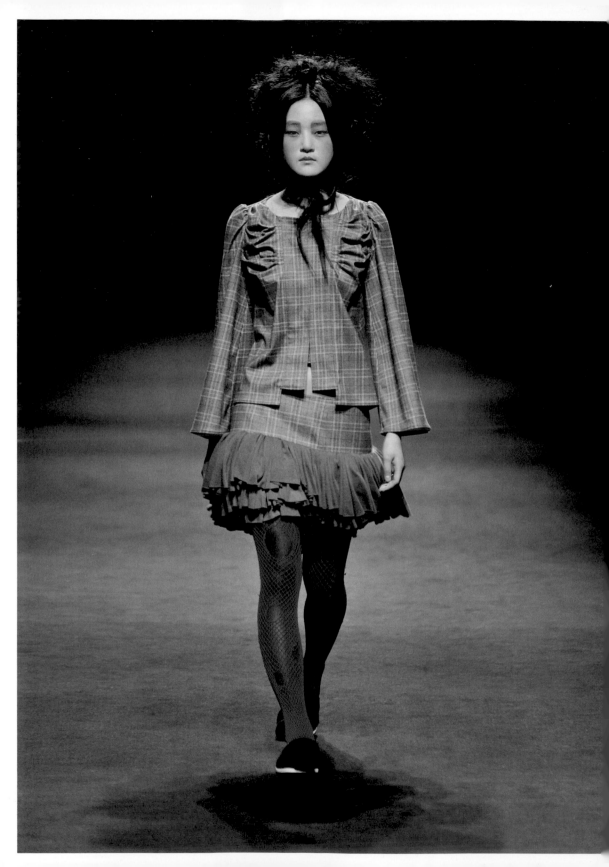

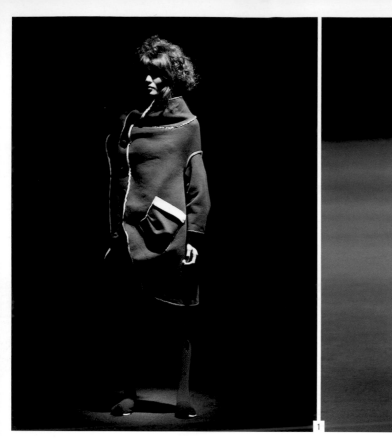
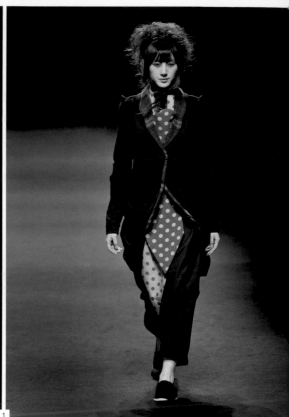

1

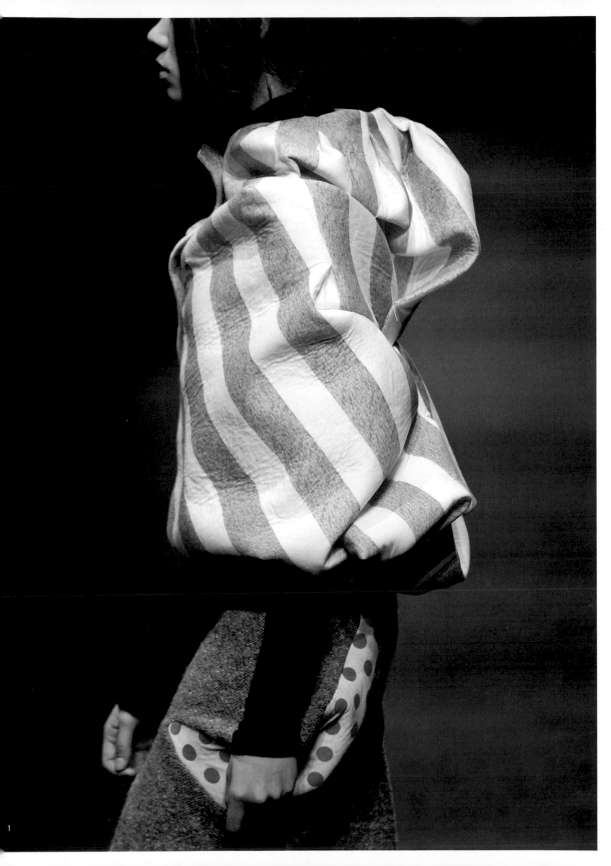

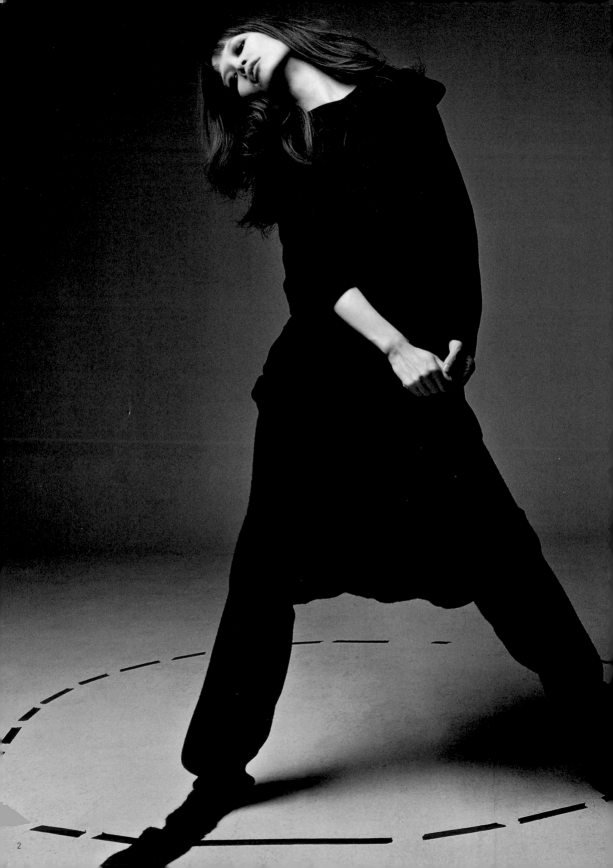

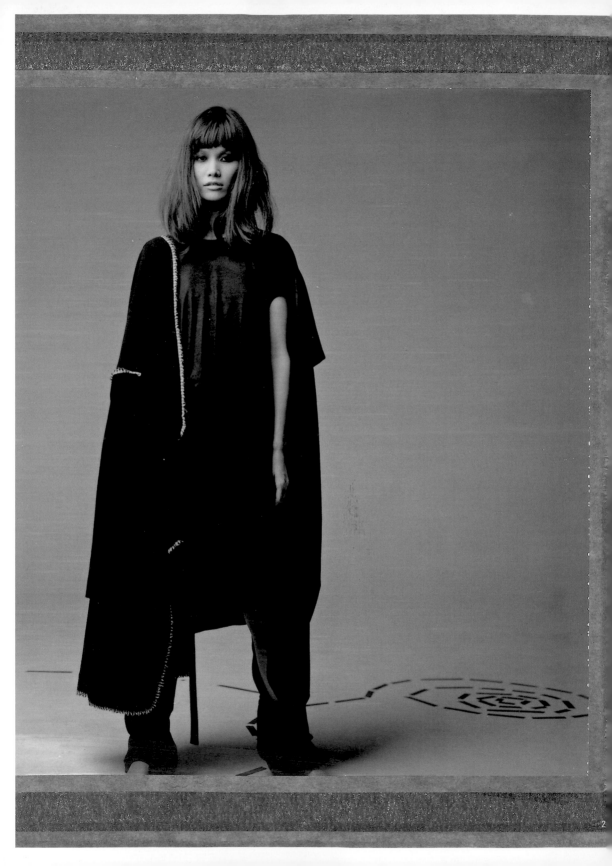

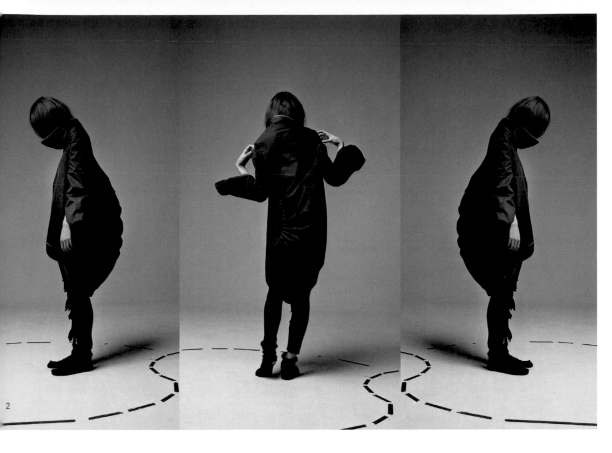

2

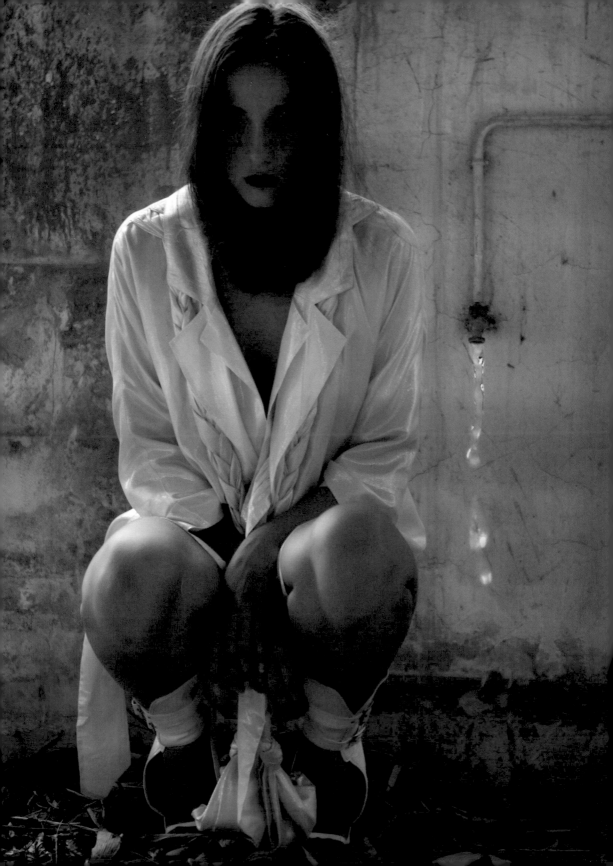

HARRYHALIM | SINGAPORE
Harry Halim

Upon graduating from Singapore's Lasalle College of the Arts the Indonesian-born designer joined the renowned fashion establishment Celia Loe as a designer, while tirelessly registering his own creations across all local and regional fashion awards. After emerging as a finalist in two important regional awards, his delicate and impressive constructions of black and red draped pieces was finally crowned a winner at the Singapore Fashion Designer Contest in 2006 and Asian Young Fashion Designer Contest in 2006. In 2007, Halim, born 1985, presented his second collection, Bias II, at the Nokia L'Amour Young Designer Show during the Singapore Fashion Festival, which was followed with a fully-fledged third collection, Lies, later in the year. Showed at the Singapore Fashion Week in October, Lies drew impressive responses from international buys from UK to Australia.

www.hhharryhalim.com

1 spring summer 2008
2 spring summer 2006

Photos: Warren Wee

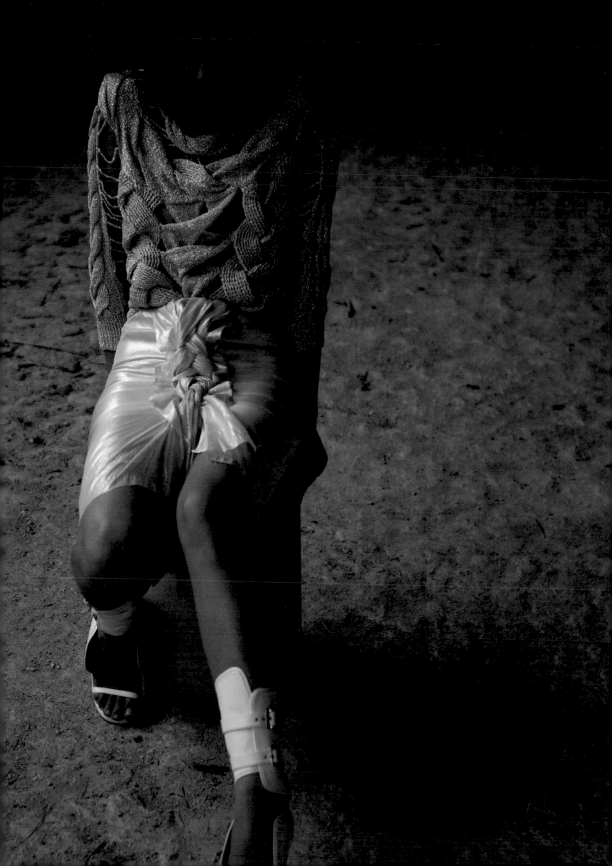

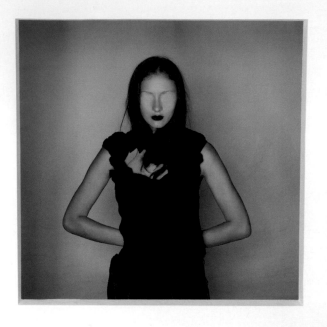

2

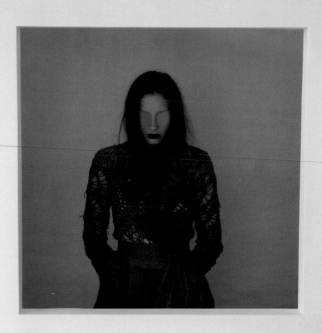

2

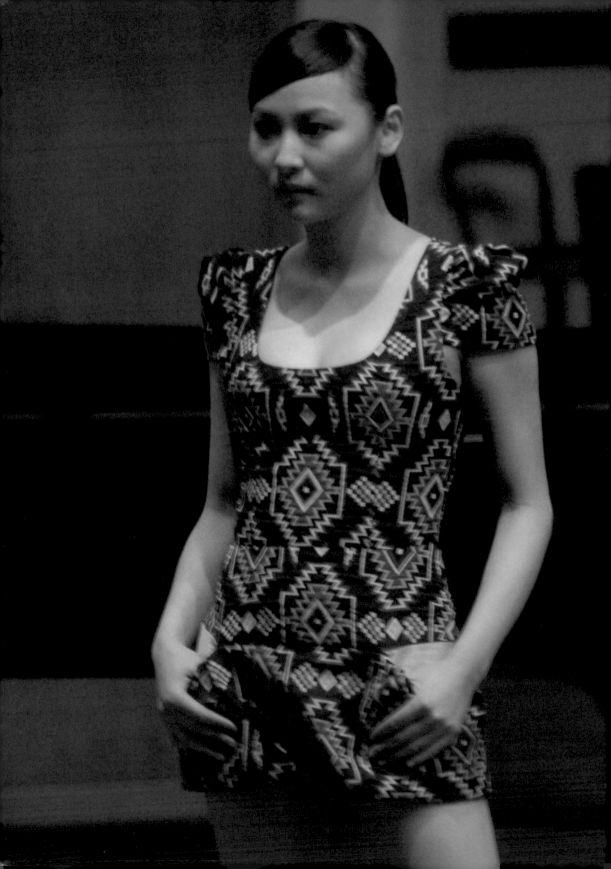

HEYAN | SHANGHAI
He Yan

Born 1976 in Jiangxi, Heyan studied fashion design at the Design School of Southern Yangtze University (formerly the Wuxi Light Industry College). After graduating she headed to Shanghai to pursue her career. By the end of 2003, she quit working as a designer under large fashion companies and set about to launch her own line. Less than a year later, she presented her first collection over three shows in a small café, which attracted a small yet highly-impressed audience. Selling her clothes from her back alley workshop via word of mouth, Heyan continued to push out one collection per year. In 2007, she opened her first shop and launched her fourth collection, Spring Republic. Inspired by the mesmerizing construction of the elaborate costumes of the Beijing opera, Spring Republic presents a subtle tribute to the art which is at once modern and poetic.

www.heyan.org

1 spring summer 2007, *Spring Republic*
2 spring summer 2006, *Nue Xing*

Photos: Xiao Guan, Pixy

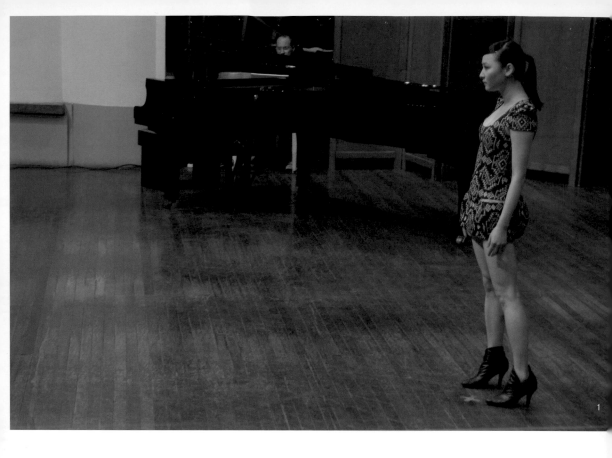

1

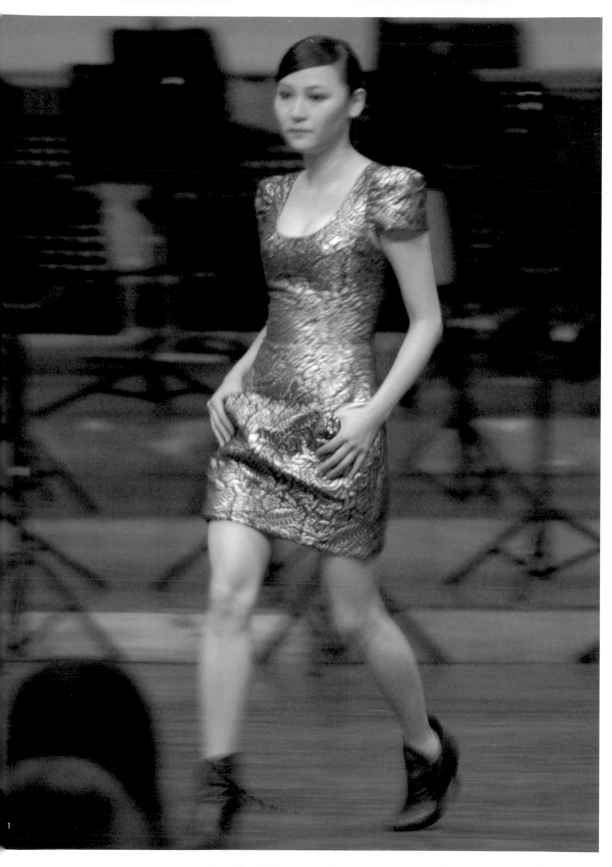

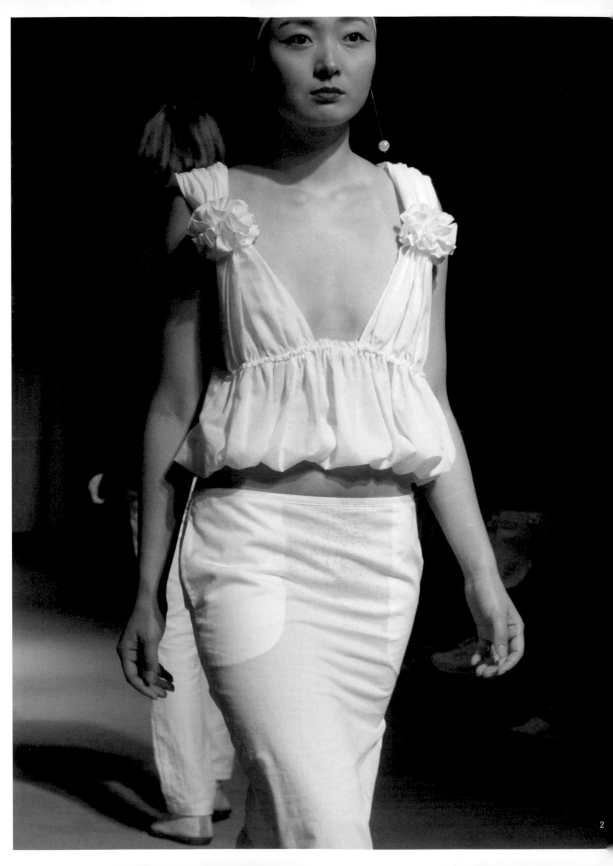

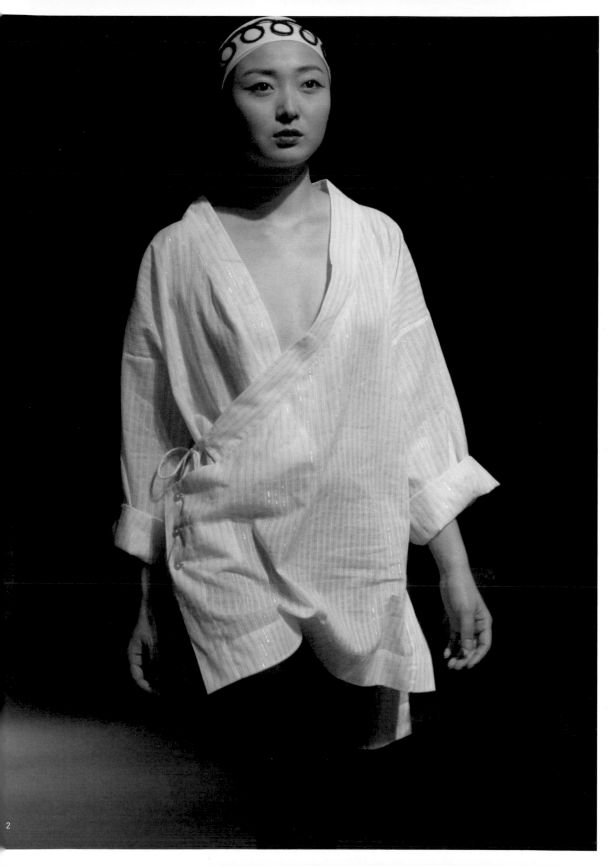

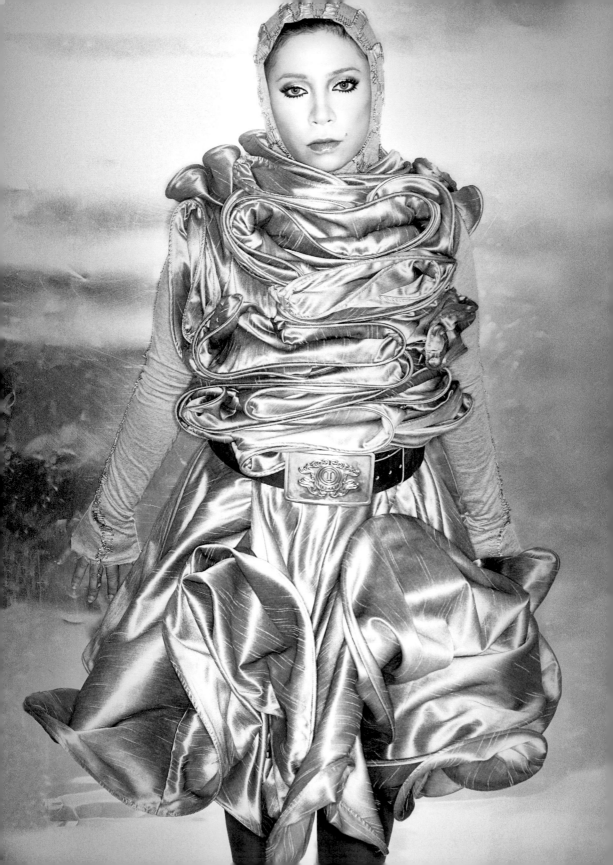

IRSAN | BALI
Irsan

Indonesian born and bred Irsan was barely 20 when he entered the industry. He learnt on the job as an assistant stylist and designer for local studios until founding his own in 1993, just two years after he left the Susan Budiardjo fashion school in Jakarta. Initially specializing in made-to-order bridal wear and evening gowns and accessories, the brand has since expanded to a 3 boutiques-large business with bases in Jakarta, Bali and Lombok. The brand also extended its reach with a uniform label, White Line, as well as the ready-to-wear line Irsan 1711. Besides strutting his works in gala fashion shows every year, Irsan collaborates constantly as stylist and designer for South East Asian films and TV ad projects. In 2007, Irsan extended his small fashion empire once again with two more ready-to-wear lines, the Red Label and L'Indonesie.

house_of_irsan@yahoo.com

spring summer 2006/07

Photos: Davy Linggar (1), Robby Agus

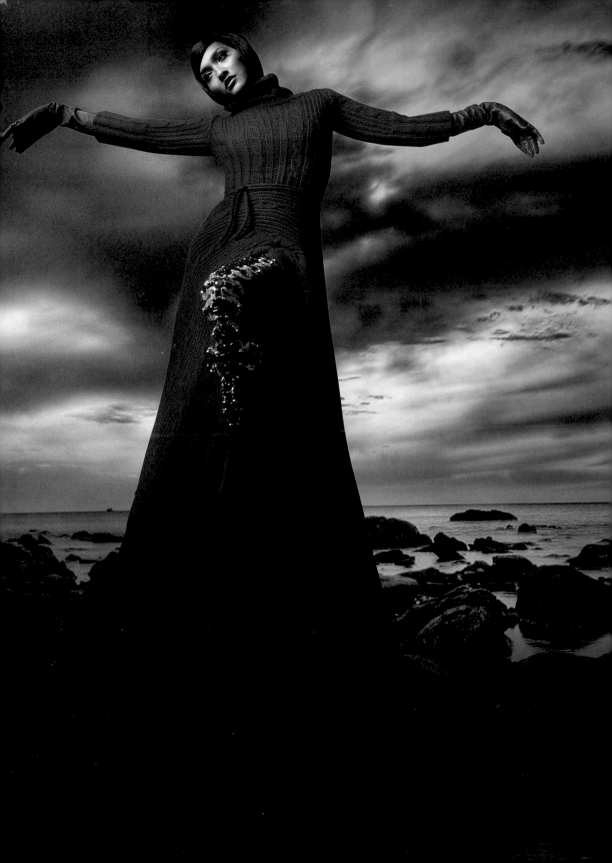

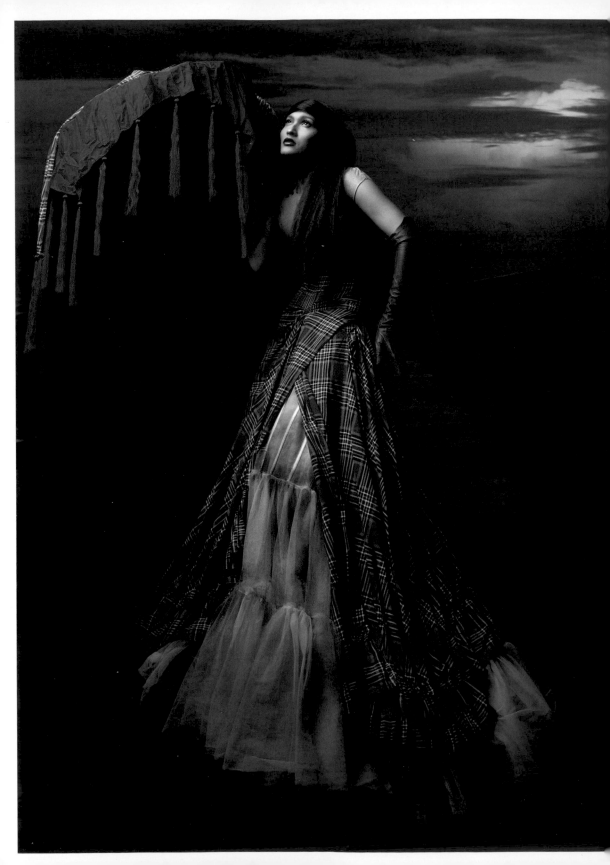

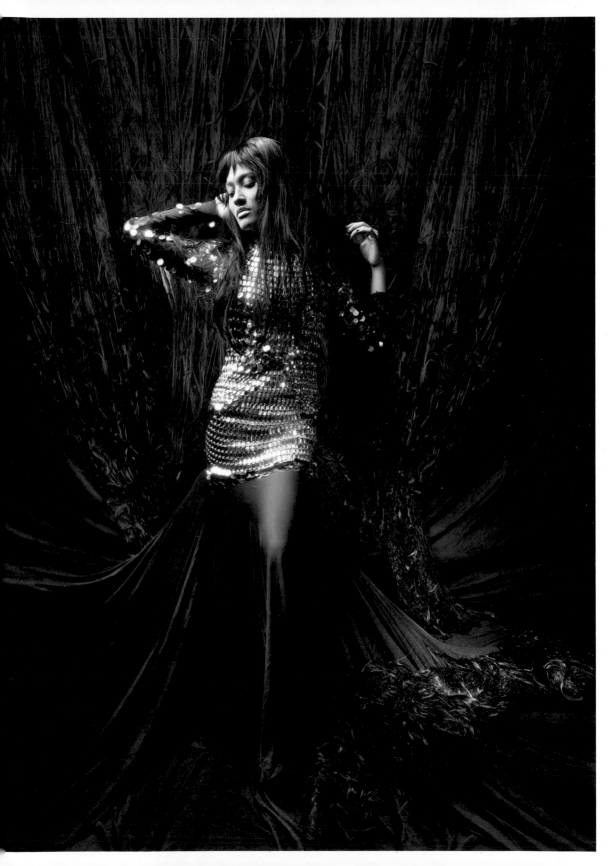

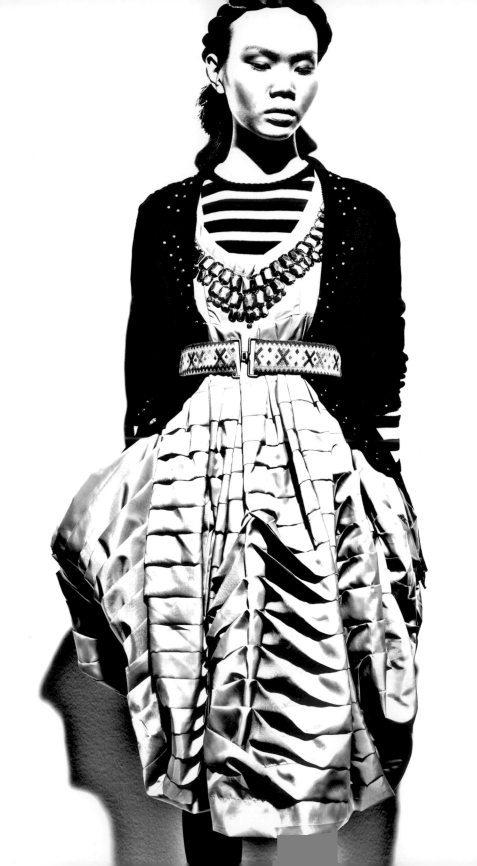

ISSUE | BANGKOK
Roj Singhakul

Strongly influenced by the wisdom and world views of H.H.
Dhalai Lama XIV, Roj Singhakul, born 1973, believes design-
ing is about the ability to equilibrate self perception and
creativity. The result is a unique and compassionate brand
that pays tribute to all walks of cultures and folk beauties
from around the world through an eclectic mix of unique
patterns, prints, materials and objects. Receiving a Diplo-
ma in Fine Arts from the Thai Vichitsin College in Bangkok,
Singhakul had worked for Greyhound, one of Thailand's
most progressive fashion groups, for over 5 years before
launching his own brand in 1999. Now Issue is regular par-
ticipant at Bangkok's fashion weeks.

www.issue.co.th

1 fall winter 2007
2 fall winter 2006
3 spring summer 2007

Photos: © issue

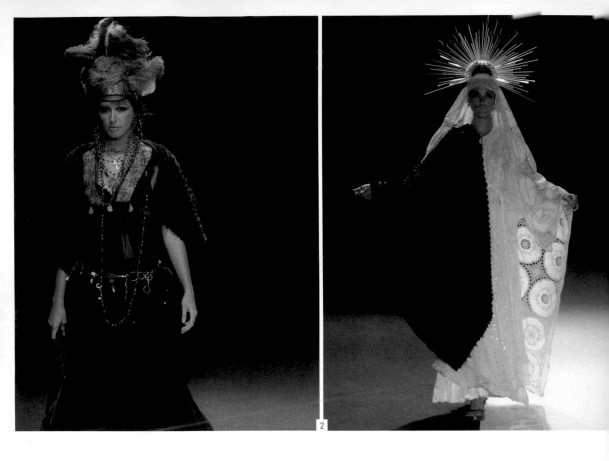

2

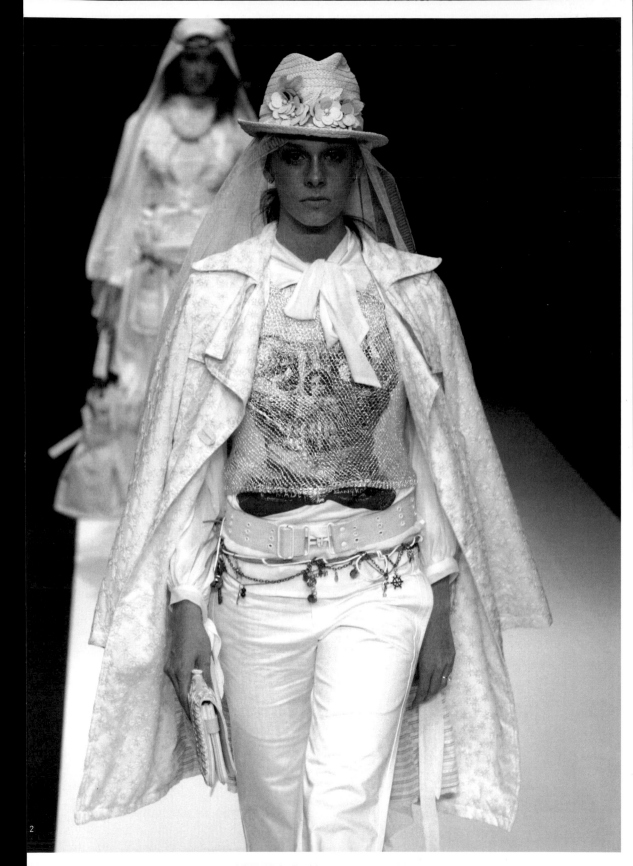

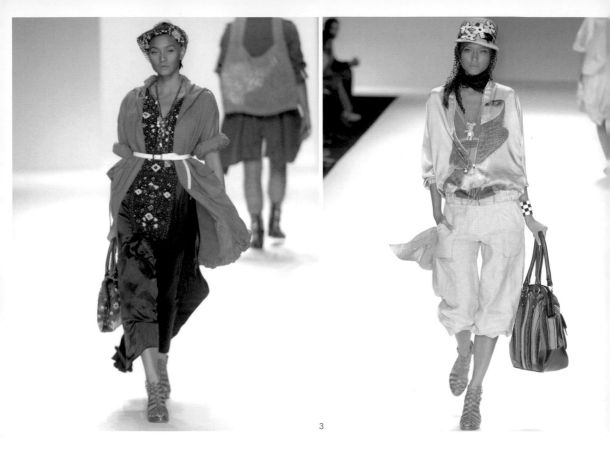

3

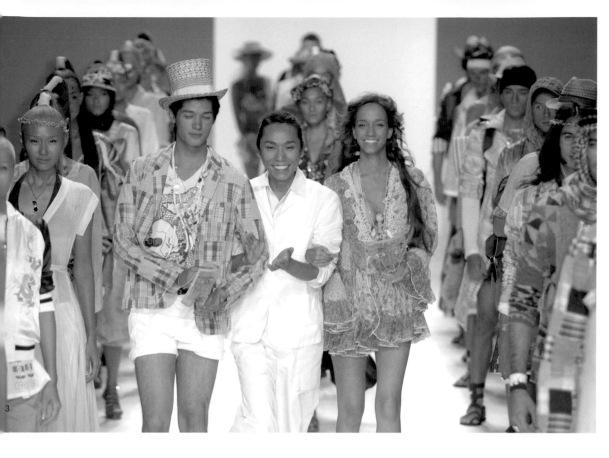

3

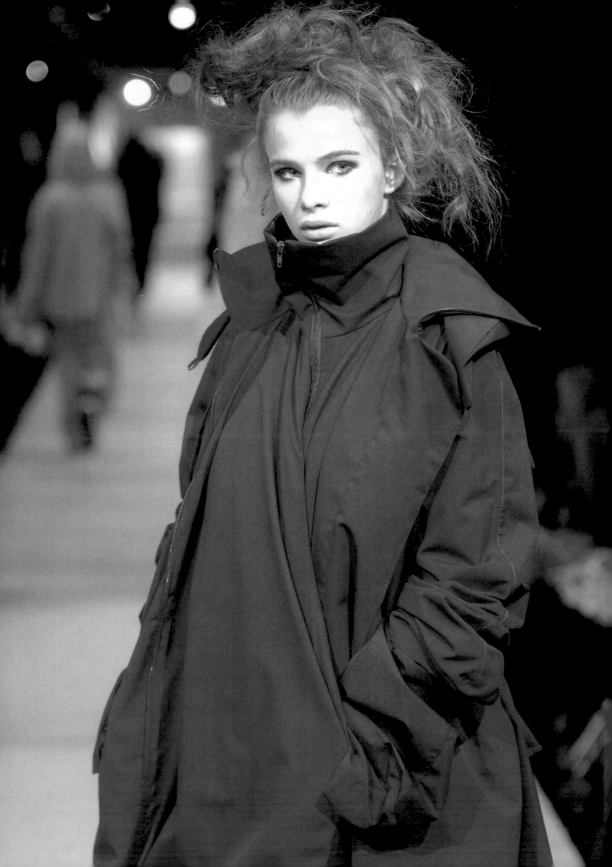

JAEHA | AUCKLAND
Jaeha-Alex Kim

Before he even graduated from the Auckland University of Technology in 2006, Jaeha-Alex Kim, born 1986, launched his first collection as part of the Auckland University of Technology Rookie Show at the AW 2006 Air New Zealand Fashion Week. Instantly, he cinched his first overseas order from Australia. A year later, the Korean-born 21 year old was already on course for a fully-fledged debut at the same fashion week, no longer in the rookie category. Featuring bold, graphic and heavily draped designs which in parts paid homage to Tim Burton's Edward Scissorhands, Kim's highly innovative and sophisticated winter 2008 collection stole the show and won the hearts of many critics, who unanimously hailed him to be the next big thing in New Zealand fashion.

www.jaeha.co.nz

1 fall winter 2007
2 fall winter 2008, *lookbook*

Photos: Chris Sullivan (1), Michael Ng (1, p 173 right side), Minnie Chan (1, p 173 left side), Richard Orjis (2)

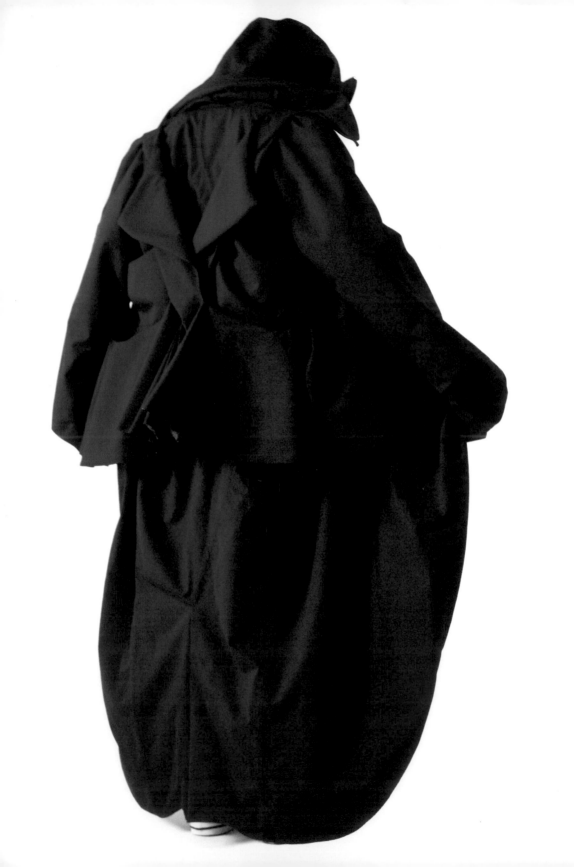

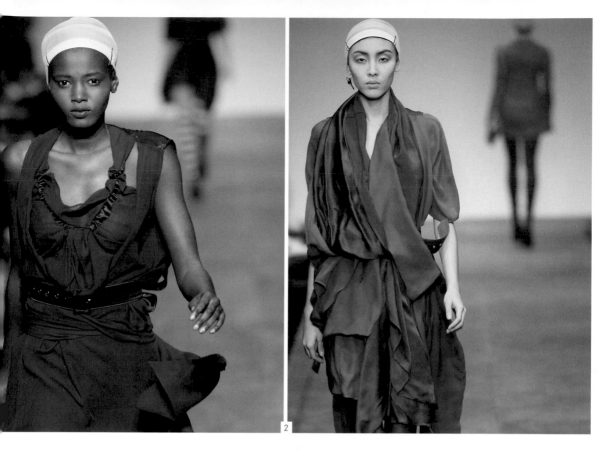

2

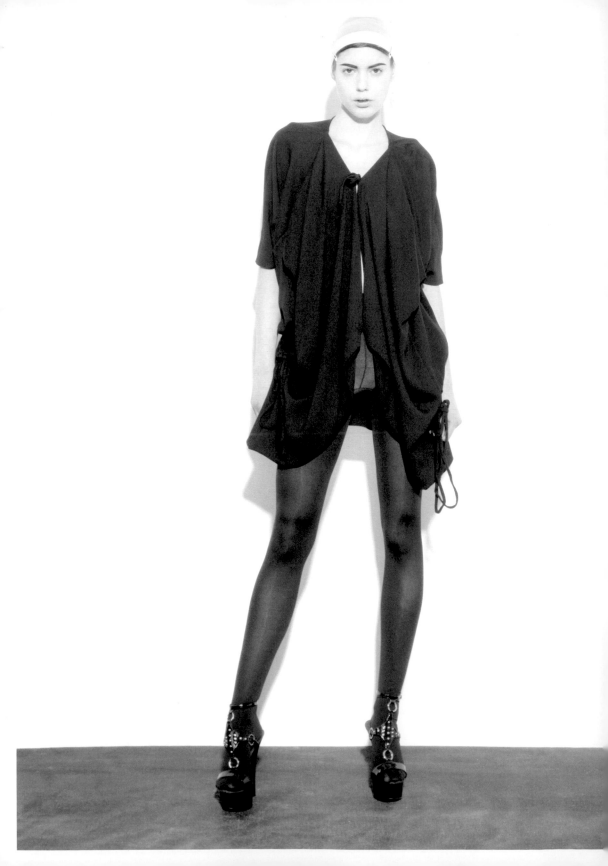

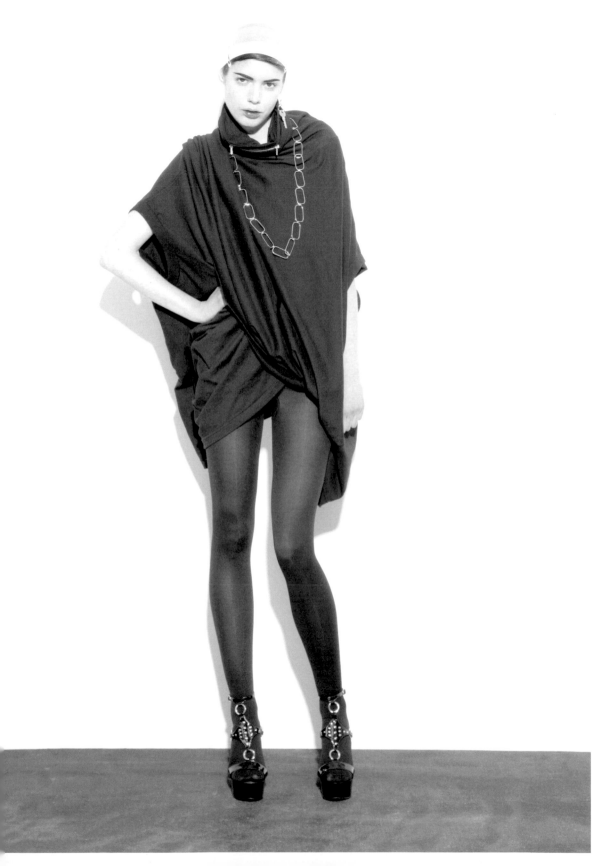

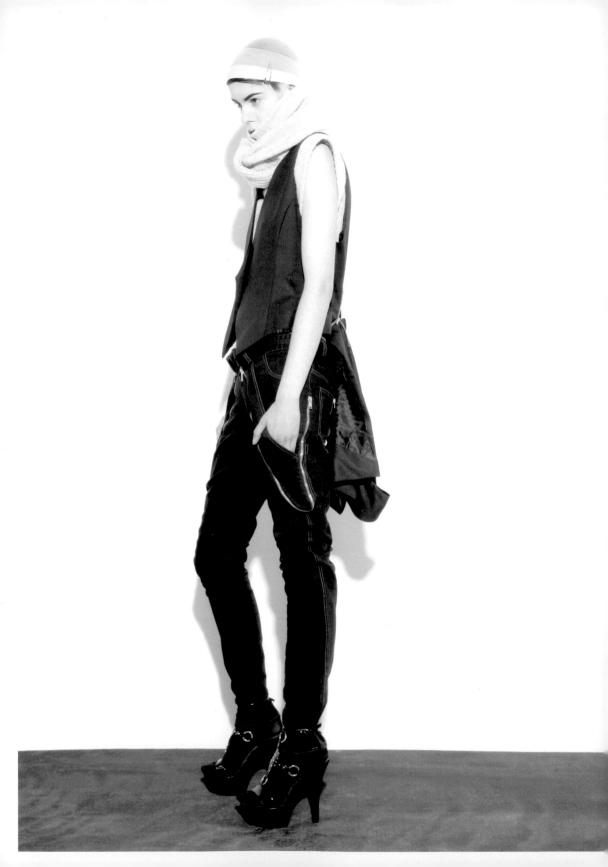

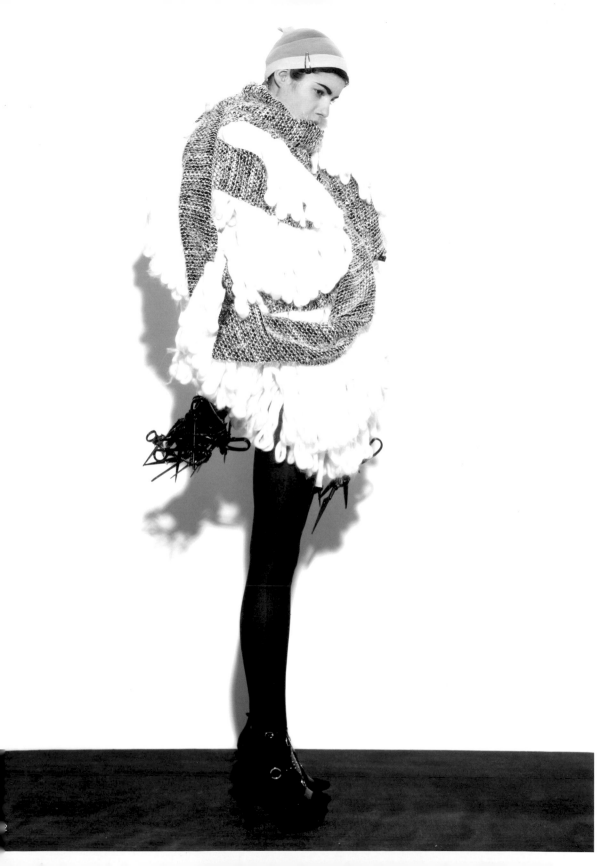

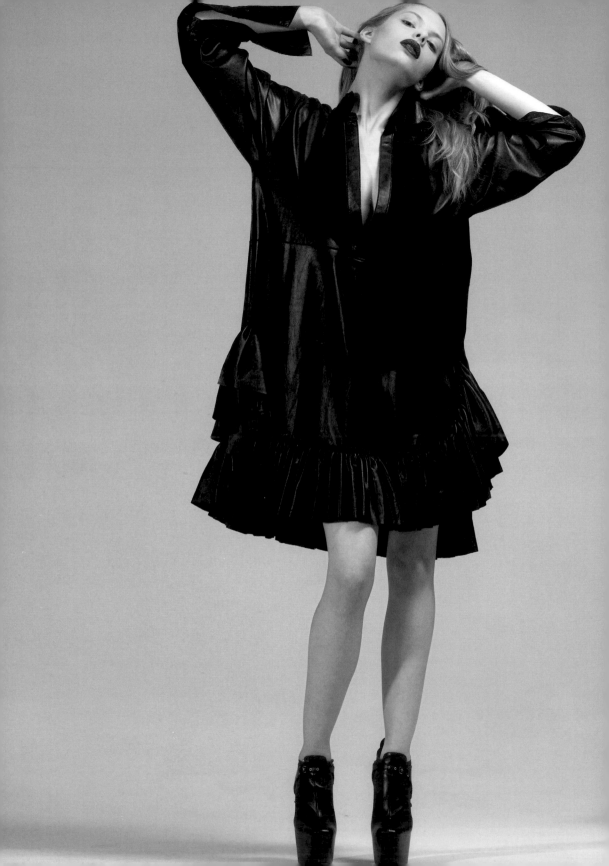

JOSEPH LI | HONG KONG
Joseph Li

Launched in 1999, Joseph Li's first demi-couture collection immediately met the interests of renowned retailers including Neiman Marcus, Bergdorf Goodman and Lane Crawford. Upon working for five further seasons on his own brand, which subsequently showcased in Australian and New York Fashion Weeks, Li, born 1975, took a break in 2002 to take up an apprenticeship at Lanvin and study at Studio Berçot in Paris. In 2003, to deepen his training and academic knowledge of the art, he enrolled in Central Saint Martins College of Art and Design and graduated with a Master of Arts in Fashion in womenswear. Returning to Hong Kong, Li continued to strut the runway with his own collections with small-scale production. His deep knowledge and respect for period dresses combined with a strong panache for re-invention has earned him numerous recognitions, including a nod as the Asia Designer of the Year at the 2006 China Fashion Awards. In late 2007, Li joined Shanghai Tang as chief designer of womenswear.

www.mrjli.com

1 fall winter 2005/06
2 spring summer 2007

Photos: Paul Tsang (portrait), Jean Louis Wolf, John Paul Pietrus (1, page 178)

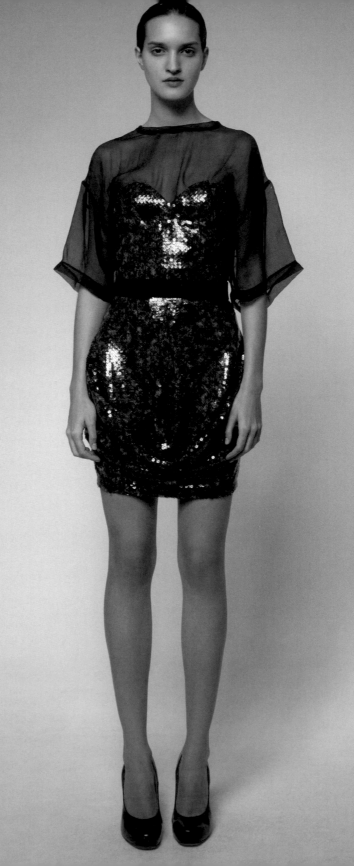

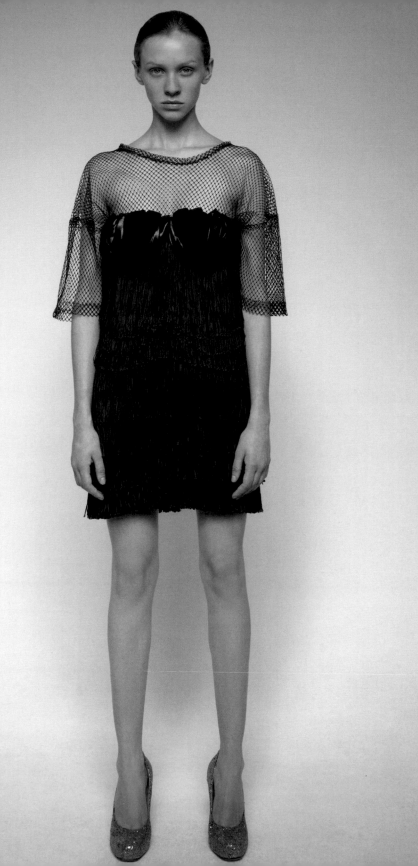

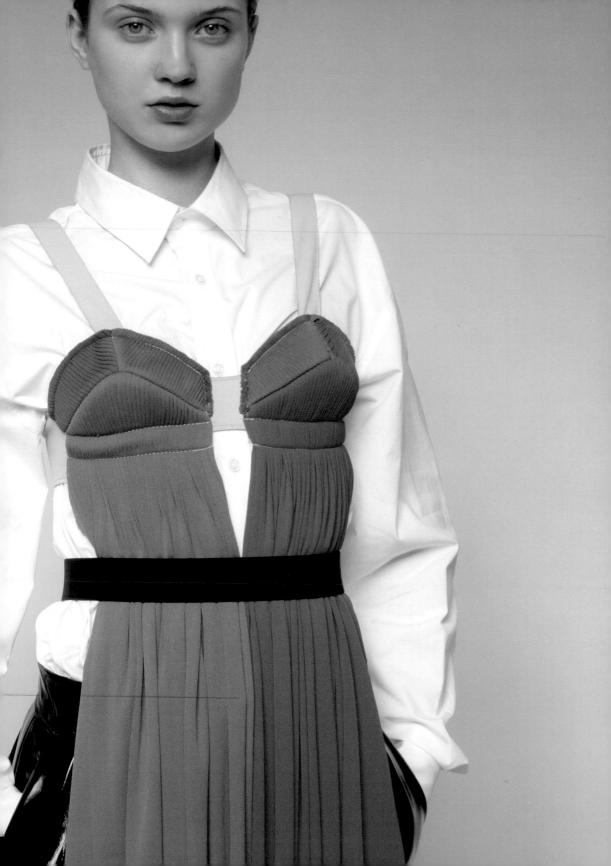

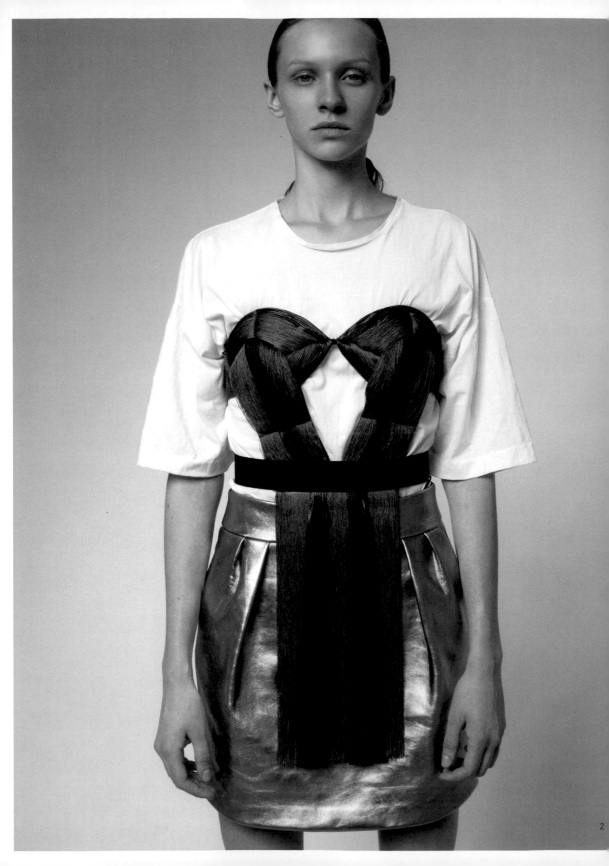

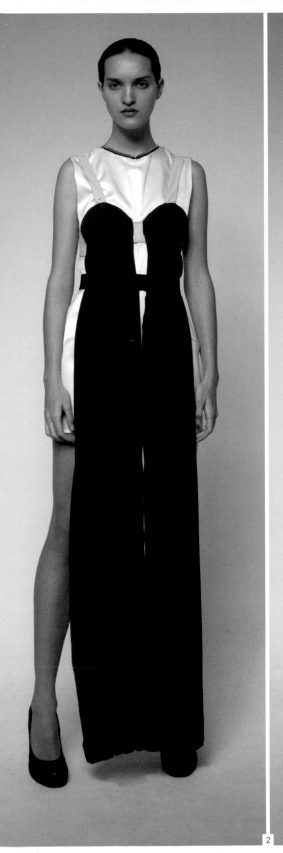
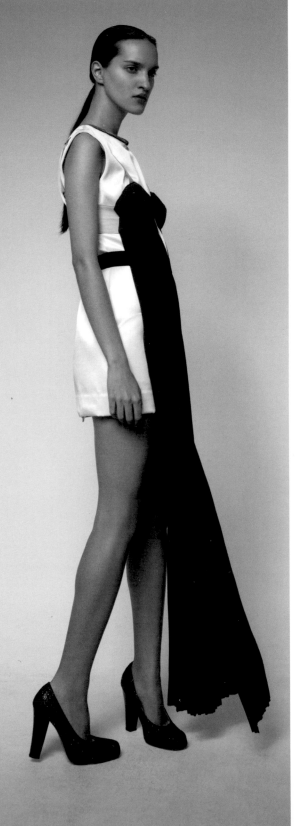

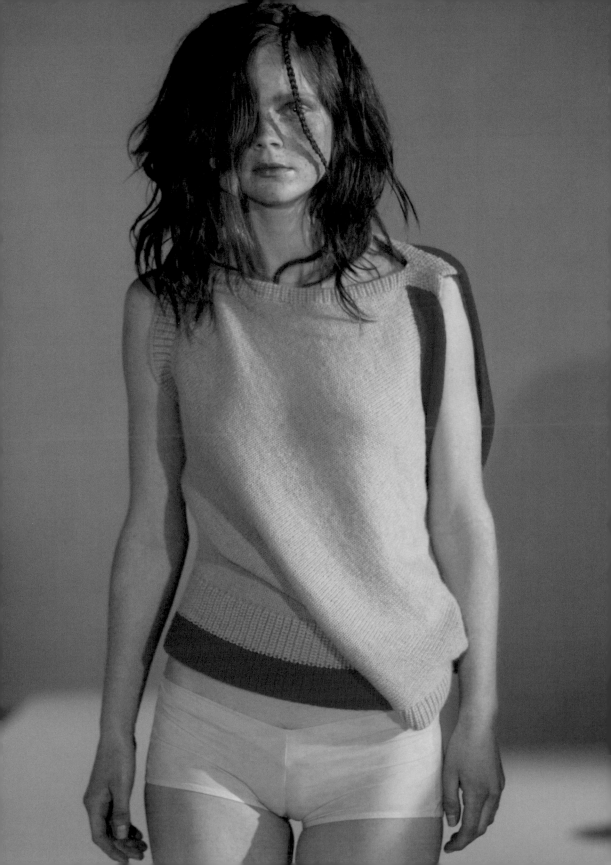

KINO | TOKYO
Tomoe Ishikawa

Graduated from Vantan Design Institute, Tomoe Ishikawa started KINO in 1999 after working for BIGI and INDIVI as a designer and has been strutting her collections at the Tokyo Fashion Week every season since her debut show in 2003. Branded after a girl name, which also means cinema in German, KINO is designed with an imagined actress in mind whose intellectual and sophisticated mindset preside her tastes in clothes.

www.kino-inc.com

1 fall winter 2003, *"Way"*
2 fall winter 2006, *"Jet Setter"*
3 spring summer 2007, *"Unicorn"*

Photos: Etsu Moriyama

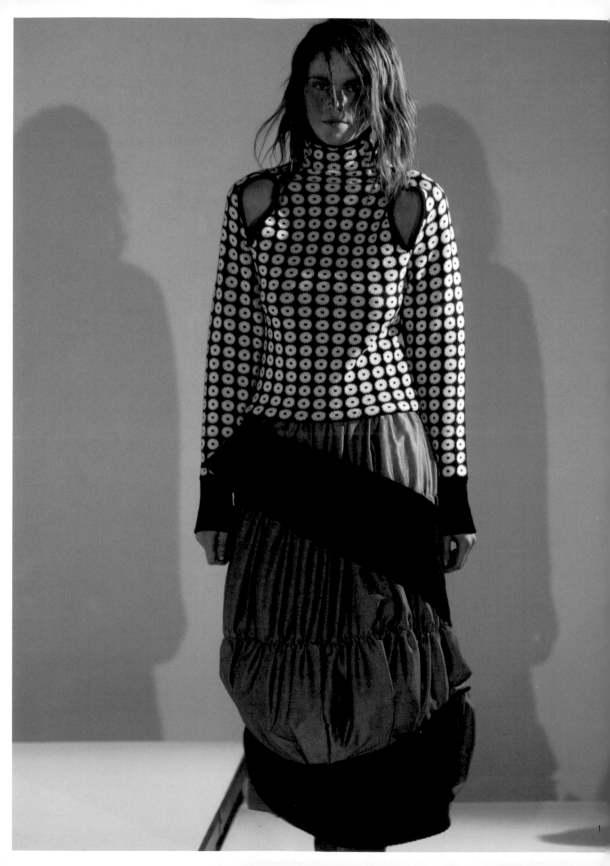

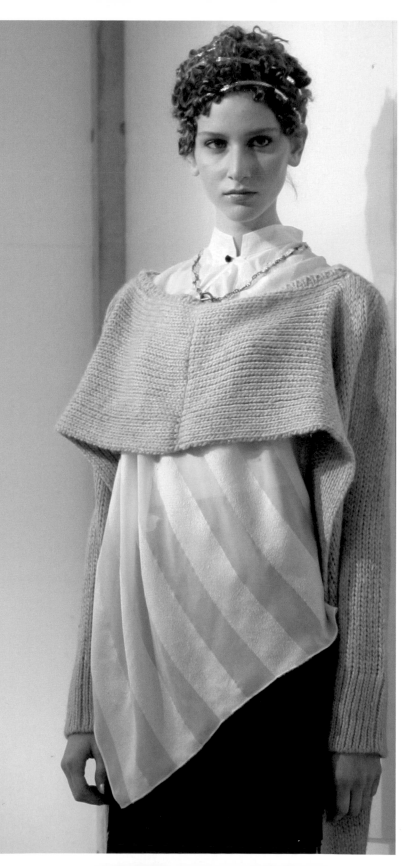

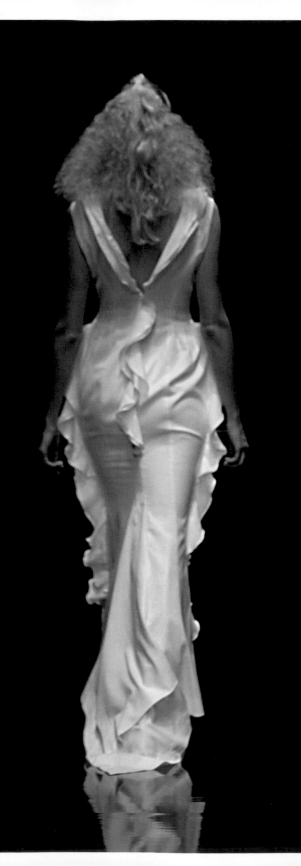

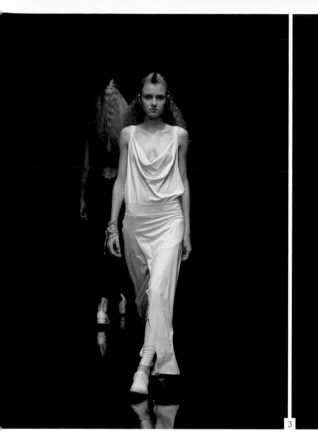
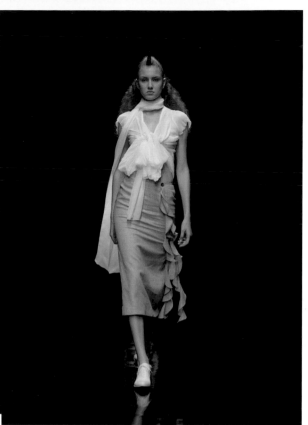

3

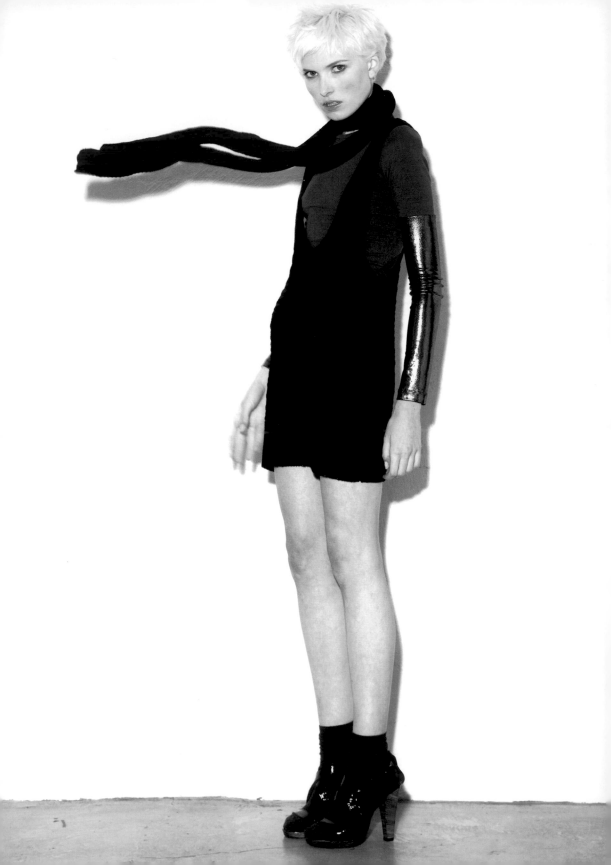

LIFEWITHBIRD | MELBOURNE
Bridget McCall, Nicholas Van Messner

The Melbourne-based label is the brainchild of photographer, Bridget McCall, and designer, Nicholas Van Messner. After graduating from the Photography Studies College in Melbourne, Bridget, born 1980, pursued her styling interests in London, where she collaborated magazine shoots for 'The Face' and 'ID' magazines. Nicholas, born 1978, studied Fashion Design at RMIT in Melbourne. During the course, he hooked up the street couture label, Maiike, and helmed the brand as their creative director. Starting with conceptual ultra modern leather bags launched in 2002 the brand has since grown to include womenswear, menswear and a jewellery line. Their latest collection, titled 'Simple Futures' and featuring radical prints and designs inspired by their 'beauty of function' philosophy, received a nomination for the 2006 Australian Designer Award at the L'Oreal Melbourne Fashion Festival.

www.lifewithbird.com

1 fall winter 2007/08
2 spring summer 2007

Photos: Trevor King (1), Titomedia.com (2)

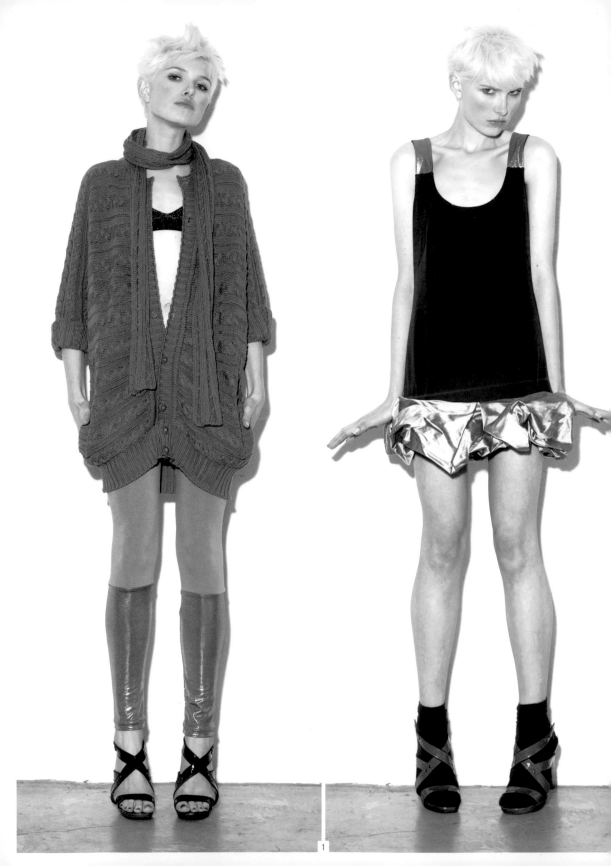

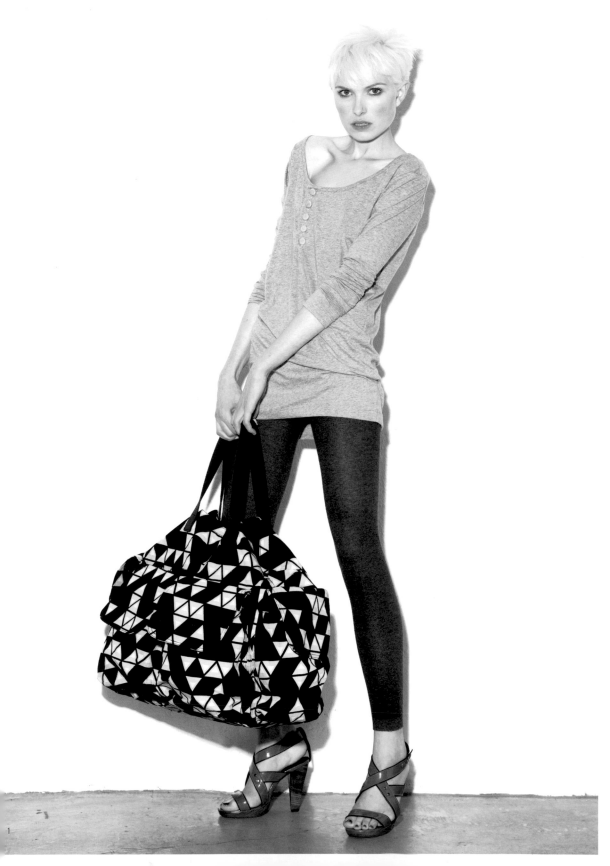

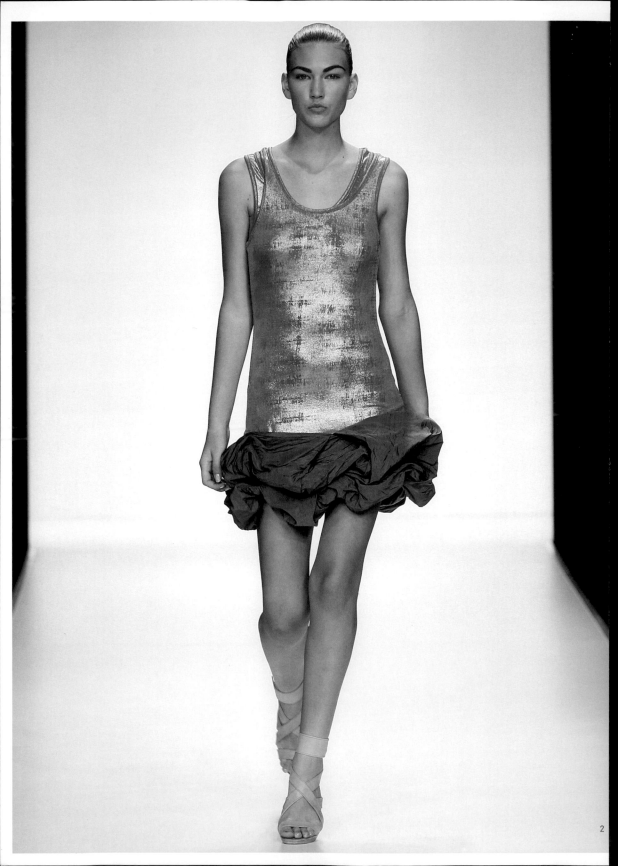

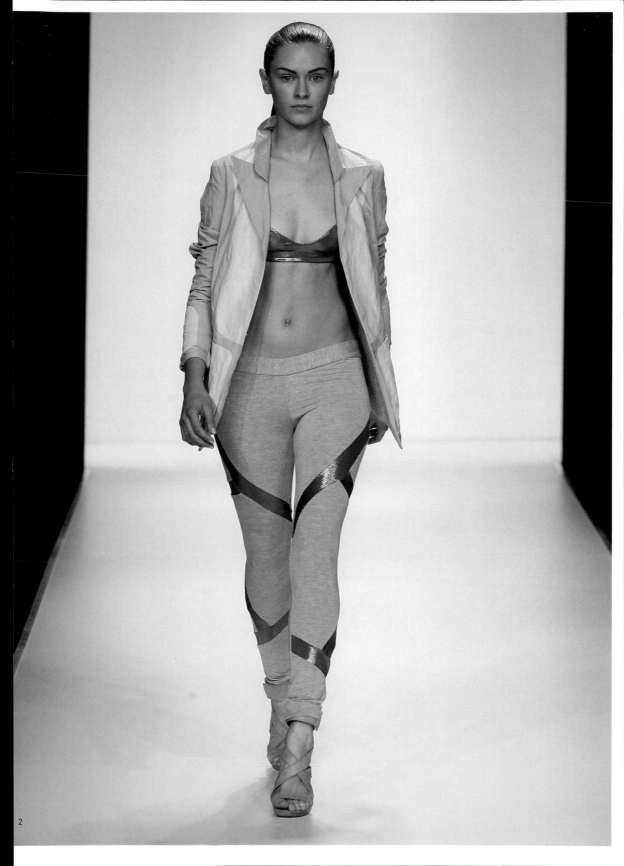

MA KE | GUANGZHOU
Ma Ke

Widely considered as the most important young fashion designer in China today, the graduate of Suzhou Institute of Silk Textile Technology founded her own brand EXCEPTION de MIXMIND in 1996. Ten years on, EXCEPTION is today sold to 60 shops across 30 cities in China, drawing an eclectic mix of clients from artists academics, entrepreneurs to trendy X-generations and elegant old ladies. Always designing from her internal dreamscape, Ma Ke, born 1971, is a philosophical purist who seeks spiritual and artistic attainment through her clothes. Early 2007, the otherwise low-profile designer stunned the Paris Fashion Week with her second brand, WUYONG, meaning useless in English, with a debut showing a collection of avant-garde pieces inspired by slow and earthy living. Later in the year, Jia Zhangke's film based and titled after her label won the Horizon documentary award at the Venice Film Festival.

www.wuyonguseless.com, www.mixmind.com

1 WUYONG 2007
2 Costume Design for Dadawa 2001

Photos: Zhou Mi (1), MIXMIND (2)

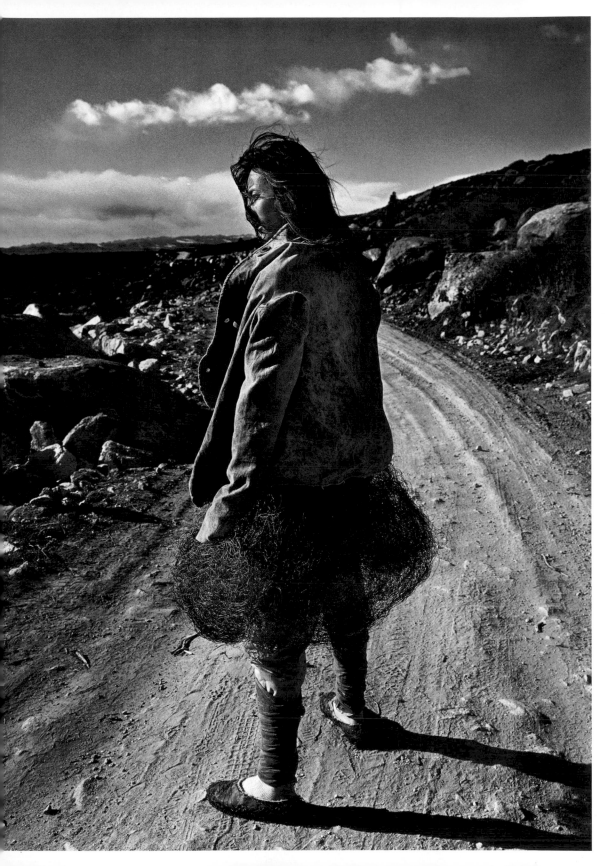

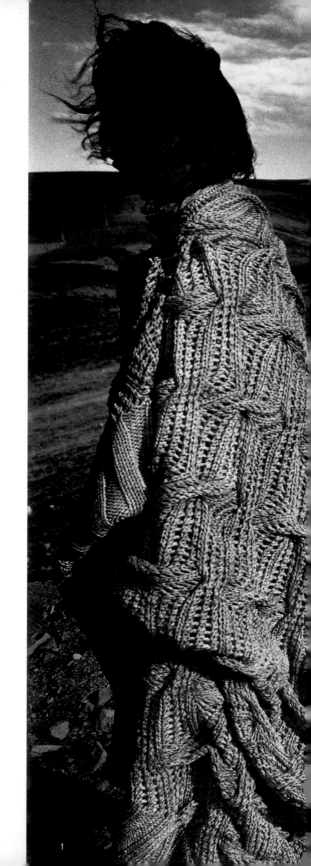

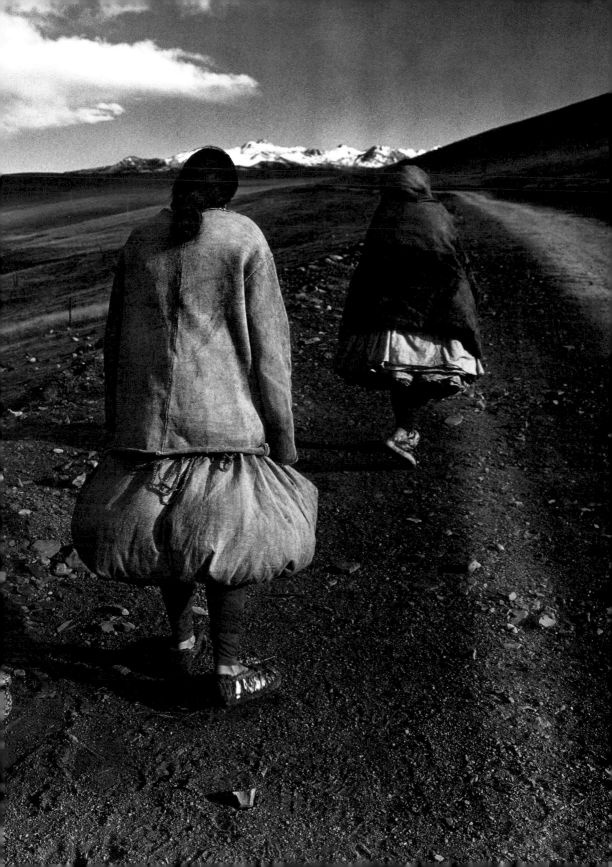

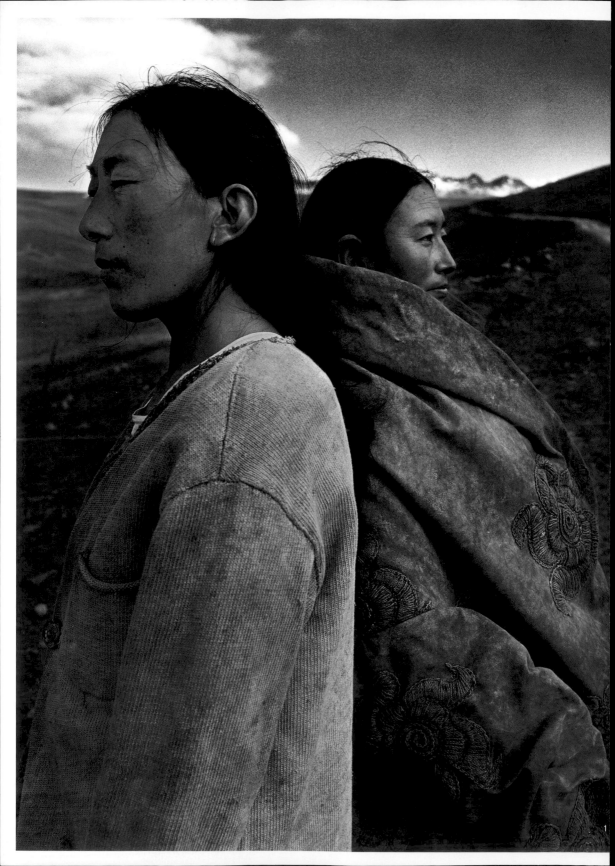

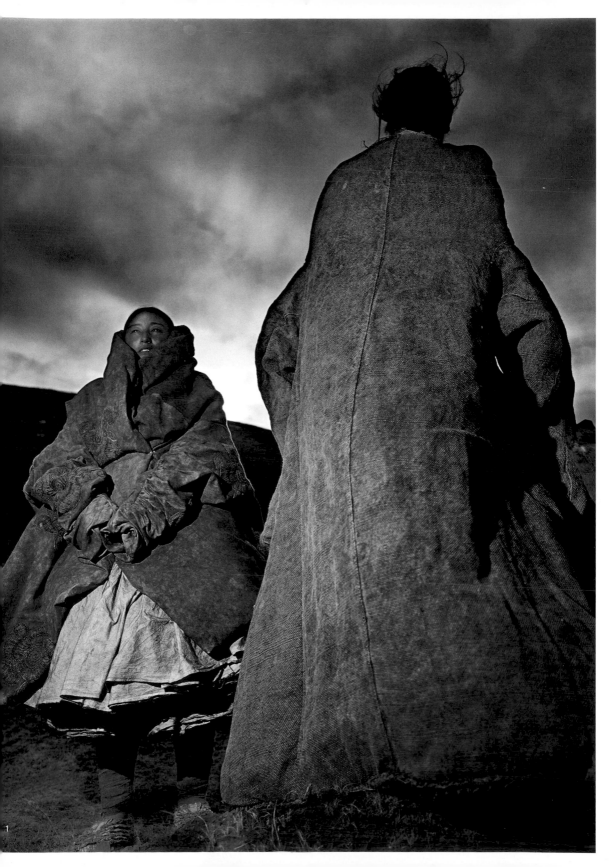

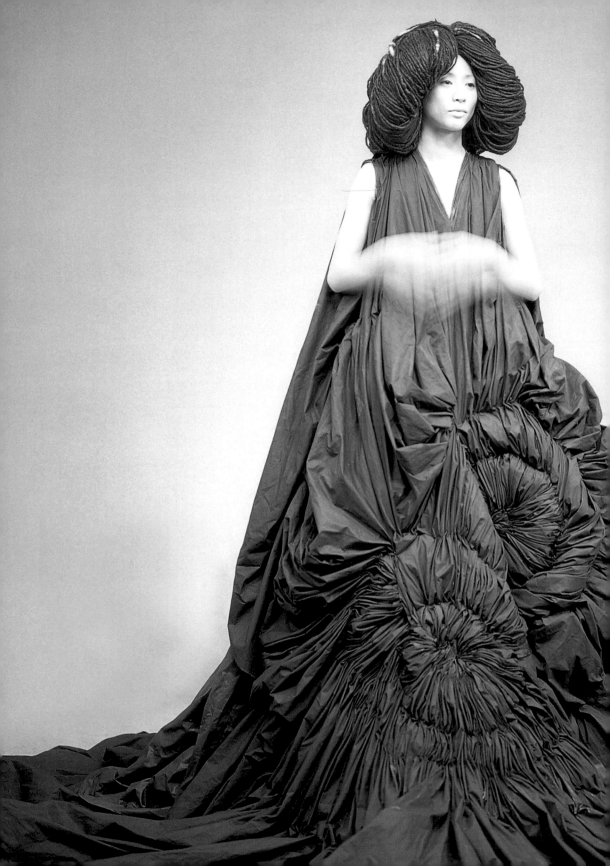

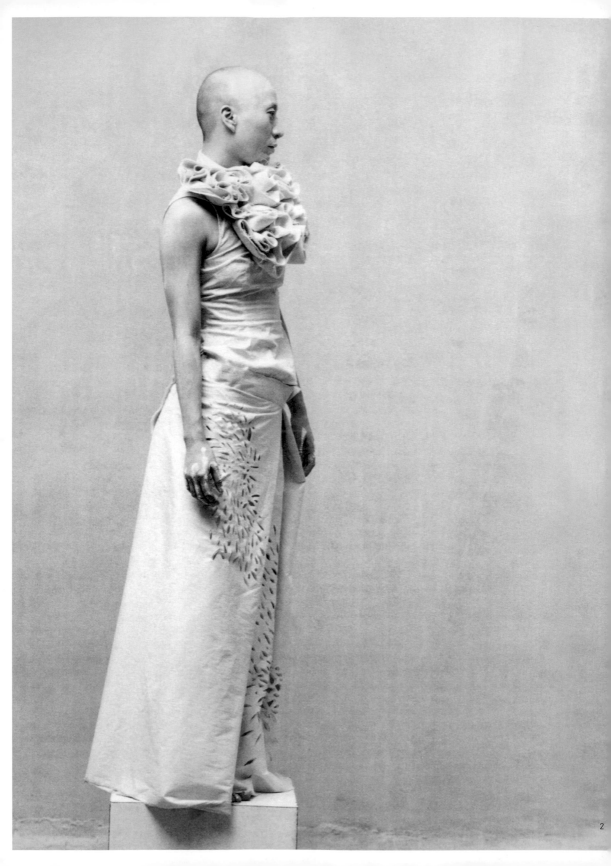

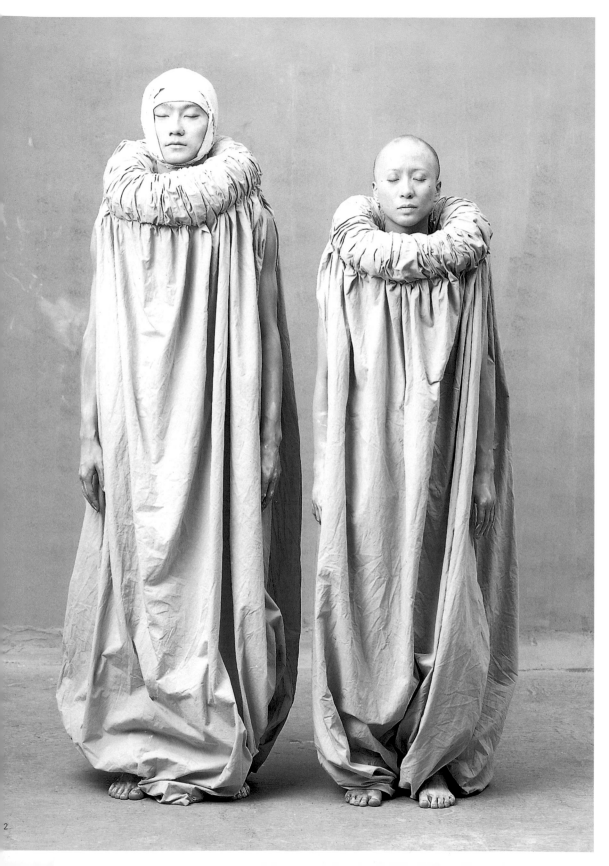

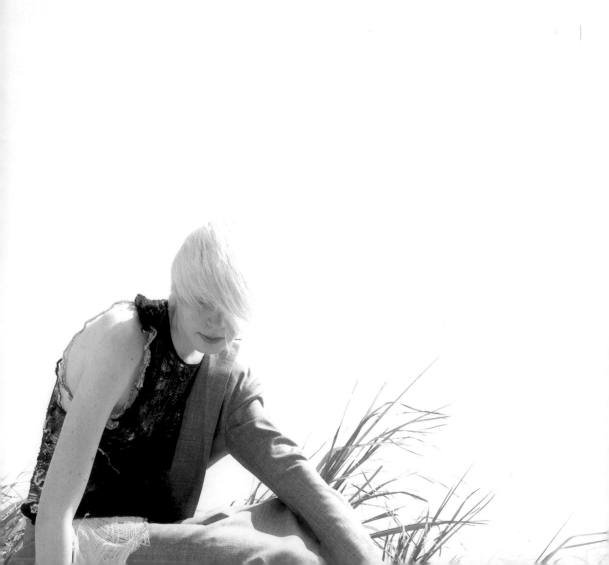

MANIQUE | HONG KONG
Yuen Pui Chun

As a young child, Yuen was forced to sit obediently next to her mother while she worked long hours on the sewing machine. Little she knew those moments were actually her first apprenticeship in fashion. In 1992 and 1994, she went on to complete two fashion diplomas in local design schools and in 2003 added a fine art diploma in her portfolio of studies. In between she worked for various fashion houses and launched her own label Manique in 1997. Since then she has been invited to showcase her collections at the Hong Kong Fashion Week on numerous occasions while her label progressively expands from knitwear to footwear and accessories. Drawing inspirations from the beauty of her surrounding and freedom found in possibilities, Yuen, born 1973, thrives in her passion for conceptual and deconstructed designs. She adores unconventional silhouettes, geometric forms, timeless materials and multi-faceted clothes which gives the wearer infinite styling options. Besides Hong Kong, Manique can be found in Taiwan, China and Sweden.

www.manique.com.hk

1 fall winter 2001
2 fall winter 2007
3 spring summer 2001

Photos: Derek Fung (portrait), JONEJONE.com

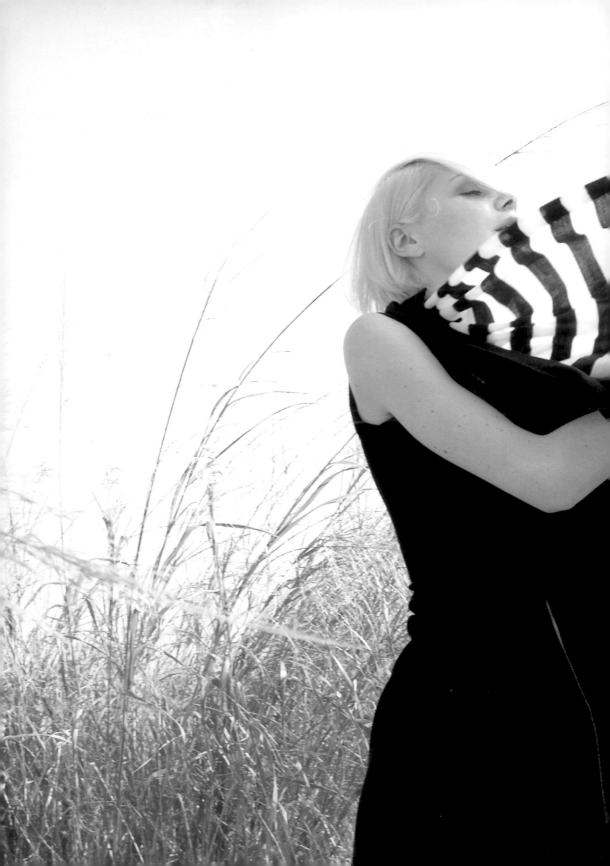

3

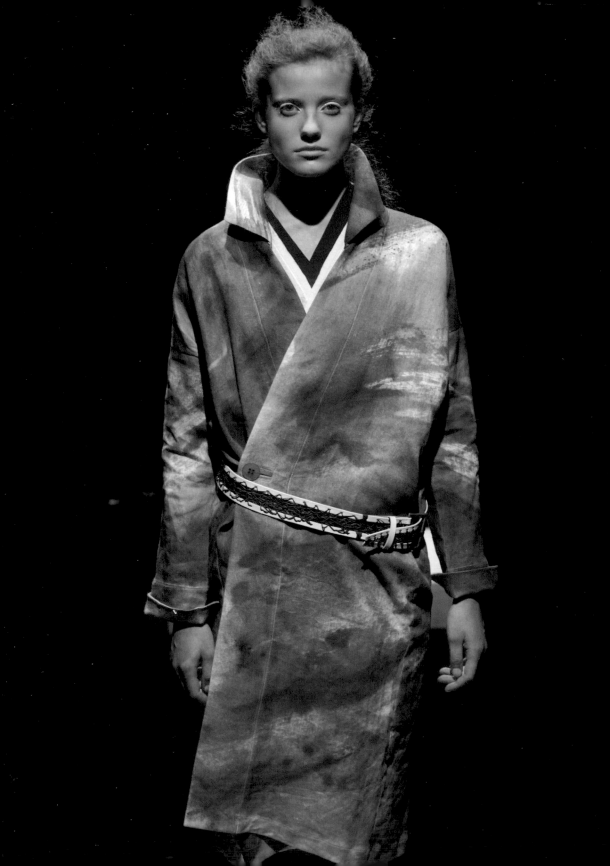

MATOHU | TOKYO
Hiroyuki Horihata, Makiko Sekiguchi

Both born in 1971, the husband and wife team behind Matohu are both graduates of top Tokyo fashion school the Bunka Fashion College. Horihata subsequently worked for Comme des Garcon by Rei Kawakubo, and Sekiguchi with Yohji Yamamoto for a good few years before they moved to London together to work for Turkish designer Bora Aksu. Returning to Tokyo in 2005, they established Matohu and presented their debut collection at the Tokyo Fashion Week a year later. Meaning to wrap around lightly, and to wait a while in English the label is steeped in lasting and cerebral subtleties. It is intensely driven by Japanese kimono aesthetics especially of the Momoyama Period, which saw a brief era of elegant and minimalist style borne from free-thinking foreign influences. Their latest spring summer collection, inspired by fragile cracked ivory surface of late 16th century shino pottery unveiled to rave reviews from local to international press.

www.matohu.com

1 spring summer 2008, *"Shino"*
2 fall winter 2005/06
3 spring summer 2007

Photos: Keisuke Akabane (portrait), matohu (1, 3), Hayato Yamazaki (2)

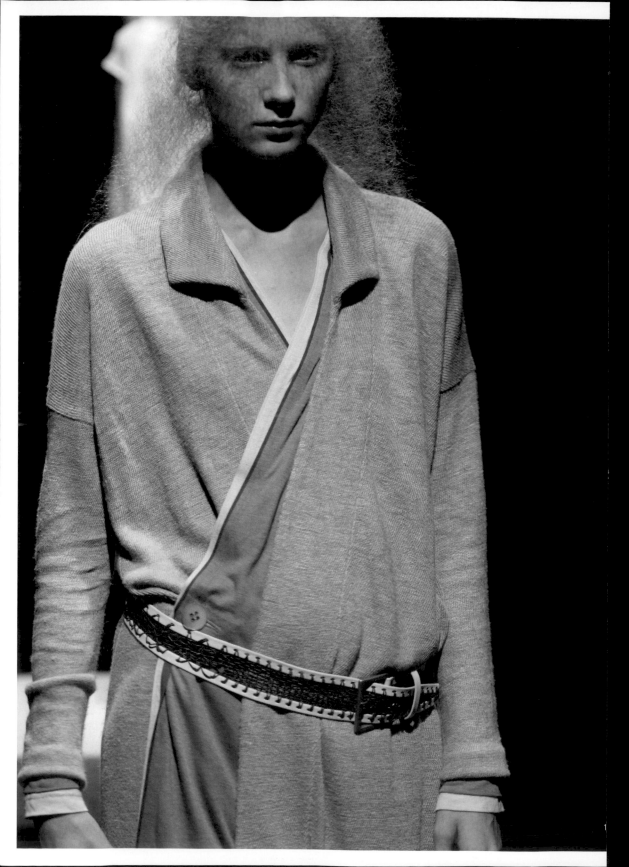

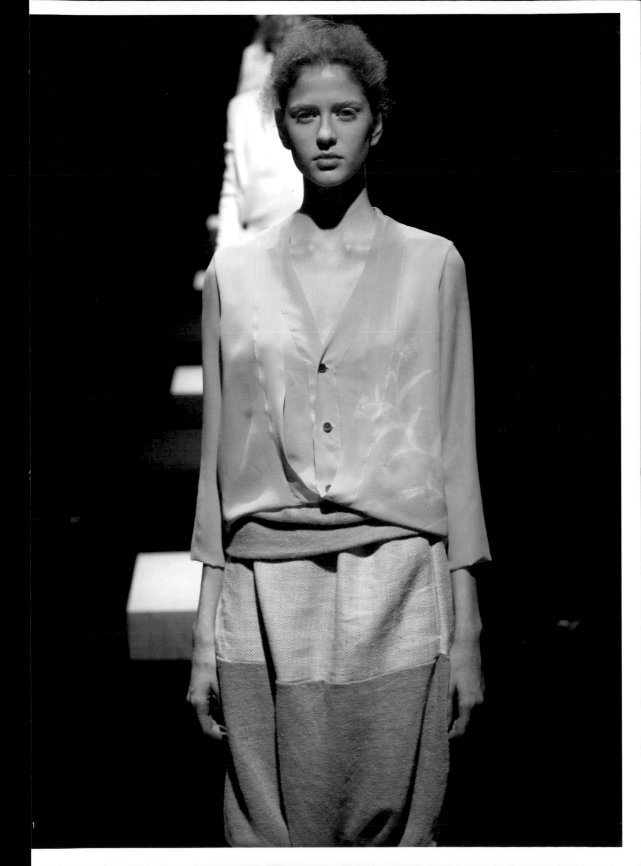

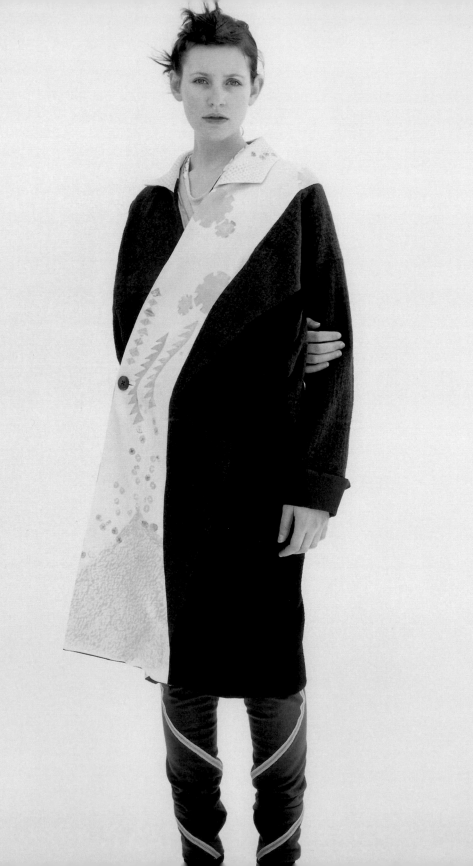

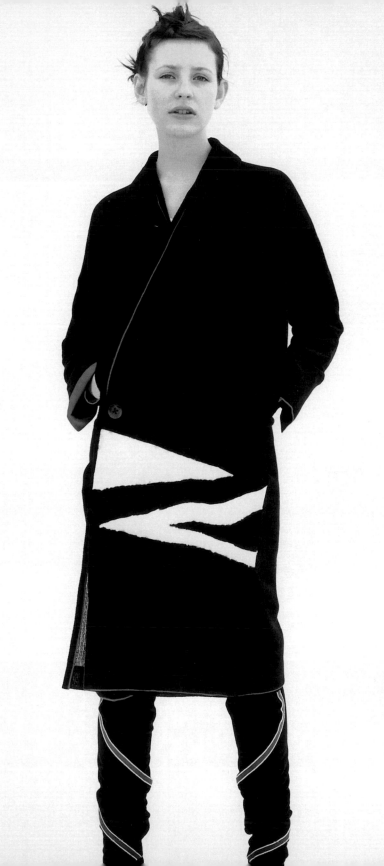

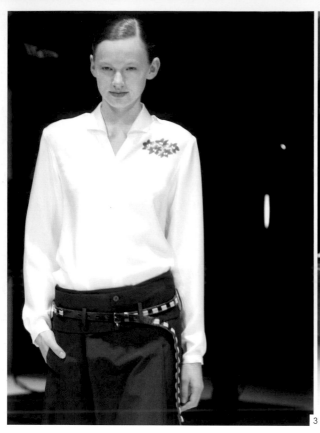

3

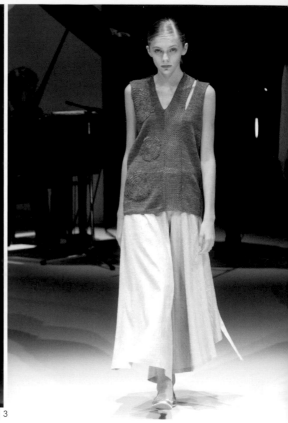

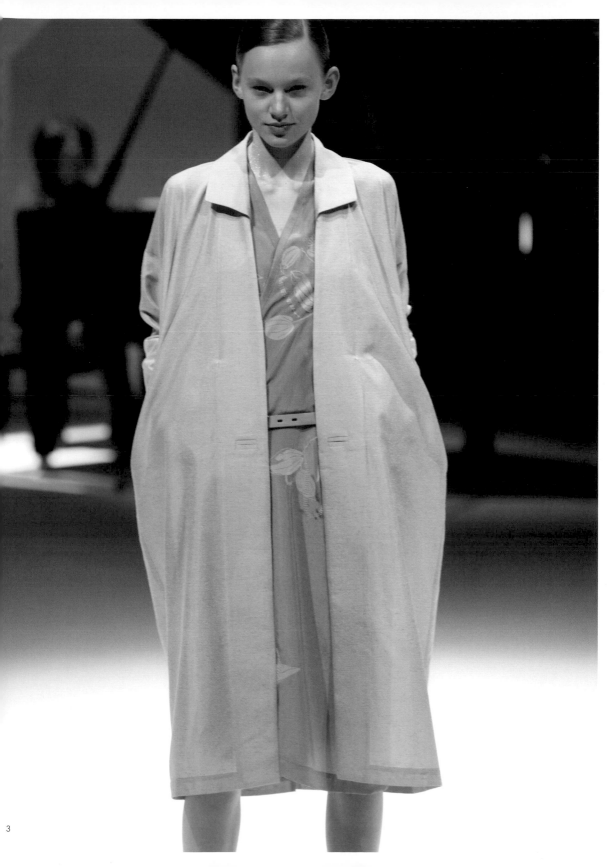

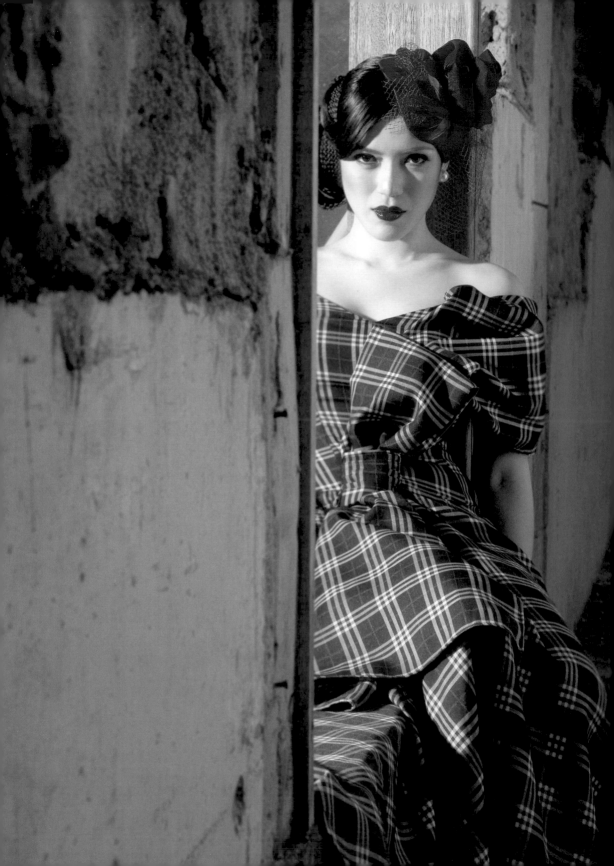

MICH DULCE | MANILA
Michelle Dulce

Born in 1981, Filipino designer Mich Dulce studied exten-
sively at some of the world's best fashion schools including
Central Saint Martins, London College of Fashion, and the
Fashion Institute of Technology in New York. After interning
with Marjan Pejoski, Jessica Ogden and Susan Cianciolo,
Dulce launched her eponymous label in 2001 and within
a short year won a spot as the Philippines' finalist for the
International Young Fashion Designers Competition in Paris
and picked up the first runner up nod at the Philippines'
MEGA Young Designer's Competition. As her presence con-
tinues to grow in her home country, Dulce won one further
nomination in the Philippines as the Revolutionary Design-
er of the Year at the MTV Style Awards in 2004 and was
crowned the Streetwear Fashion Designer of the Year for
MEGA Fashion Awards in 2007. Six years on, her trademark
quirks and offbeat draping has evolved from voluminous,
textured and hand treated garments to a more mature
sensibility. In 2005, after studying the craft for sometime,
Dulce also added hat wear to her designing repertoire.

www.michdulce.com

1 AIDS Awareness Exhibition 2007, *by Mich Dulce, Every-
 where We Shoot and MAC Cosmetics*
2 spring summer 2006
3 spring summer 2007

Photos: Everywhereweshoot.com

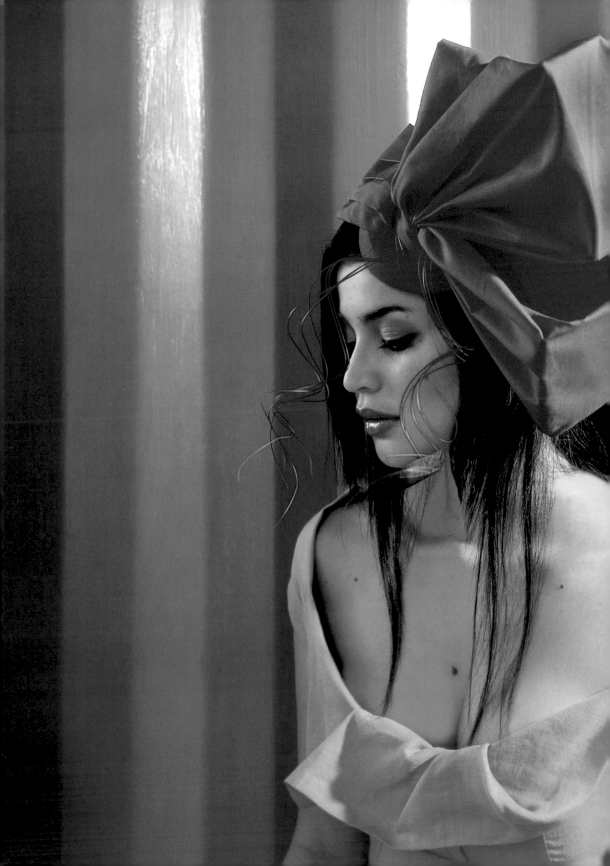

1

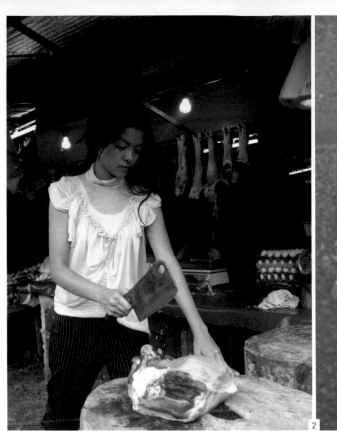
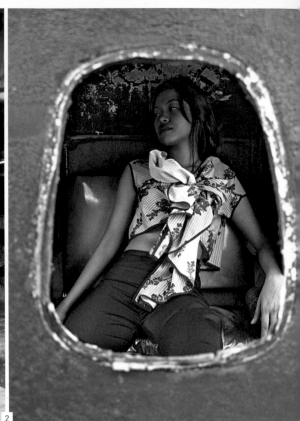

2

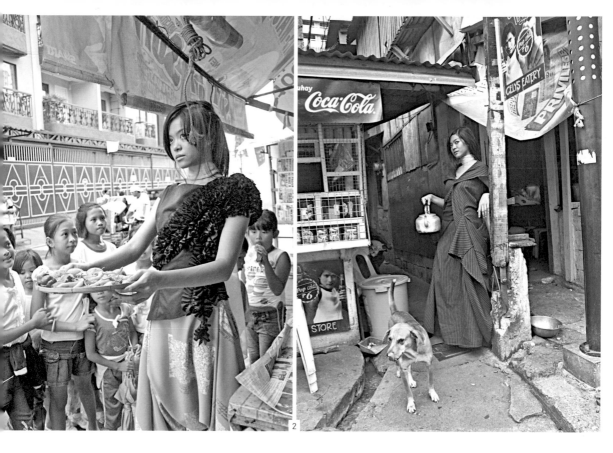

2

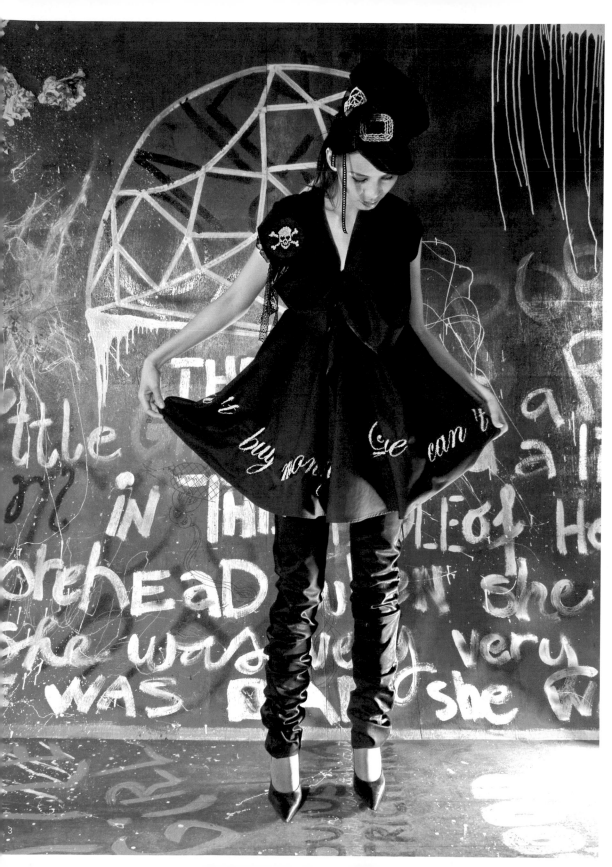

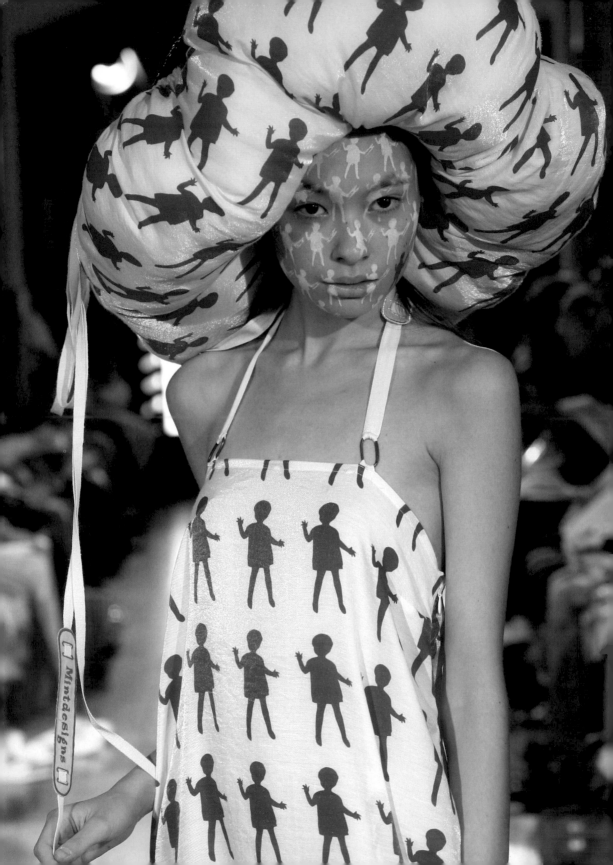

MINTDESIGNS | TOKYO
Nao Yagi, Hokuto Katsui

Started mintdesigns in Tokyo in 2001, the duo, both born in 1973, were classmates in Central Saint Martins College of Art and Design in London, where Hokuto Katsui graduated from the fashion design and print department and Nao Yagi from the womenswear school. Since their 2002 spring summer debut, the brand has grown steadily domestically and was crowned the winner of the 7th Moet & Chandon Designer Debut award in 2005. Preferring to consider their creations more as timeless product design classics rather than fashion per se, they approach fashion with a non-conformist attitude focusing on simple and utilitarian details instead of visual impact. In 2007, after years of selling successfully on-line as well as to retailers from across the globe from Singapore, Russia, Taiwan, Seoul to New York and Los Angeles the pair finally opened their first stand-alone boutique in Tokyo.

www.mint-designs.com

1 spring summer 2007, *"dame ni-ikiru"*
2 spring summer 2008, *"the flying girls 1808"*
3 spring summer 2004, *"printing project"*

Photos: Kentaro Oshio (portrait), ©mintdesigns (1, 2), Orie Ichihashi (3)

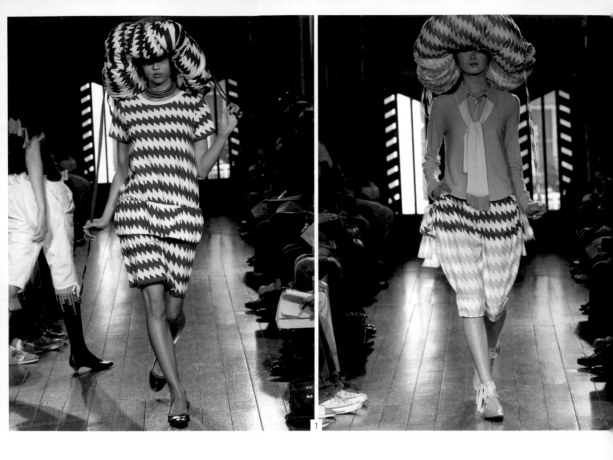

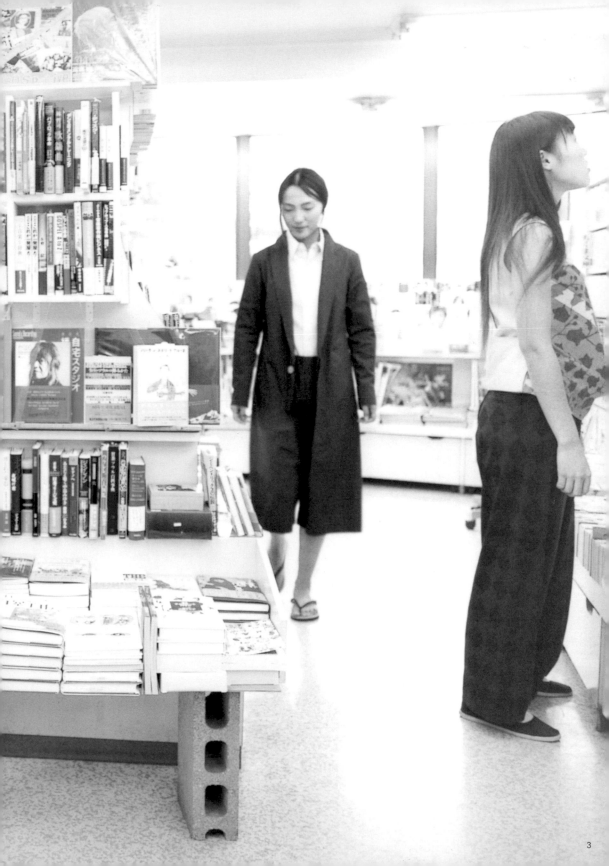

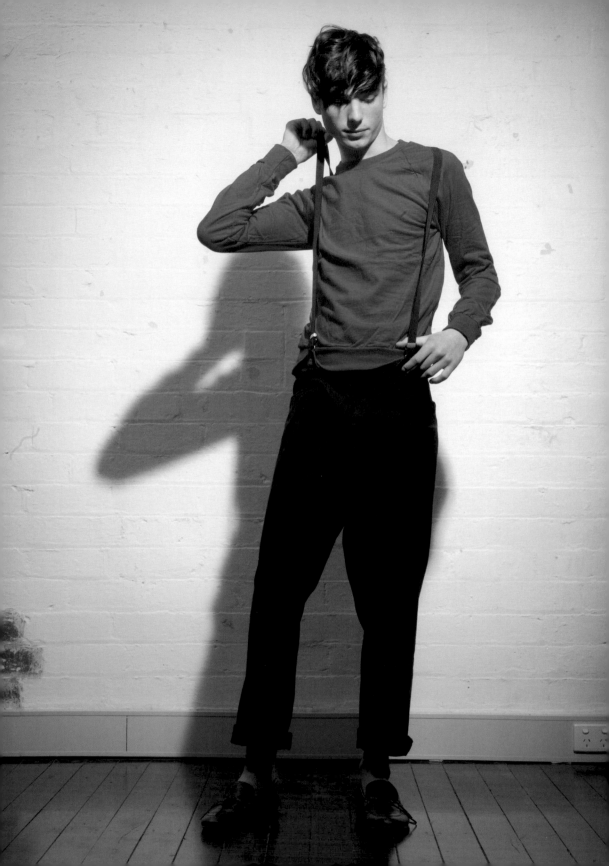

MJÖLK | MELBOURNE
Lars Stoten

Unflinching design pragmatism coupled with high-end fabrics and artisan craftsmanship are Mjolk's enduring trademarks. Created in 2003 by menswear designer and Denmark Designskole (DKDS) graduate, Lars Stoten together with Central Saint Martins graduate John Clarke, Mjolk has sent forth a fresh breath of fluent coolness to menswear in Melbourne. Focusing on clean aesthetics derived from classic men's tailoring, Mjolk is driven by ironic continuity and a reconciliation of opposites. In its very short history, Mjolk, now stocked in select shops worldwide from New York, Paris, Madrid to Brazil and Tokyo, has already cultivated a large underground following, dressing the famous faces in British band Franz Ferdinand, Australian rockstars Jet, Ben Lee, and Grinspoon, as well as the disco queens the Scissor Sisters. After much acclaim and success, Mjolk has now extended their creative point-of-view into women's wear in 2006. The range plays on traditional tailoring elements like the menswear, re-inventing itself with a strong female personality and aesthetics to give the clothing its own distinctive flair.

www.mjolk.com.au, www.mjolkisyourfriend.com

1 fall winter 2007/08
2 spring summer 2008

Photos: Julie Wajs (1), Justin Ridler (2)

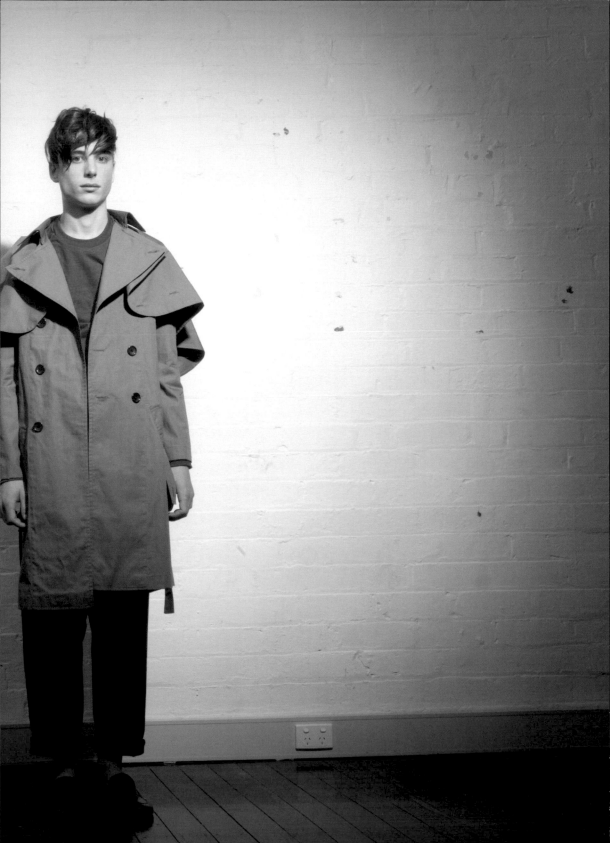

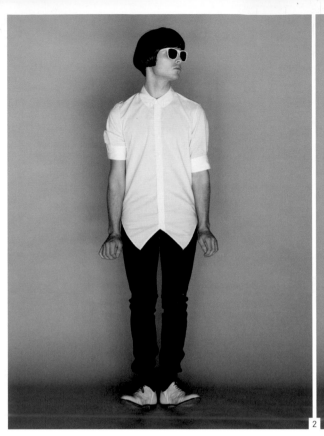
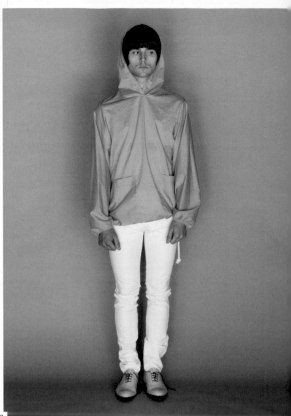

2

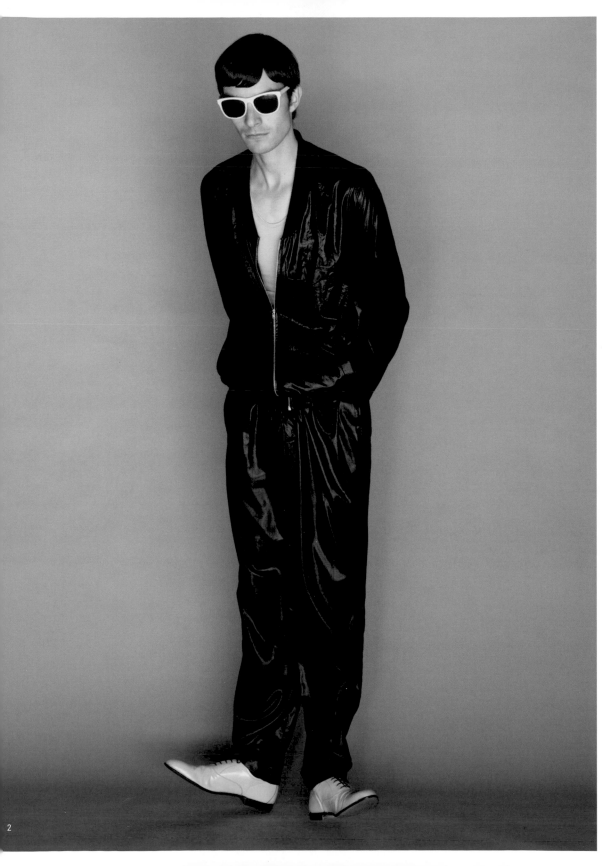

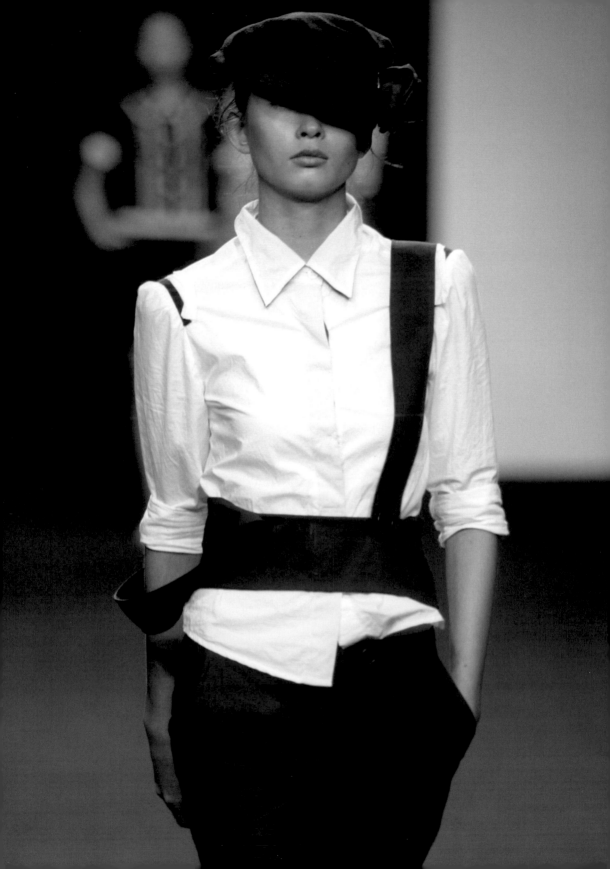

MUNCHU'S | BANGKOK
Munchumart Numbenjapol

Swaying between brutally femininity and angular boyish-
ness, Munchu's women are sexy, daring and empowered
by a subtle mix of male uniformity. A graduate of London's
Central Saint Martins College of Art and Design, Mun-
chumart Numbenjapol, born 1975, didn't wait long to go
solo after earning her degree in fashion design. Just over
a year into the job as a designer for Playhound, one of the
most celebrated and established Thai fashion collectives,
Numbenjapol had already launched her debut collection for
the Elle Bangkok Fashion Week in 2004. She opened a flag-
ship store the following year and continues to expand her
domestic presence.

munchumart@yahoo.com

1 spring summer 2005
2 fall winter 2007/08

Photos: Woson Lertwachakul

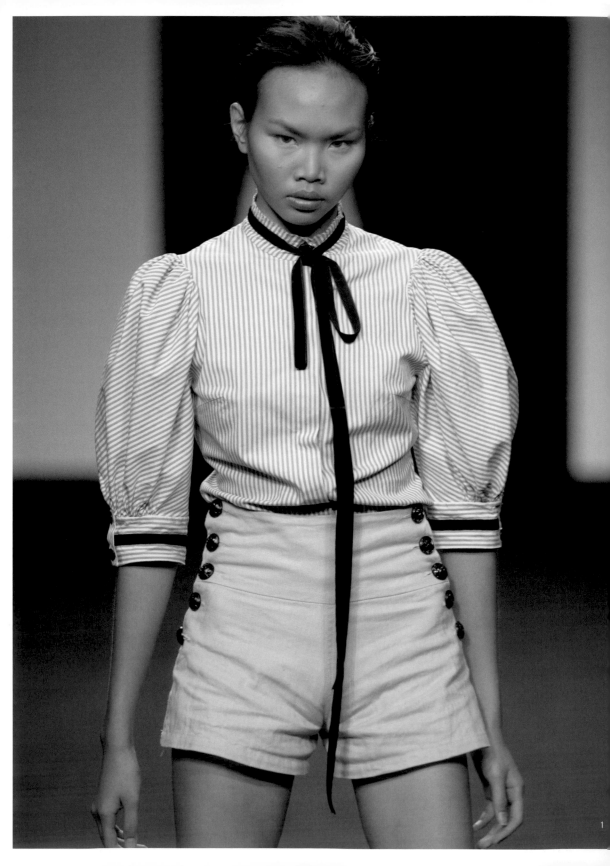

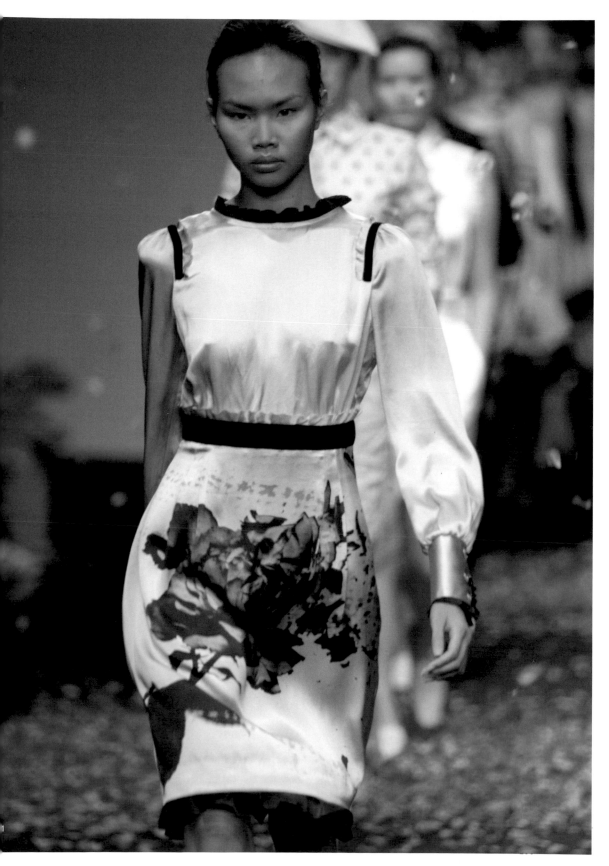

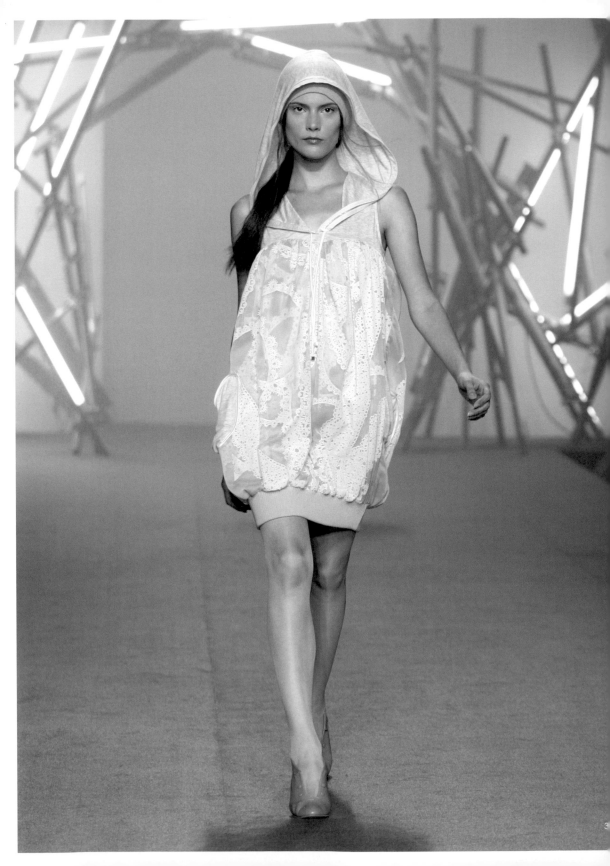

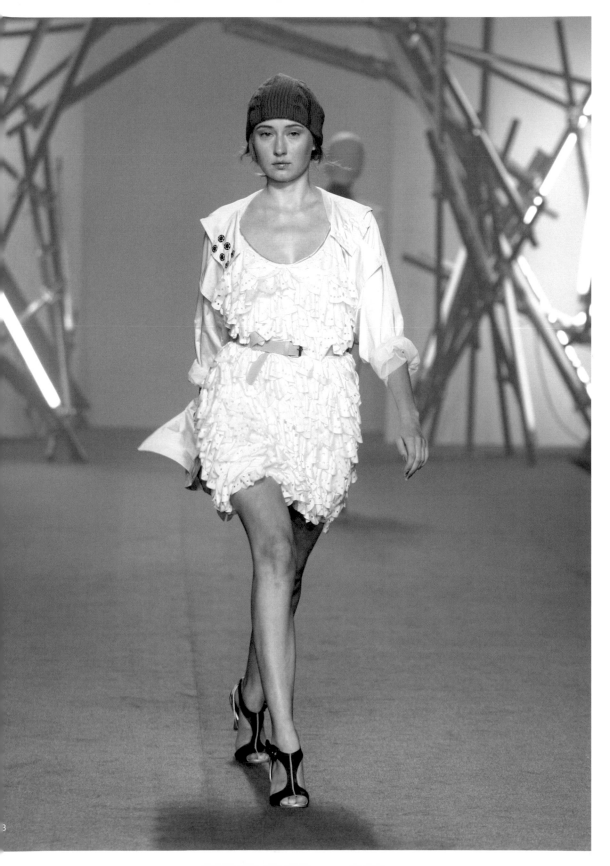

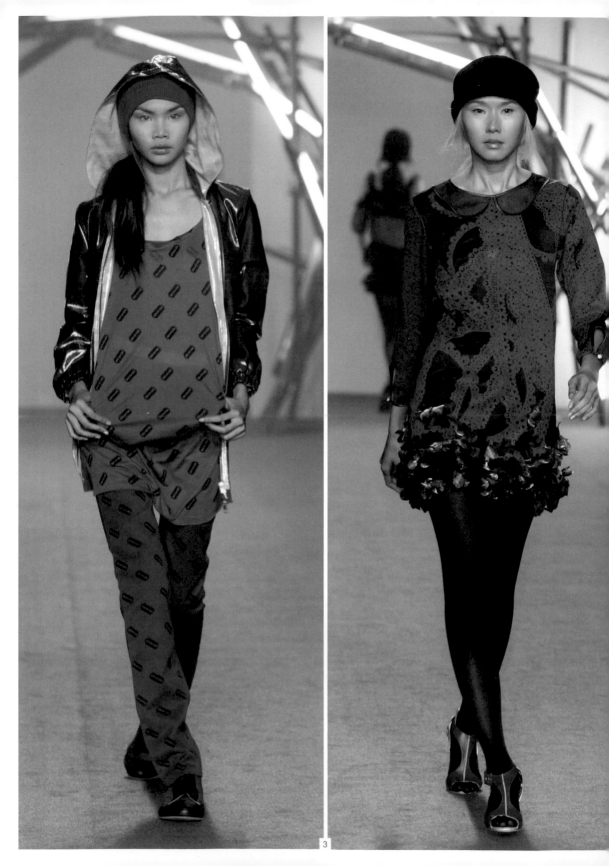

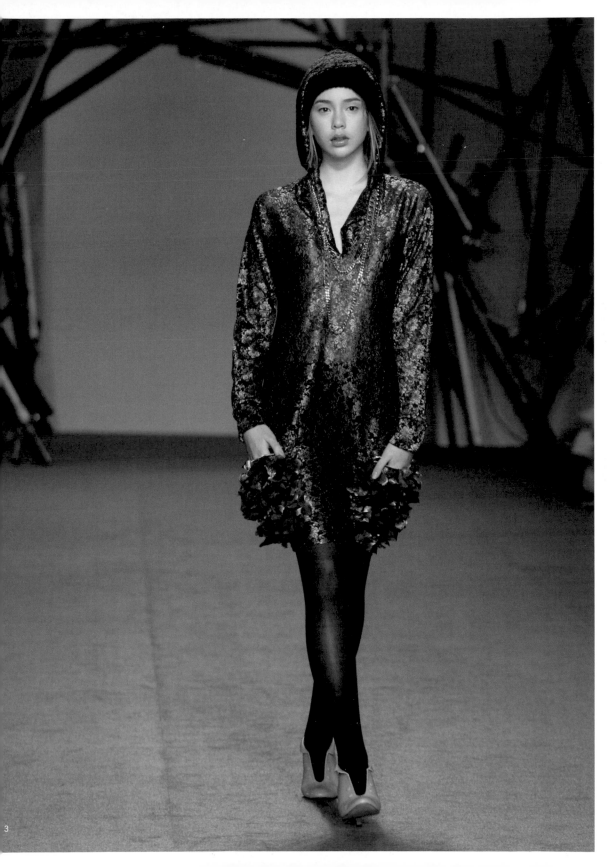

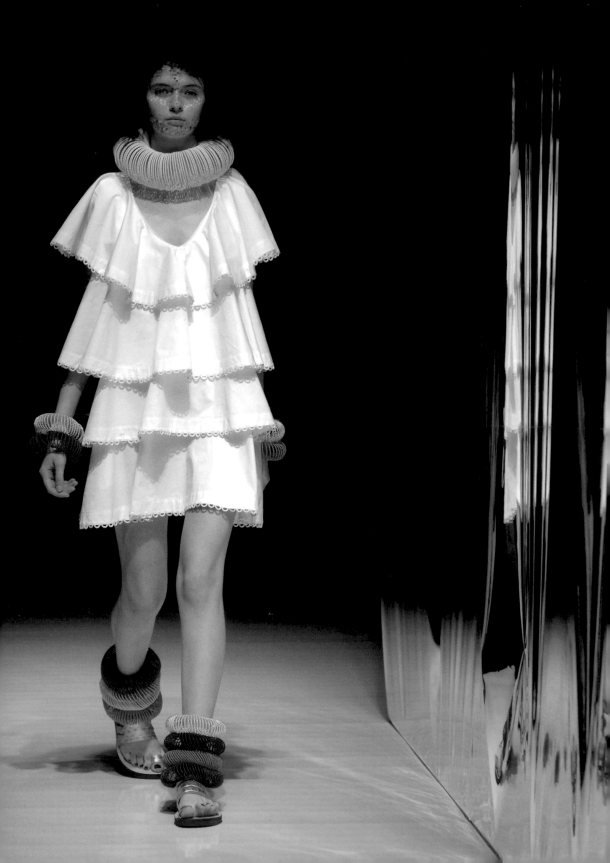

NÉ-NET | TOKYO
Kazuaki Takashima

Born in Kumamoto 1973, Kazuaki Takashima graduated from Bunka Fashion College in 1994 and joined ISSEY MIYAKE in 1996. Following a three year tenure as PLEATS PLEASE ISSEY MIAYKE's chief designer from 2002, Takashima launched Né-net under the umbrella of A-net Inc., a Miyake sister company, in 2005. Following his spring summer 2006 show at the Tokyo Fashion Week, he won the best newcomer award at the 24ᵗʰ Mainichi Fashion Awards. Known for his bright, innovative and satirical take on fashion, Takashima treasure finding inspirations from the dark nuances and sentiments of modern day Japanese youth culture.

www.a-net.com

1 spring summer 2008, *"roots" LUCY's pray - finding own from former incarnation*
2 spring summer 2007, *"Idea of dream in reverse"*
3 fall winter 2007/08, *"TAIKUTSU"*

Photos: Josui

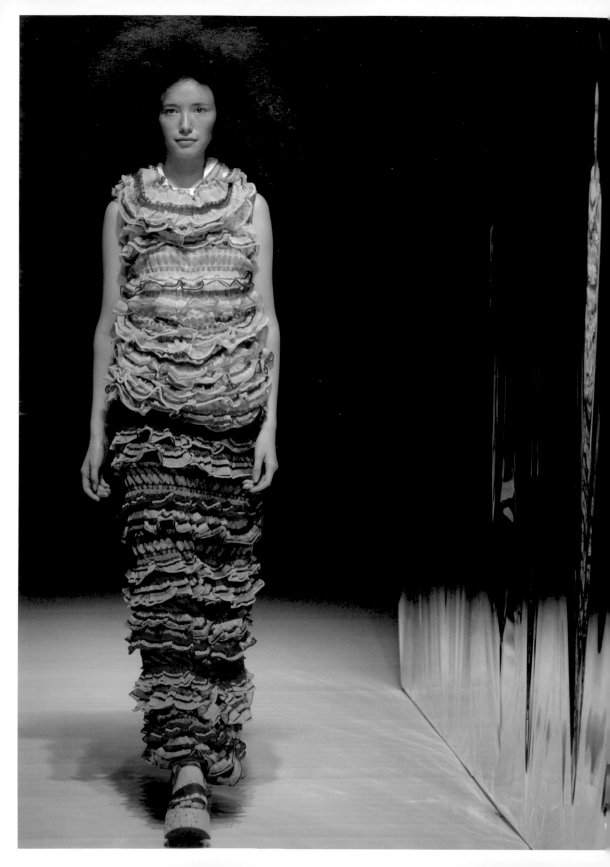

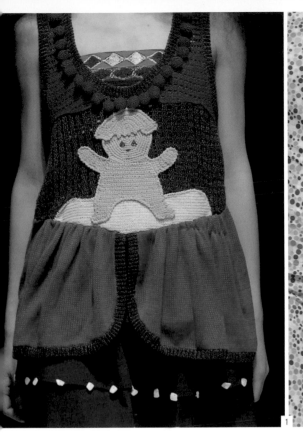

1

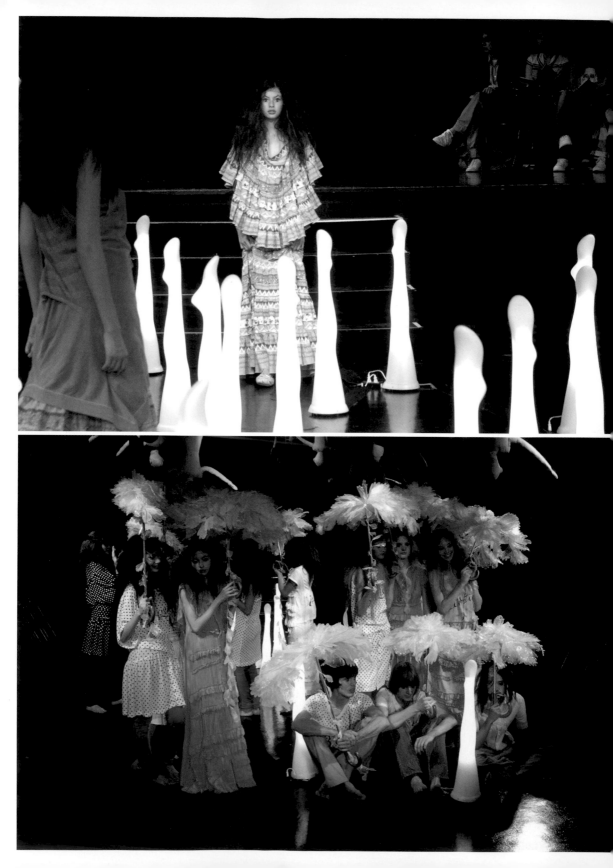

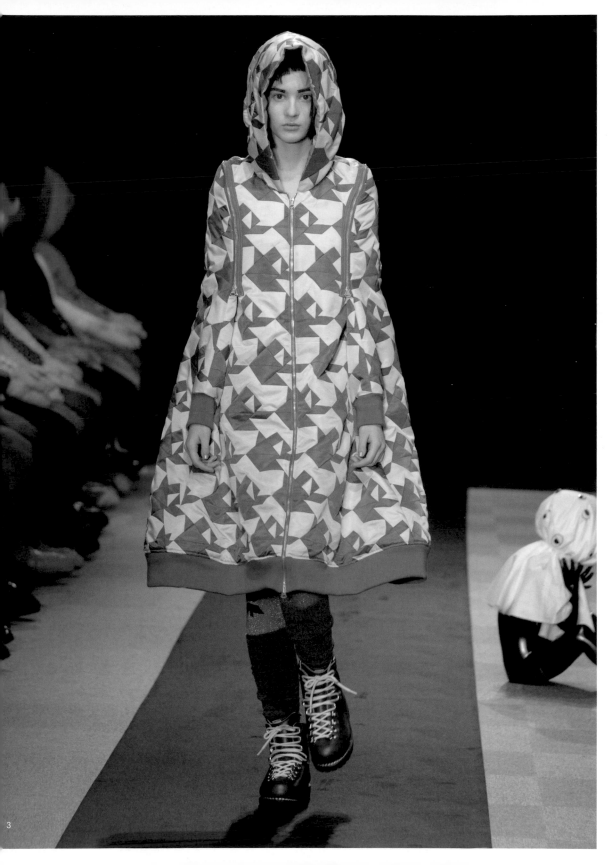

3

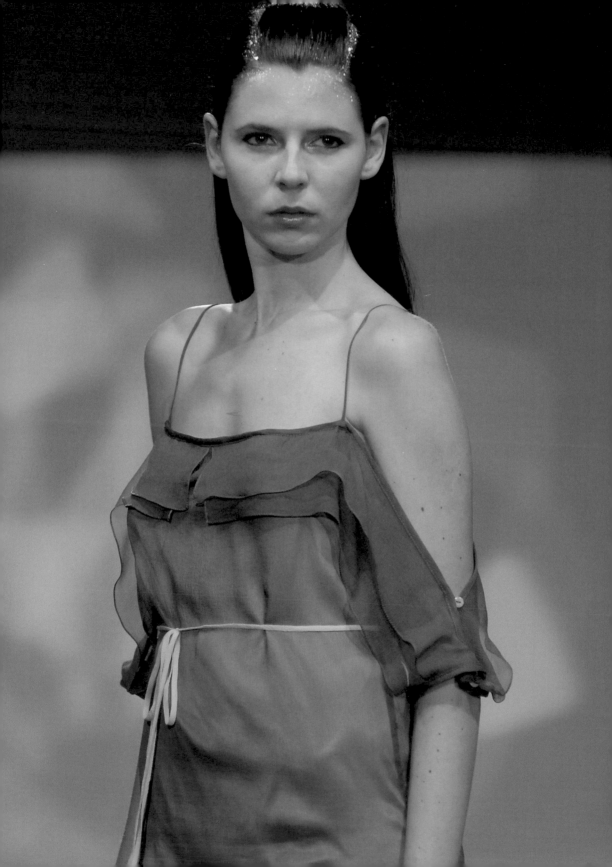

POSSE | SINGAPORE
Madeleine Wong, Jay Quek

Singapore based fashion label created by the award winning duo of Madeleine Wong and Jay Quek, Posse is a fusion of Wong's love for color, texture and print and Quek's skills in intricate pattern construction and fine craftsmanship. The label's off-beat glamour vibe accented with casual couture touches has won over many fans, and was also awarded the Designer of the Year Award during the Elle Fashion Awards 2006. Both trained at Raffles Design Institute in Singapore with degrees from Middlesex University, UK, Quek, born 1980, graduated top of her class in 2003 while Wong, born 1982, won the Asian and Singapore Young Designer Award the same year. Collectively they have exhibited their works in many countries such as the UK, Germany, Sydney and Shanghai. Both designers also worked for various local and international companies including Club 21, J.P. Braganza in London and Celia Loe in Singapore, before striking out on their own.

www.possestudios.com

1 spring summer 2008, *Singapore Fashioon Week*
2 spring summer 2007, *Mercedes Australia Fashion Week*

Photos: Steve Woods Photography (1), Lucas Dawson Photography (2)

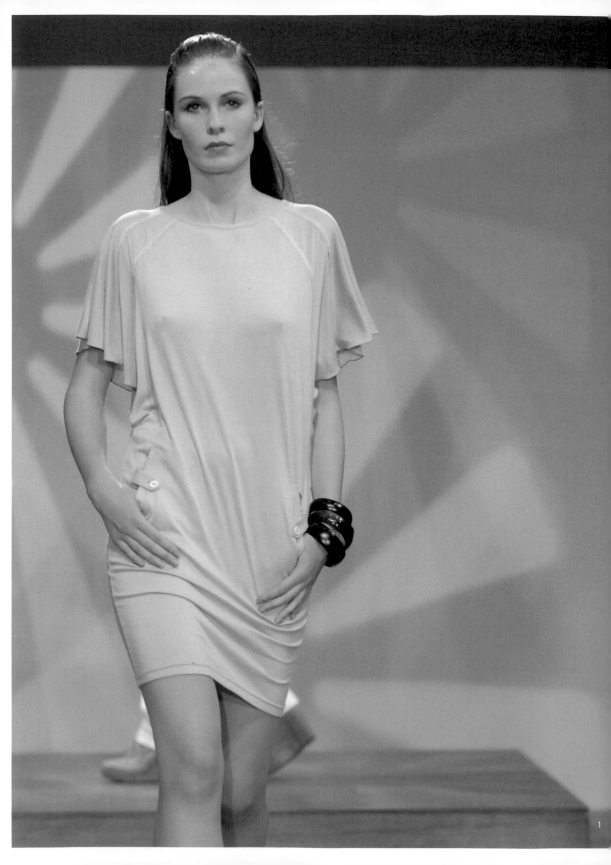

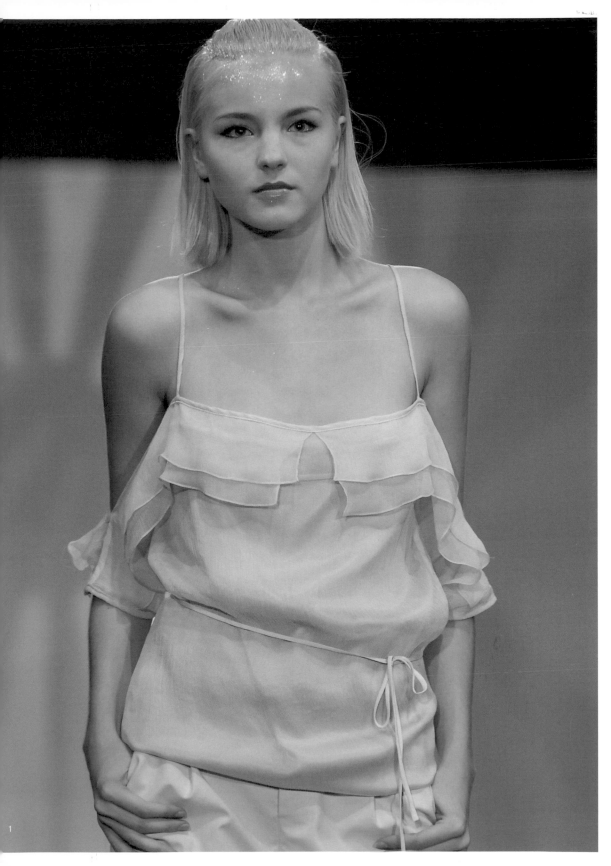

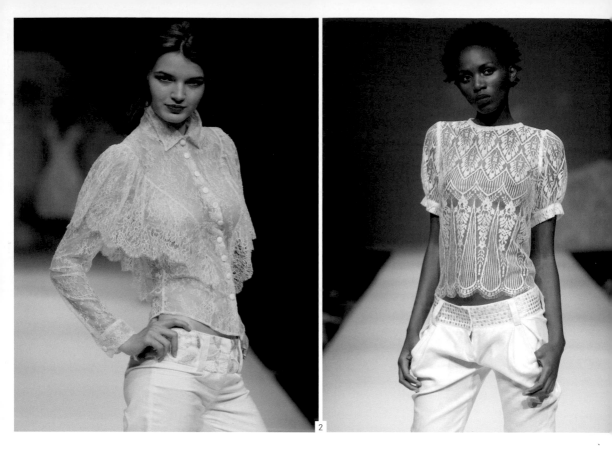

2

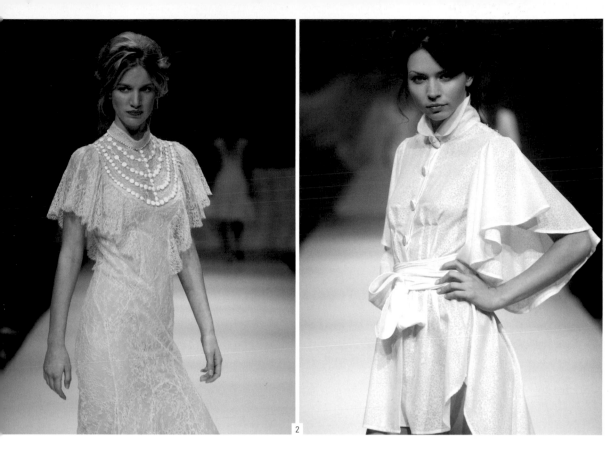

2

QIU HAO | SHANGHAI
Qui Hao

After graduating as an interior designer with a bachelor's degree from Su Zhou University, China in 2001, Qiu Hao straddled in both the fields of interior design and fashion for several years until fully committing to fashion with his own label and boutique named lab/one by one, which he founded with a partner. The ensuing success prompted him to move to London in 2004 where he studied fashion at Central Saint Martins and trained under Alexander McQueen. Returning to Shanghai in 2006, Qiu set up a new eponymous label and shop taking inspiration from the raw surroundings of Shanghai's back alleys and proved himself to be a strong undercurrent force to be reckoned with. With two collections under his belt, both critically-acclaimed at home for his unique and intricate interpretation of deconstructivism, Qiu opened up one more shop and was invited to participate in Vogue China's 2007 second anniversary "Fashion Art" installation.

www.qiuhaoqiuhao.com

1 spring summer 2007
2 fall winter 2006/07

Photos: Jean-Louis Wolf (1), Qiu Hao (2)

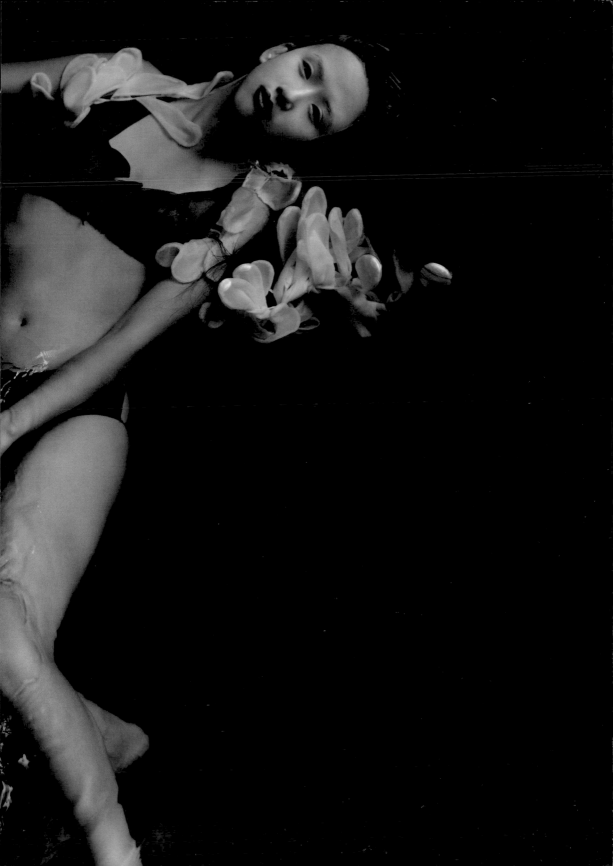

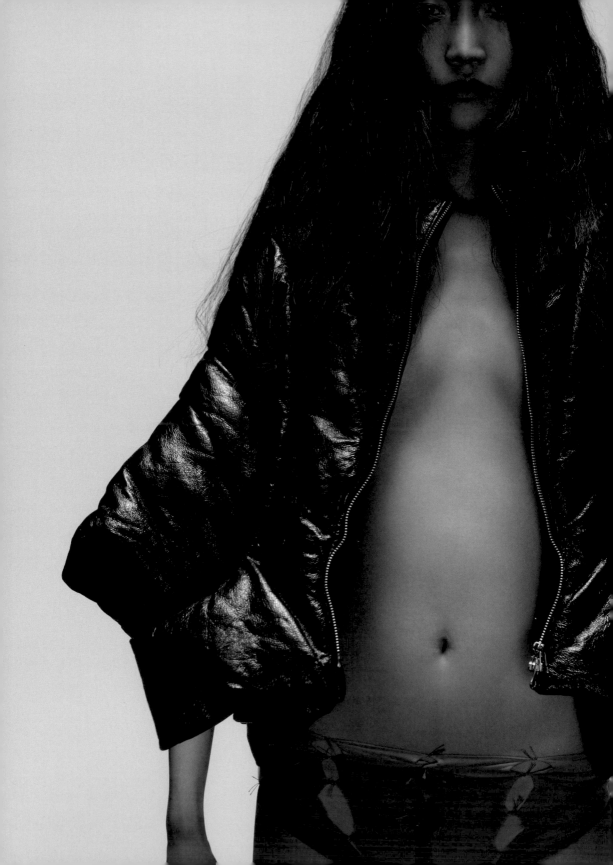

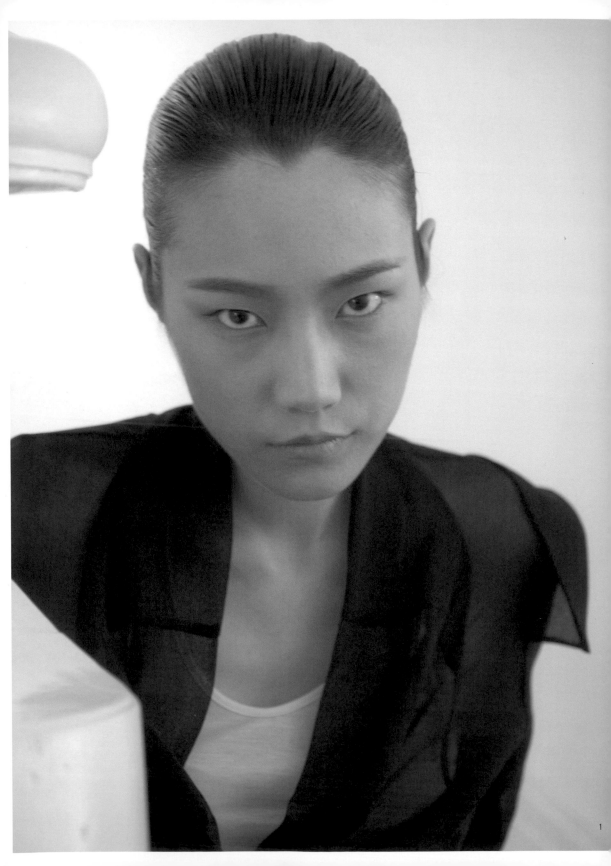

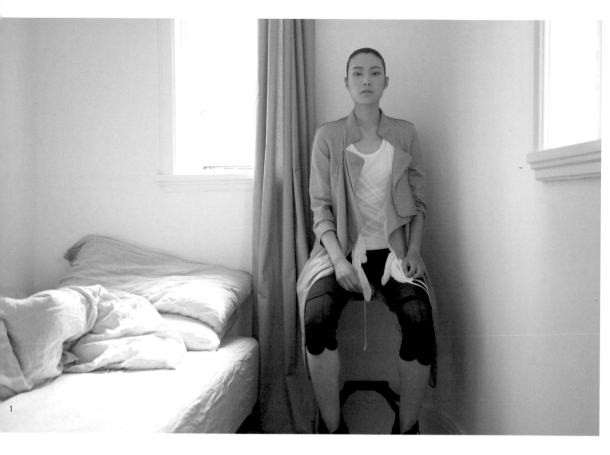

1

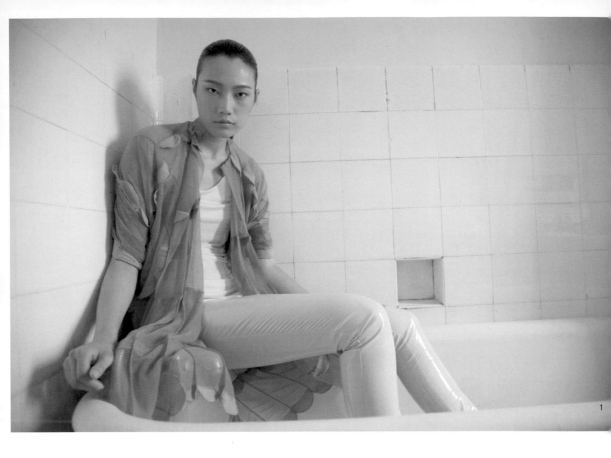

1

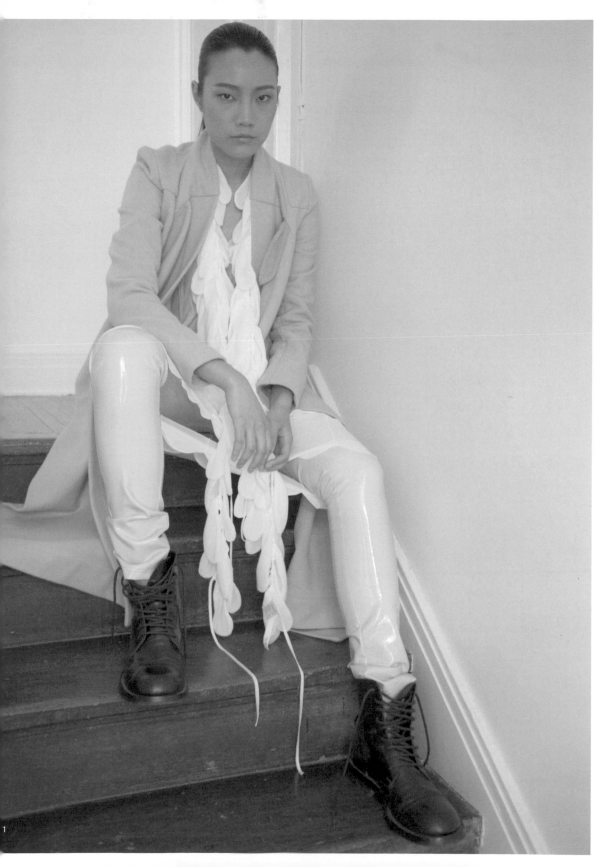

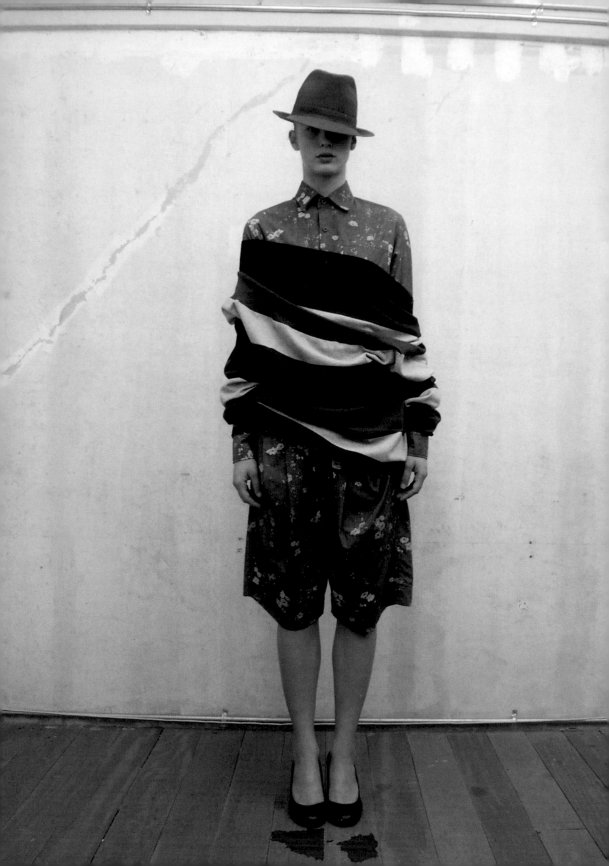

REALISTIC SITUATION | BANGKOK
Patsarun Sriluansoi

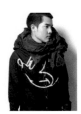

Born in Bangkok 1973, Patsarun Sriluansoi is a graduate of LaSalle College in Montreal, Canada, where he studied fashion design under a scholarship awarded by the Singapore Government. Enriched with new influences and inspirations from culturally-rich Montreal, he returned to Bangkok and entered another design contest in Japan, where his ingenious deconstruction on fabric and form won him a grand prix at the Onward Fashion Competition in Tokyo. Prior to starting his own brand in 2005, Sriluansoi designed for the renowned contemporary couture house, Kai, and was a regular participant at the Bangkok Fashion Week designing for the Princess Mother's Mae Fah Luang Foundation. The love of experiments as well as the engineering of fabrics and new silhouettes is still very much the guiding style of his brand today.

www.realisticsituation.com

1 fall winter 2005/06, *In the classroom*
2 fall winter 2006/07, *Androgyny*
3 spring summer 2007, *NoMercy*

Photos: Tor

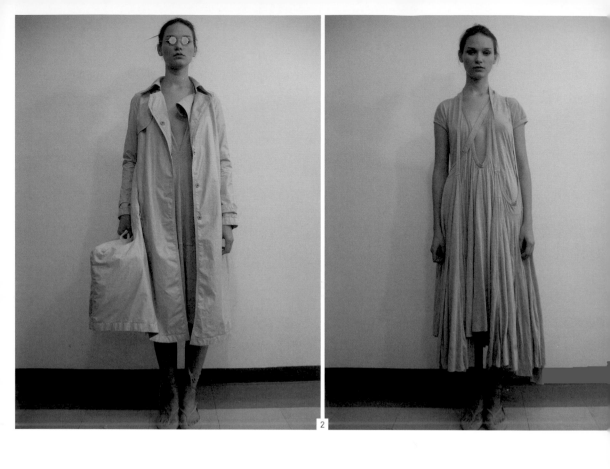

2

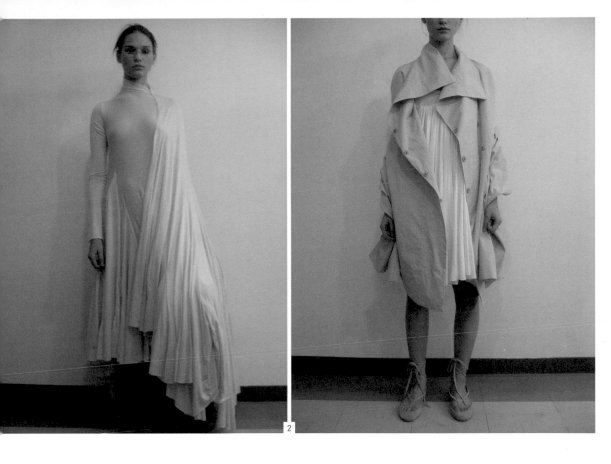

2

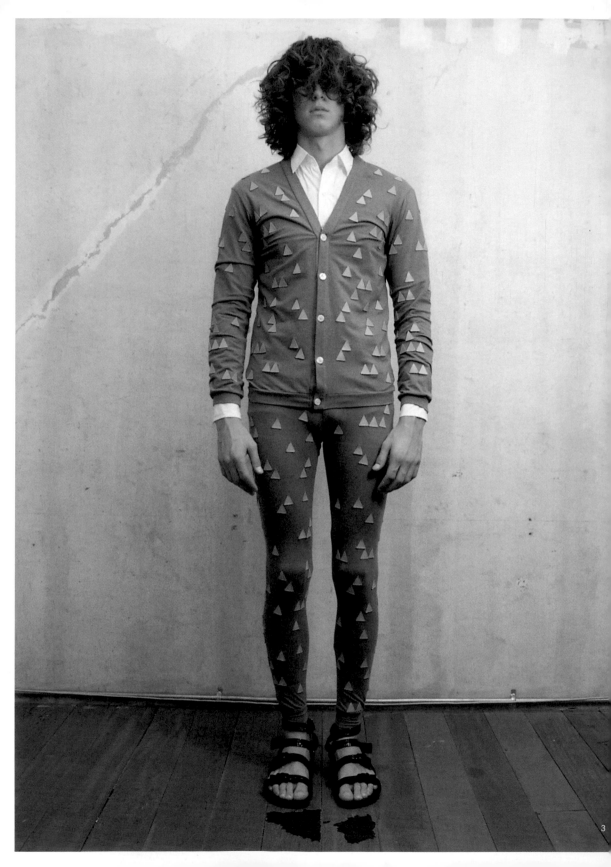

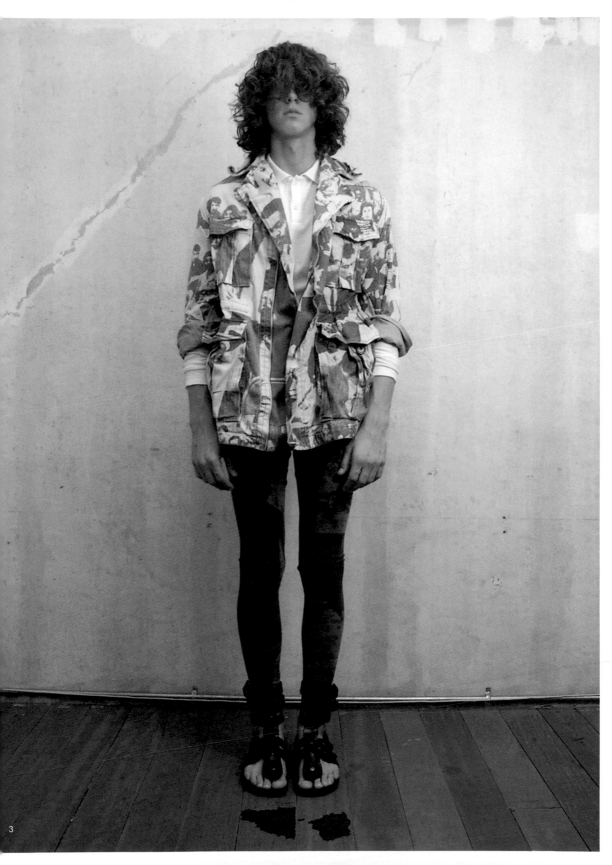

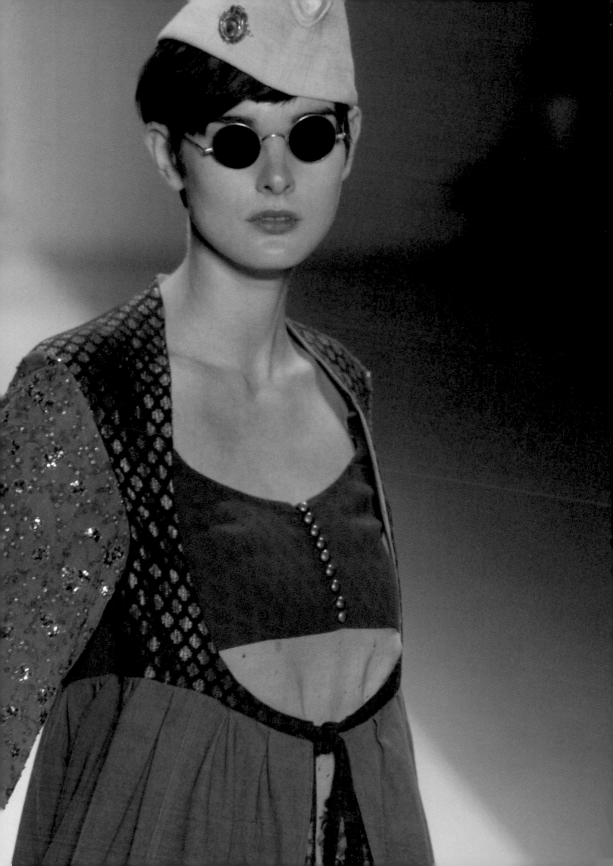

SABYASACHI | KOLKATA
Sabysachi Mukherjee

Going solo barely four months after graduating from the National Institute of Fashion Technology, India, the Kolkata-based designer was determined to make a name for himself right from the start. Three years later, armed with an Outstanding Young Designer Award by the Femina British Council and an internship with Georgina Von Etzdorf in the UK, Mukherjee, born 1974, debuted at the Lakme Indian Fashion Week to rave reviews and international coverage by Women's Wear Daily. Spring 2004, having sealed a coveted retail spot at Browns in London from his last show, the designer caused another international stir when he was crowned the grand winner at the coveted Mercedes-Benz Asian Fashion Awards in Singapore. By 2004, Sabyasachi was going global. Besides India, Murkherjee now puts on regular showings at Milan's and New York's runways, which adores his indigenous use of Indian textiles and techniques in modern context.

sabyasachicouture@yahoo.com

spring summer 2008, *Mercedes Benz New York Fashion Week*

Photos: gettyimages

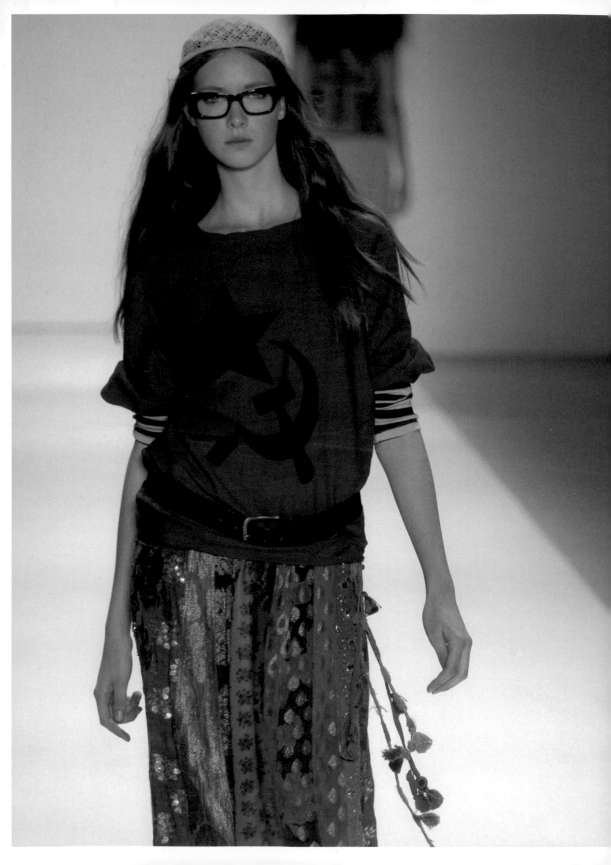

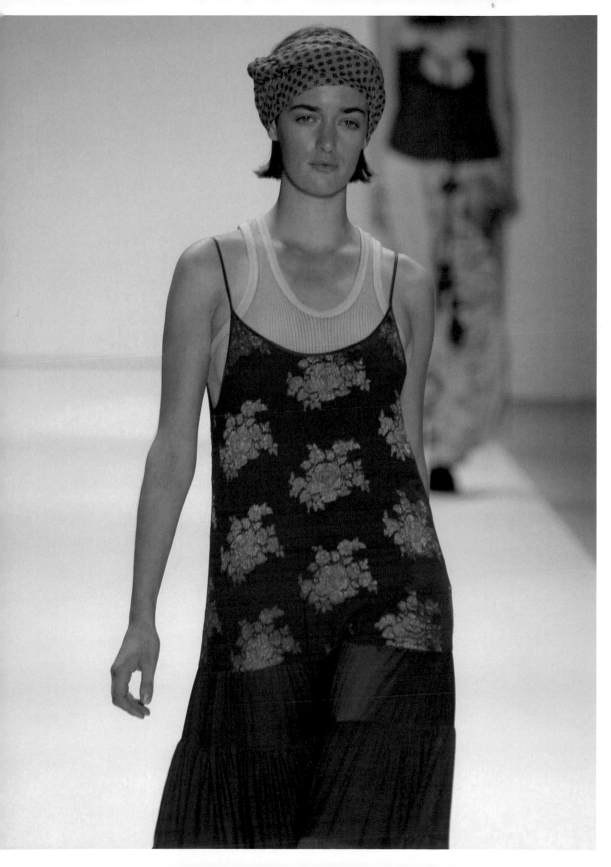

SHHHH... | HONG KONG
Kevin Ng

Born 1972, Kevin Ng sees fashion as a medium for self-expression and beyond. For him, fashion is one of the most fundamental expressions through which a person choose to conform or deviate from cultural norms. In 2007 he has chosen to deviate quietly with the launch of his own brand and shop named shhhh.... Hidden behind a mishmash of traditional market stalls, junks shops and vibrant bar and restaurant culture, the locale of the shop reflects his love of contrasts; of 'standing-out' versus 'fitting-in'. Before going solo, Ng was an in-house designer for a string of popular local brands. A 1997 fashion graduate of the Hong Kong Polytechnic University, Ng was the winner of the Wool Prize at the 1998 Hong Kong Young Designers Show as well as of a special award in the Osaka Fashion Competition in 1999. In addition to shhhh..., Kevin also collaborates with a partner on WASABI, a gutsy Asian and South American fusion street-wear brand targeting young hipsters.

www.shhhh.biz

1 fall winter 2007
2 spring summer 2007

Photos: Ringo Tang

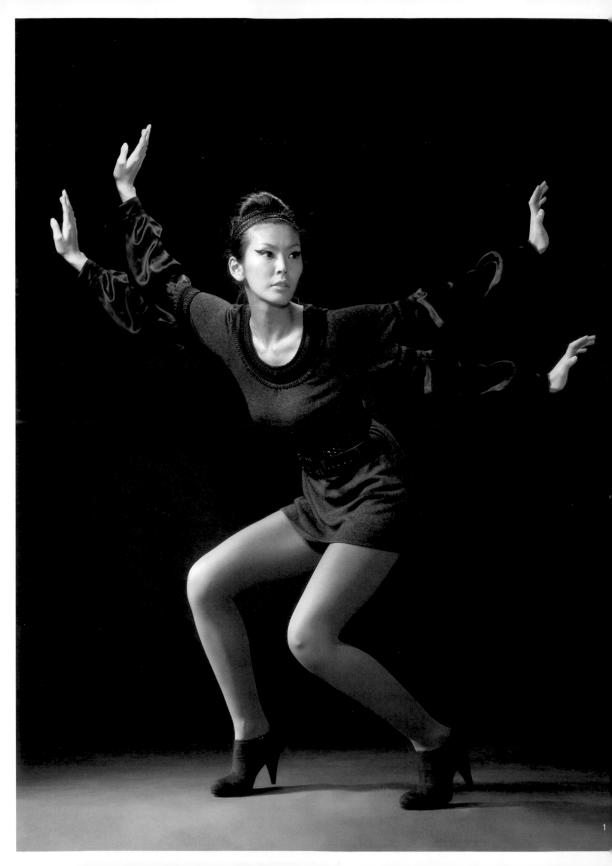

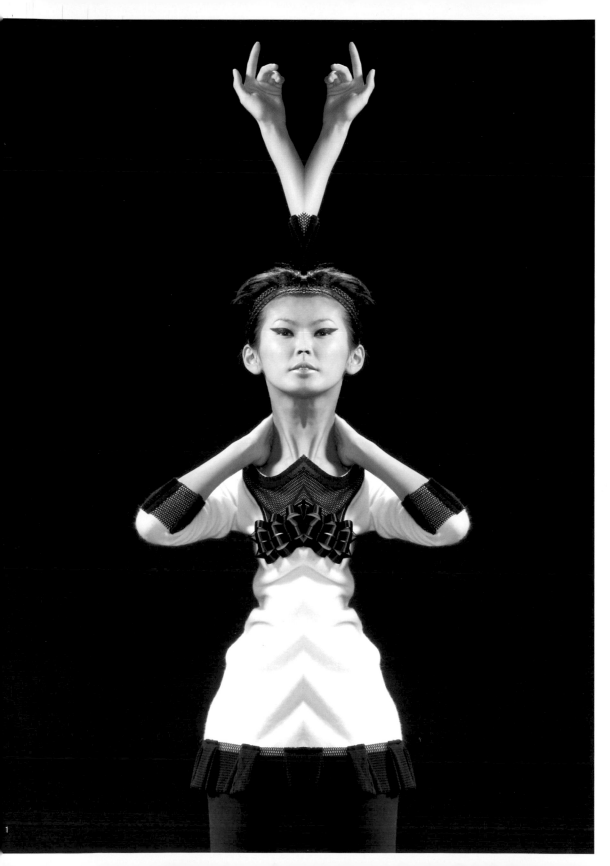

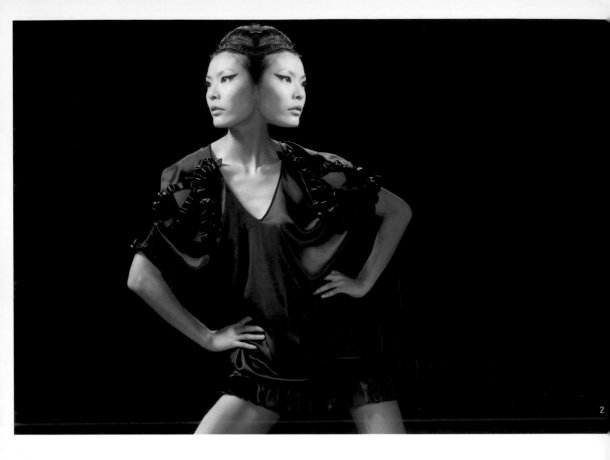

2

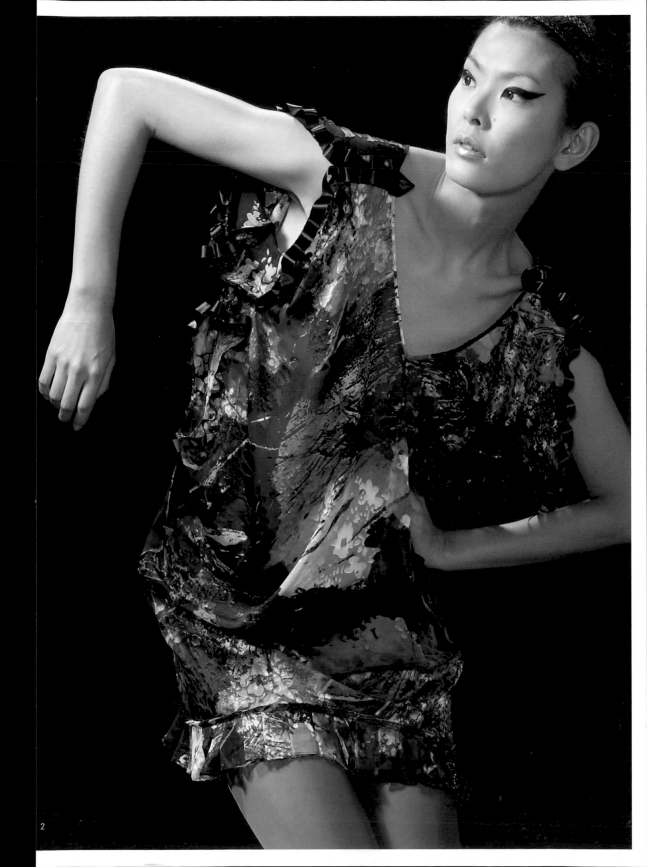

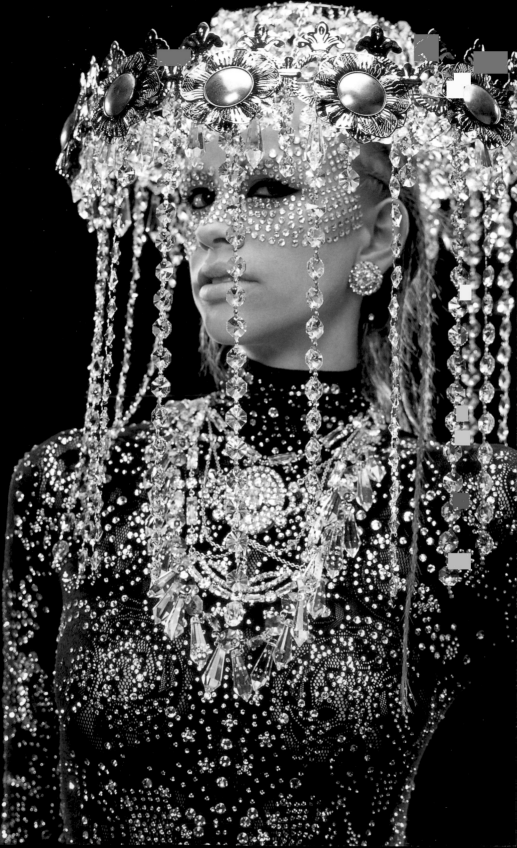

SOMARTA | TOKYO
Tamae Hirokawa

After eight solid years of working with Japanese fashion maestro Issey Miyake looking after both its main and menswear collections, Tamae Hirokama, born 1976, finally took off to set up on her own. SOMARTA was born as part of Soma Design, a fashion, art and graphic design collective Hirokawa created in March 2006. The same year the Bunka Fashion College graduate presented her debut collection, the Secret Garden, at the Tokyo Fashion Week. Another season later in 2007, she was already crowned the best newcomer by the industry's most prestigious Mainichi Fashion Award. The strongest inspirations for the Issey Miyake protégé come from her travels to faraway places, where indigenous cultures and societies are rife with the unexpected. Her latest collection, a sumptuous feast of warrior looks and innovative texture rich with details, won her many praises from both local and foreign media.

www.somarta.jp

1 fall winter 2007/08, *PROTEAN - The secret garden 2*
2 spring summer 2008, *ENGRAVER*
3 spring summer 2007, *The secret garden*

Photos: Shinya Keita (ROLLUP studio.) (1, 3), Hiroyuki Kamo (2)

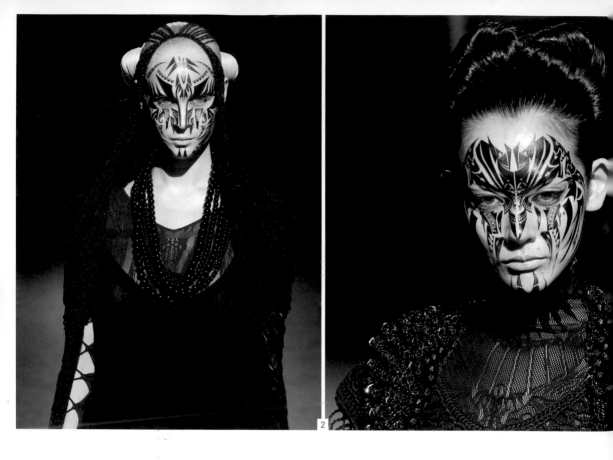

2

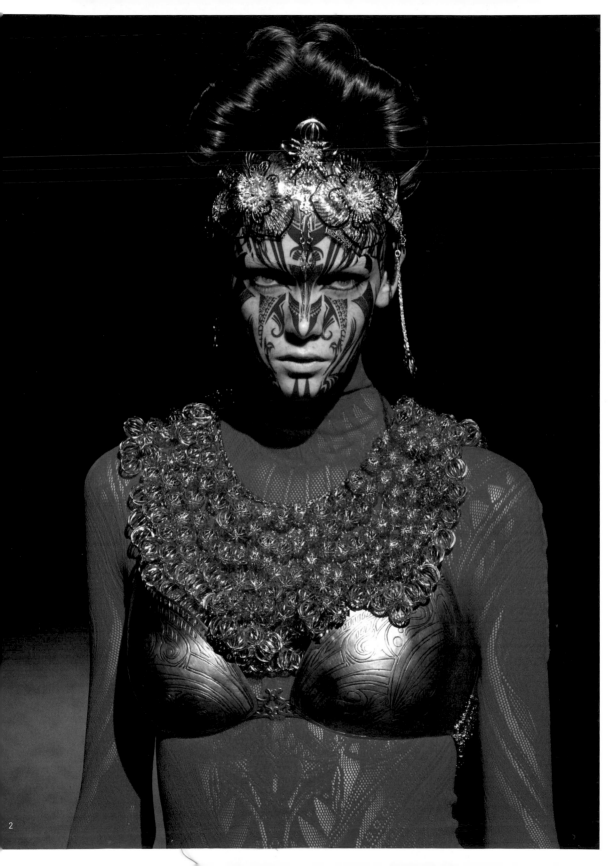

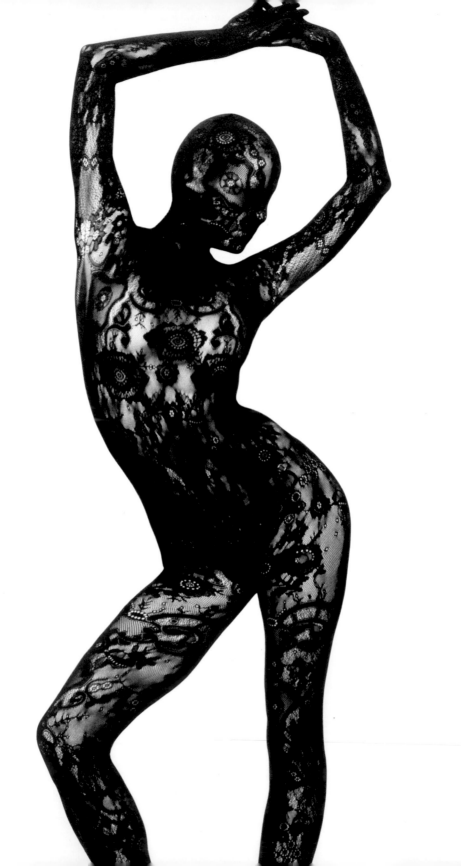

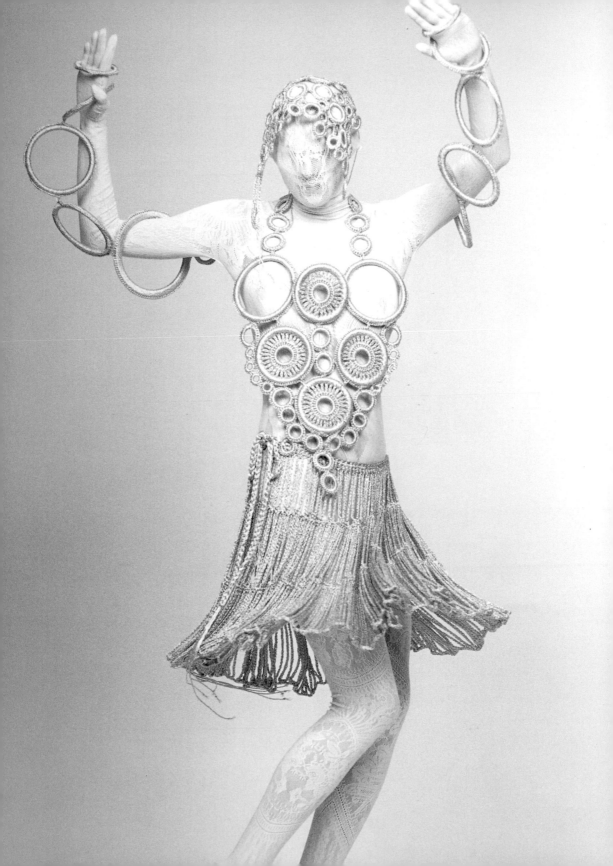

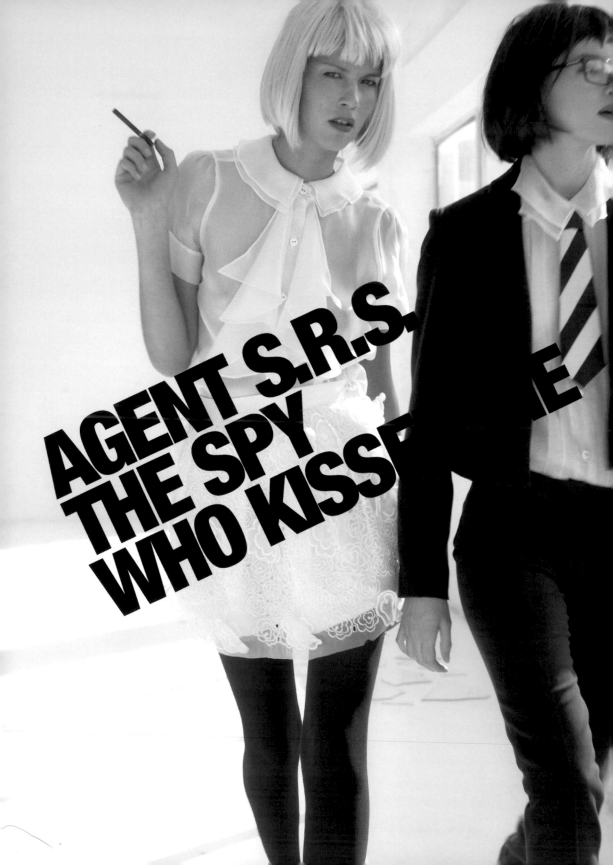

AGENT S.R.S.
THE SPY
WHO KISSED ME

SRETSIS | BANGKOK
Pim Sukhahuta

Born 1979, Pim Sukhahuta's career started before she knew it, having just an overnight to decide to open her first boutique while she was still a junior at the Parsons School of Design. By the time she graduated in 2003, Sukhahuta was already a tried-and-tested designer with one store and two fashion collections in her hand. Meaning sisters spelt backwards, Sretsis is a collaborative effort borne by three sisters. While Pim takes the helm in designs and overall creative directions, Kly is in charge of marketing and Matina designs the accessory line. The three were a close-knit sisterhood obsessed with role-plays when they were kids with Pim always acting the fashion stylist for the other two sisters. Debuted at the Elle Bangkok Fashion Week in 2002, Sretsis quickly became noticed for its whimsical prints and quirky twists to classic designs and delicate fabrics. The success later brought the brand an invitation to show in Australia, where it now has a wide following. Now Sretsis is stocked across Asia, Australia, the U.S. and France.

www.sretsis.com

1 fall winter 2007/08, *Agent S.R.S*
2 spring summer 2008, *Mon to Sun*
3 spring summer 2006, *Lady and the fox*

Photos: Kornkrit Jeanpinidnan (1, 3), Chutharat Pornmunee-soontorn (2)

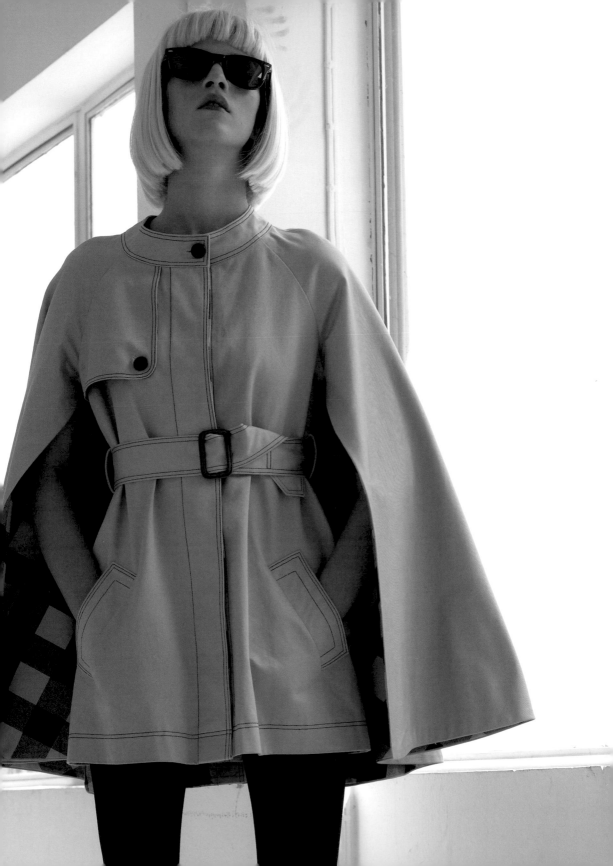

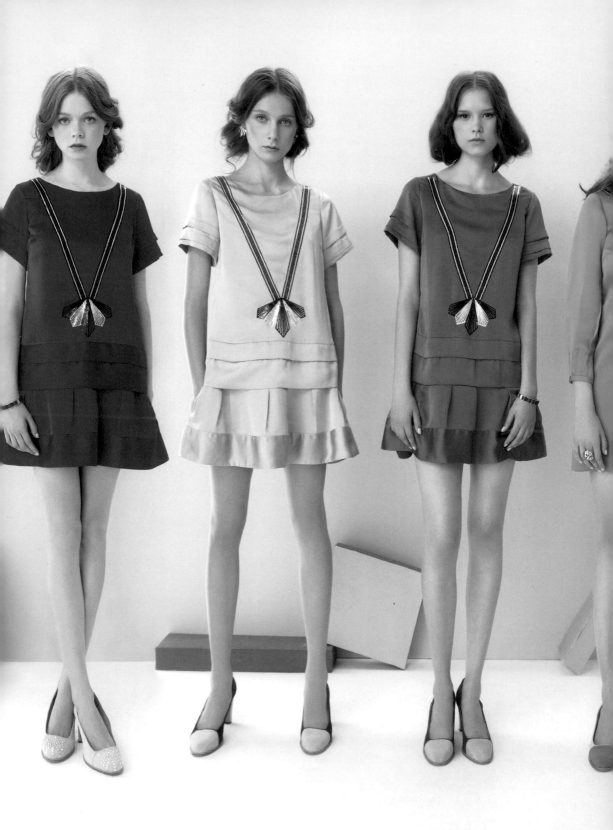

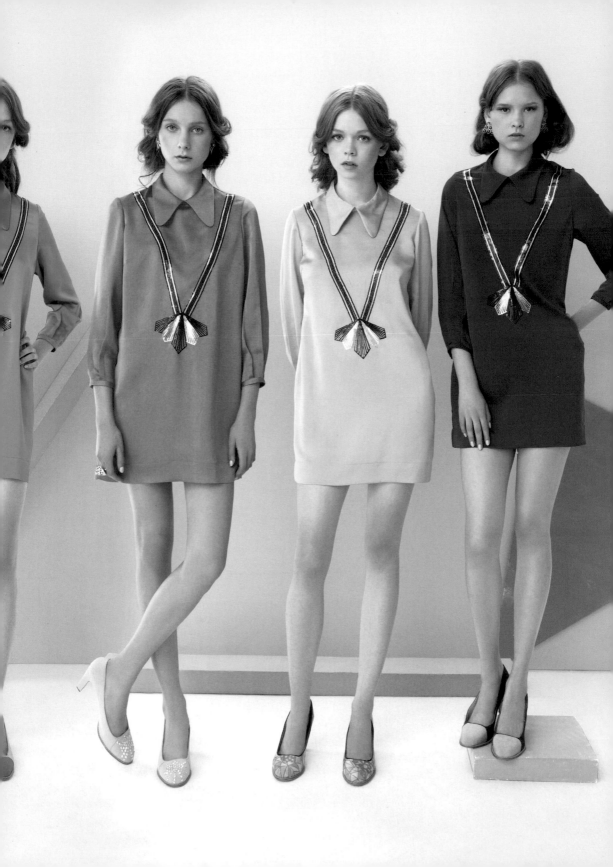

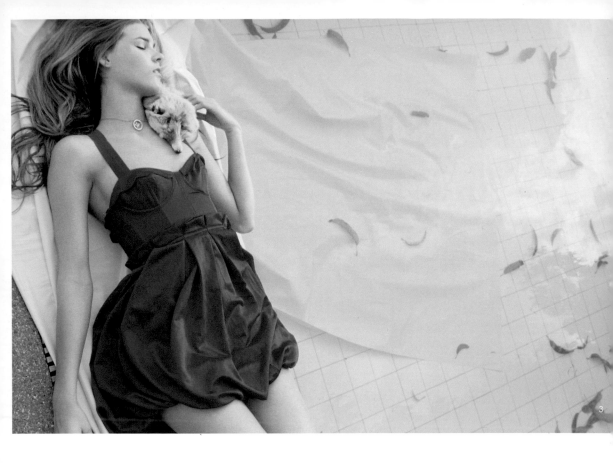

3

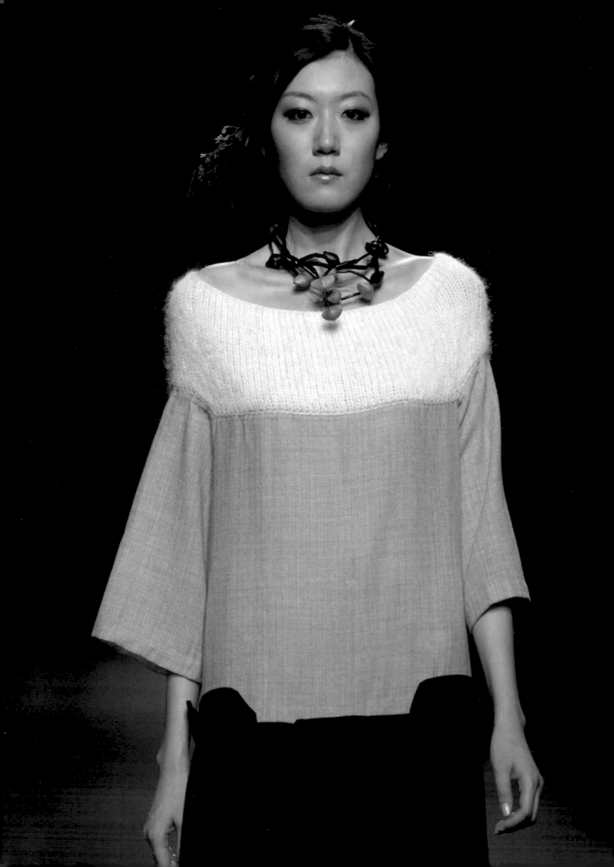

SUHSEUNGHEE | SEOUL
SeungHee Suh

After designing for several fashion brands in Seoul the graduate of Seoul's Sungkyunkwan University embarked to Britain to further train her craft at the Northumbria University at Newcastle. Having completed a Master in fashion design with distinction in 1997, Suh, born 1970, returned to Seoul to work as a design director for a local fashion brand. In 2001, she launched her own label and debut the new line at the Promising Designers Collections sponsored by Seoul City. Her conceptual approach and quirky draping soon won her the Most Promising Designer Prize by Seoul City in 2003. The same year Suh was invited to participate at Japan's Osaka Collection. Now suhseunghee is shown regularly at the Seoul Collection.

www.suhseunghee.com

1 fall winter 2006/07
2 spring summer 2007

Photos: SeungHwan Han (1), ByungGuk Lee (2)

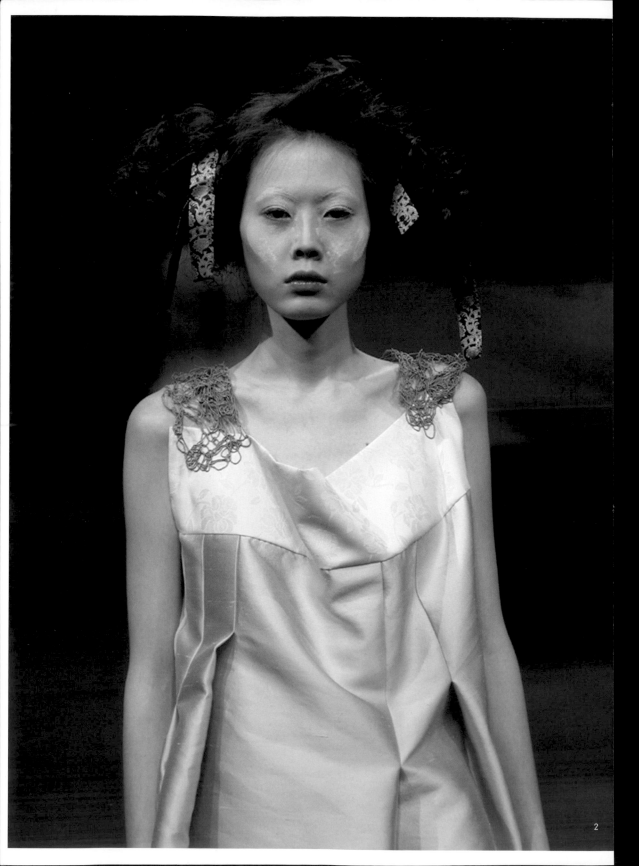

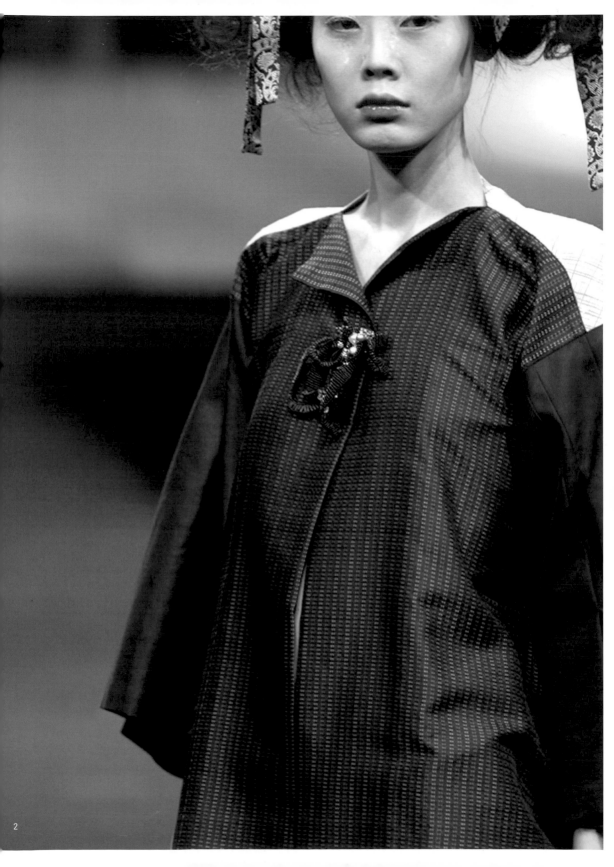

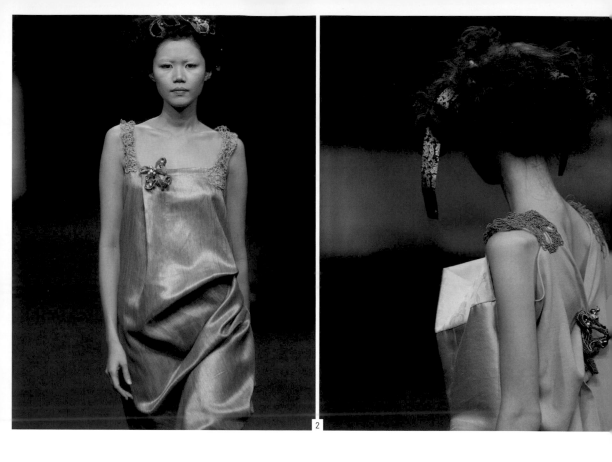

2

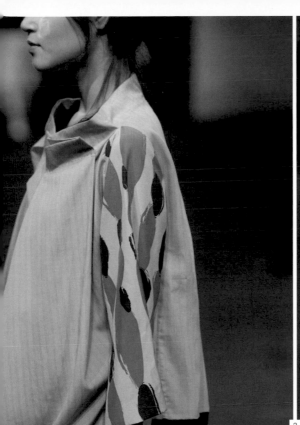
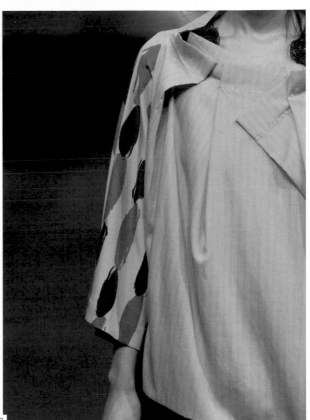

2

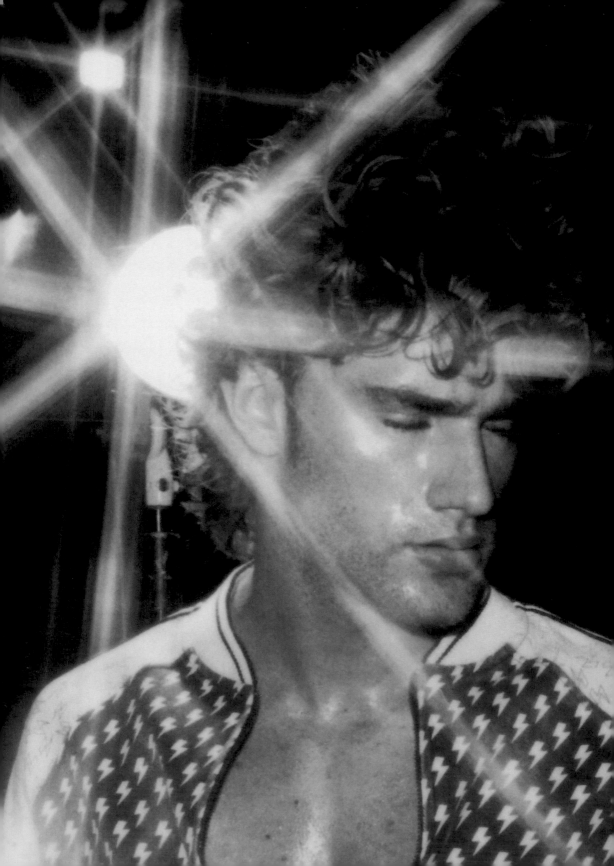

SUNSHINE | BANGKOK
Jirat Supbisankul

Graduated with a B.A. in Communication Arts from Bangkok University, Jirat Supbisankul's initial foray into the media world were multifaceted, with works spanning all aspects of magazines and advertising productions, styling for photo shoots to costume designing for film productions. In 1999 having earned a reputation as one of the country's best fashion stylists, Supbisankul, born 1973, headed to London's Central Saint Martins College of Art and Design to pursue a second degree in fashion designs. Pulling all his energy into setting up on his own, he launched a label after his own nickname as soon as he returned to Bangkok and later co-founded Headquarter with two other partners. Loved for its up-front and daring rock-n-roll attitudes, Sunshine has become a regular favorite at the Bangkok Fashion Week and now struts the runway twice a year as part of the Headquarter trios.

www.headquarter.co.th, www.pasaya.com

1 fall winter 2005/06, *"glastonbury test"*
2 spring summer 2006, *"i scream for icecream"*
3 spring summer 2003, *"queen tribe holiday"*
4 spring summer 2003, *"queen tribe holiday"*

Photos: Tada Varich (1, 4), Kornkrit Jianpinidnan (2), Nat Prakobsantisuk (3)

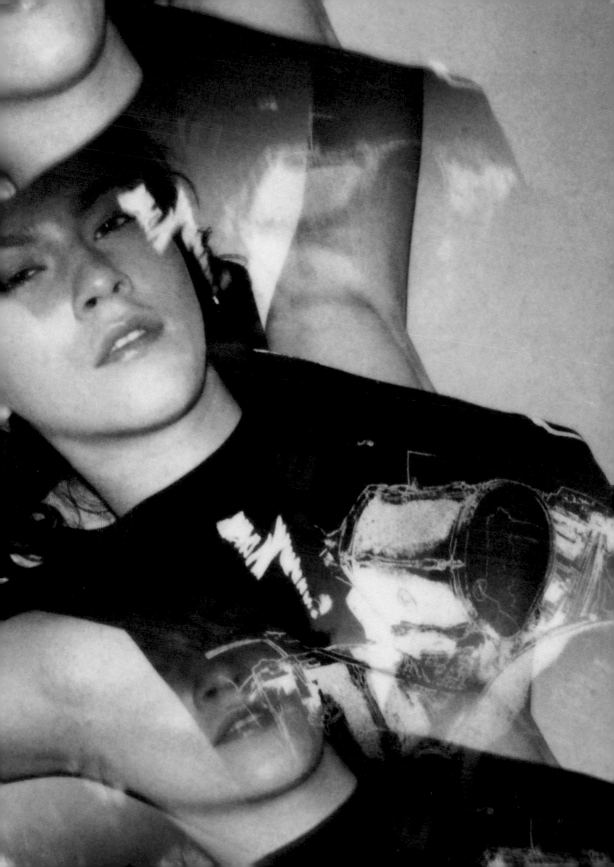

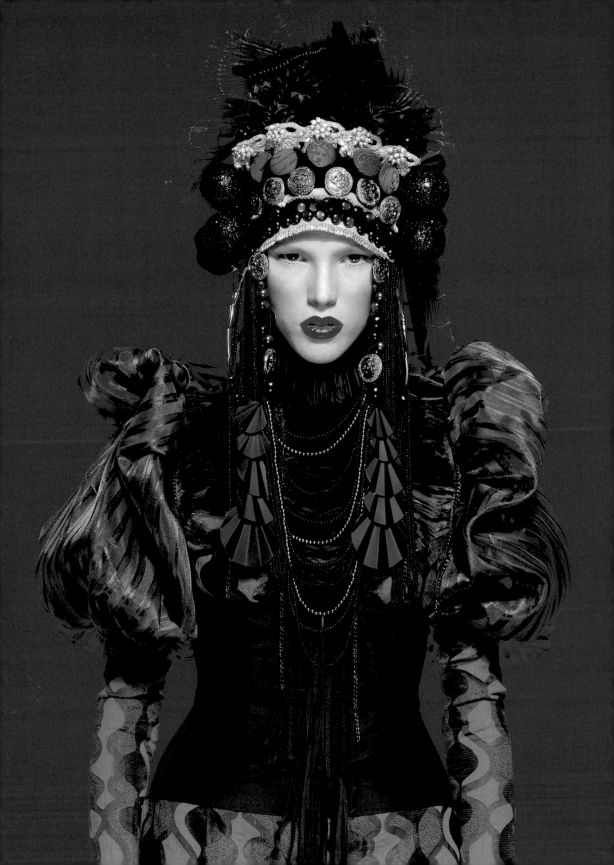

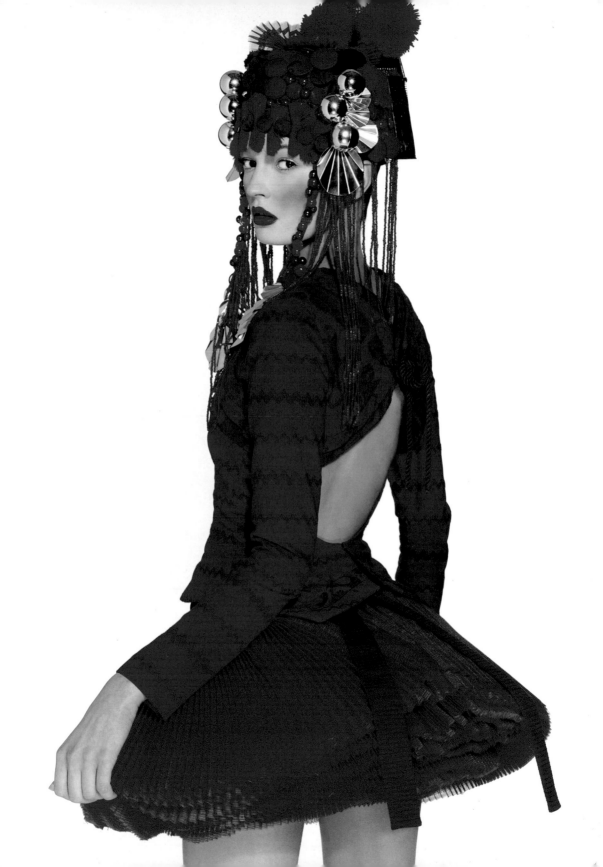

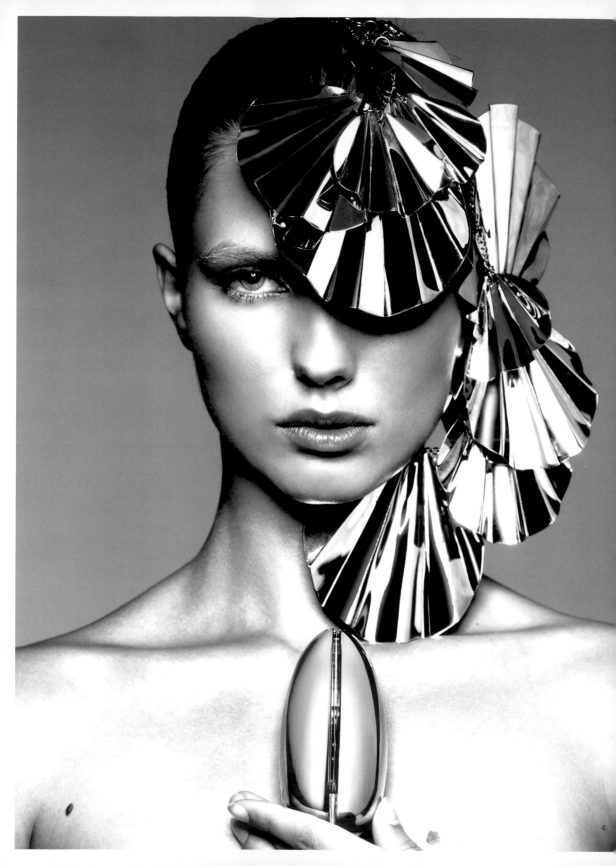

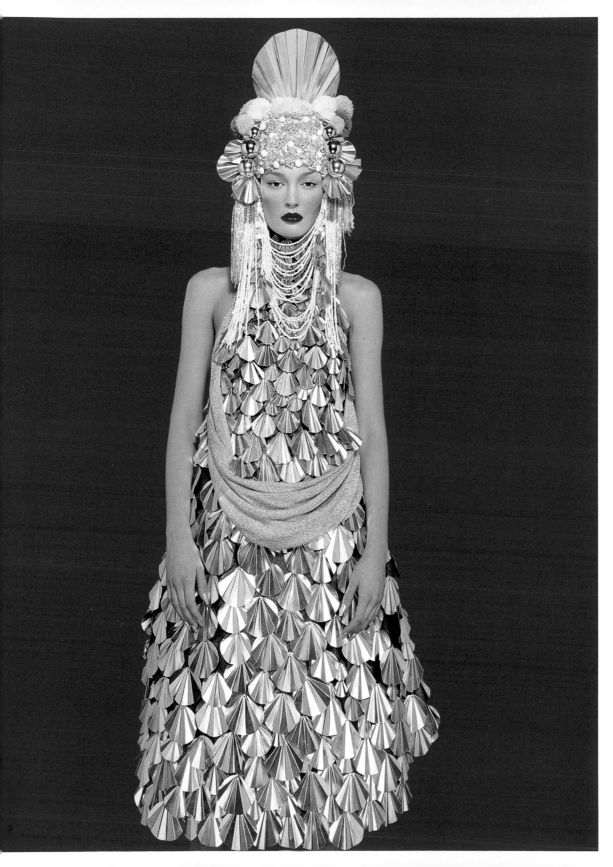

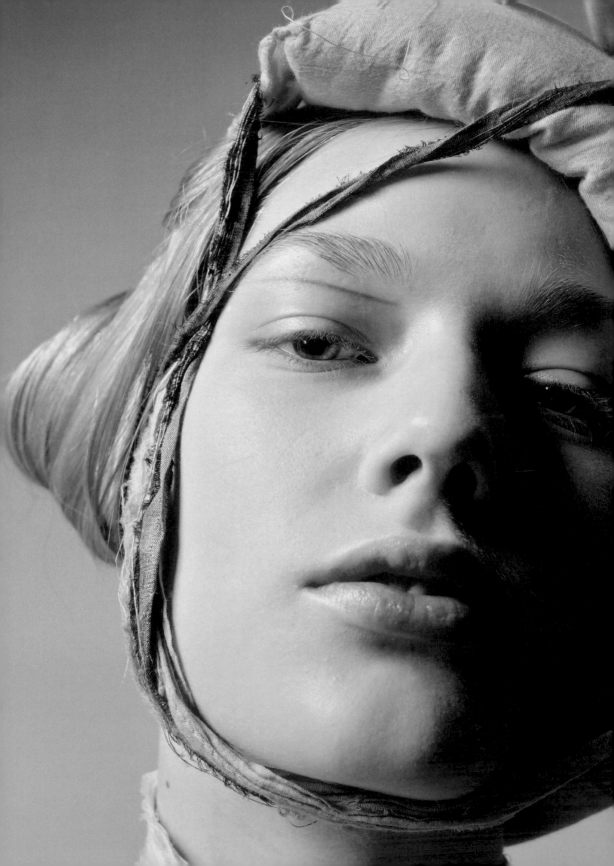

SUZUKI TAKAYUKI | TOKYO
Suzuki Takayuki

After graduating with a graphic design degree from the To-kyo Zokei University, Takayuki, born in 1975, worked in the field of costume design, creating costumes for musicians, dance companies and film actresses. During this period, his pieces were often exhibited in art galleries in both Tokyo and Osaka. Launching his eponymous brand in 2002, he finally made a runway debut for his 2007 fall winter collection. Cherishing every moment of the life of a garment, Takayuki believes beauty and inspirations can be found in everything, from a dishevelled piece of cloth, a torn out flower to an abandoned building. To give a piece of garment, no matter how old and worn out, the life and warmness of a human touch is the fundamental driving force behind Takayuki's approach to designing.

www.suzukitakayuki.com

1 June 2000
2 fall winter 2004/05
3 spring summer 2006
4 spring summer 2008
5 fall winter 2007/08

Photos: Hirohisa Nakano (1, 2, 3, 4), copyright by Suzuki Takayuki (5)

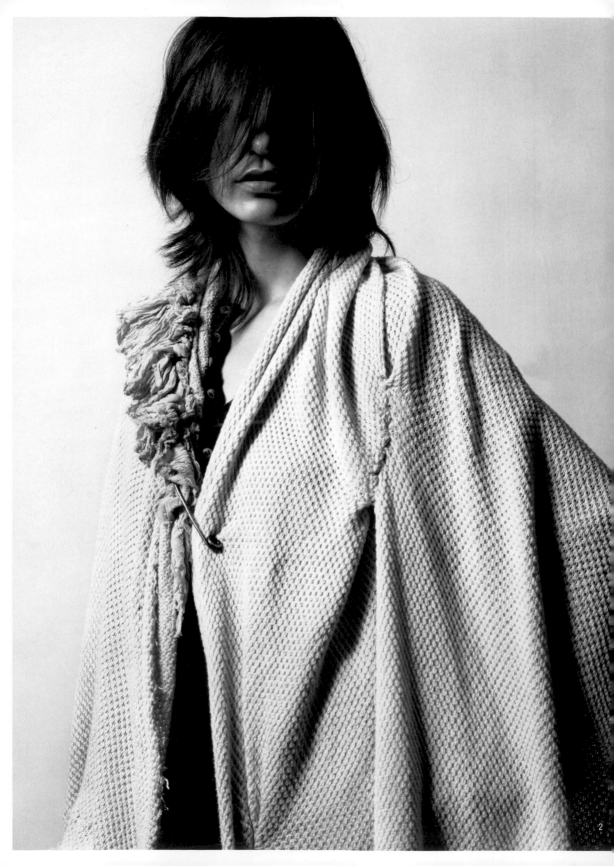

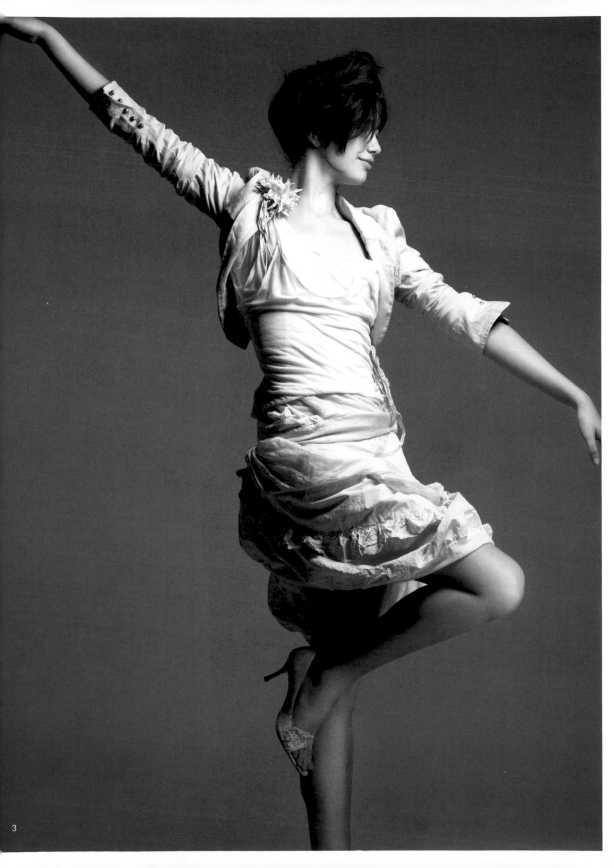

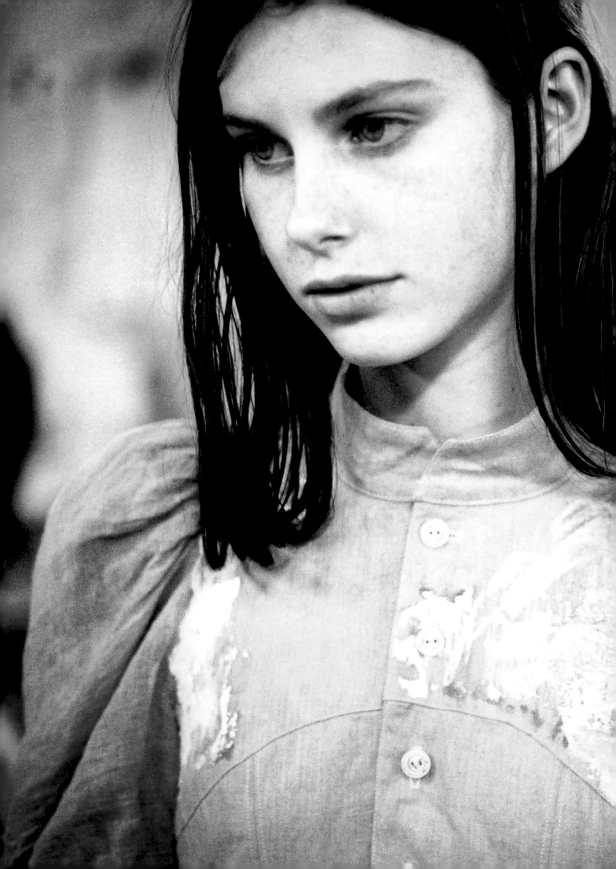

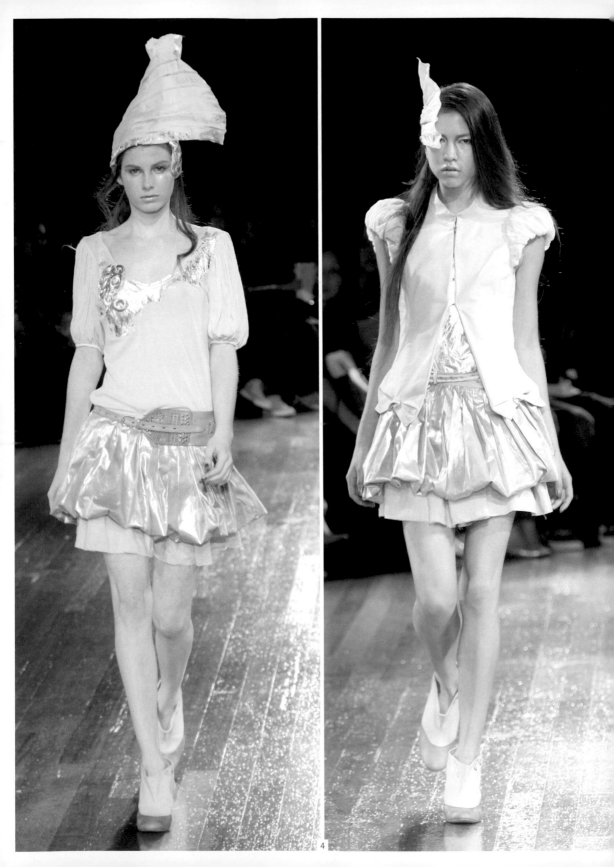

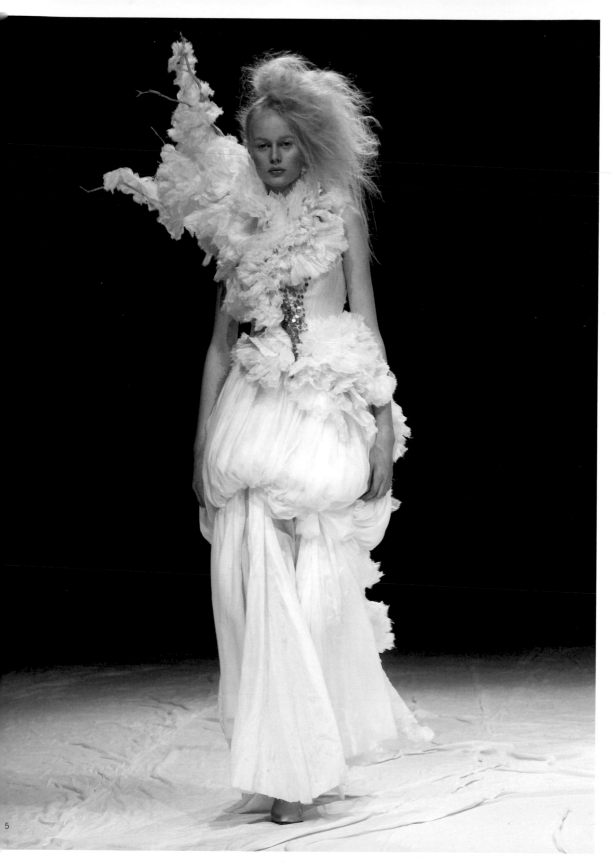

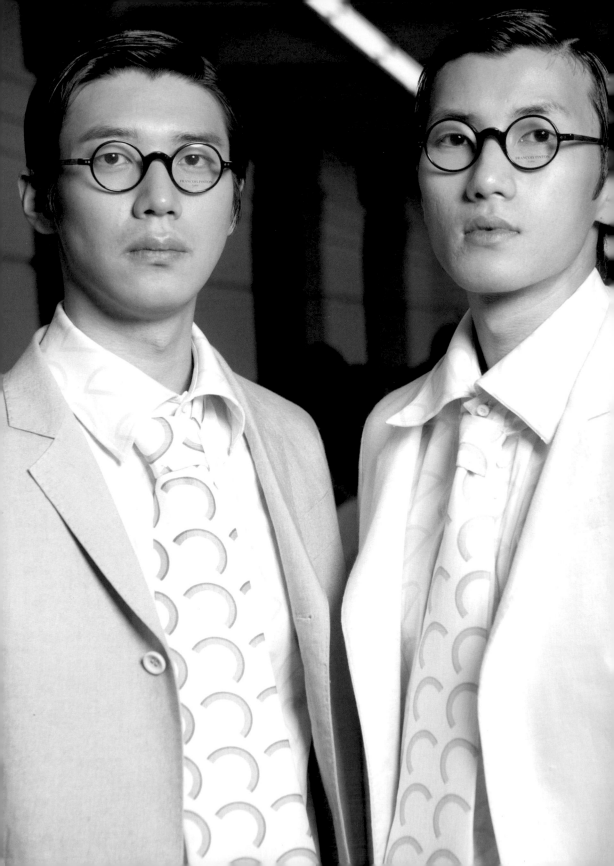

SWEET REVENGE | SEOUL
Hong Sung Wan

Graduated from the department of fashion design at Tokyo Mode Gakuen in Japan 1994, the Korean-born designer returned to Seoul and worked as a designer for a host of local industry names until setting up sweet revenge in 2001. While still in Japan, Hong showcased his earlier works in two fashion events, including the Tokyo Creator's Collection and the Sumida Fashion Competition in 1994. Since debuting at the Seoul Fashion Artists Association collections in 2001, sweet revenge has given casual tailoring a new meaning with bold, extraordinary silhouettes and a playful touch of irony.

www.sweetrevenge.co.kr

1 spring summer 2007/08
2 spring summer 2006/07

Photos: J. Kwong (1), MODA (2)

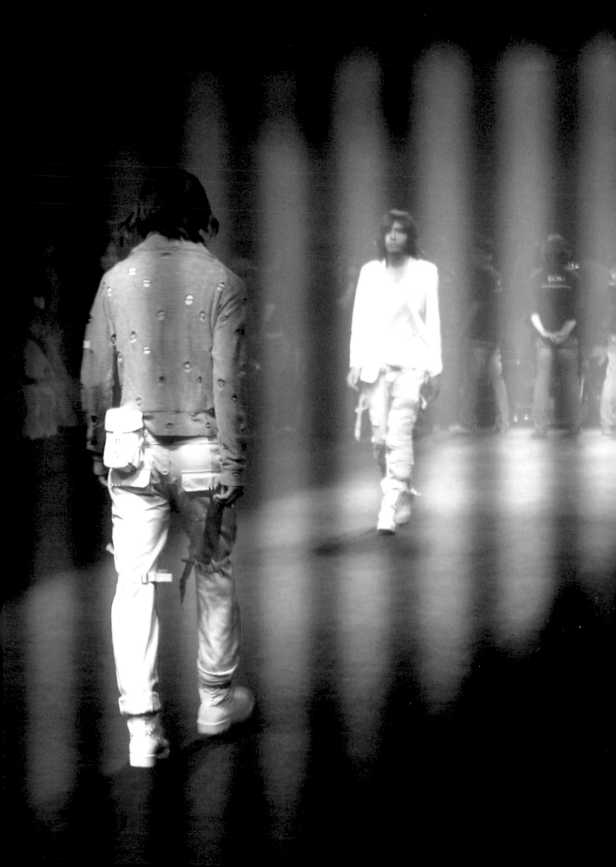

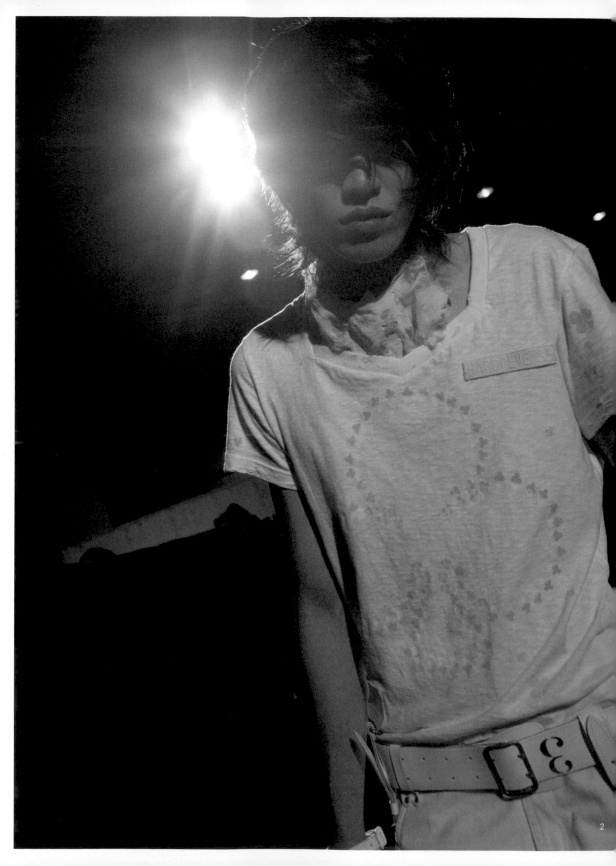

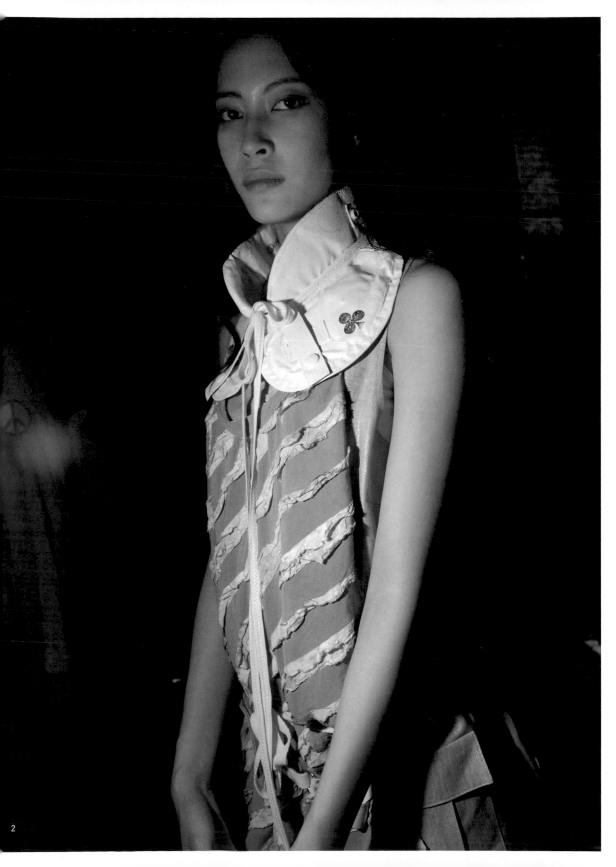

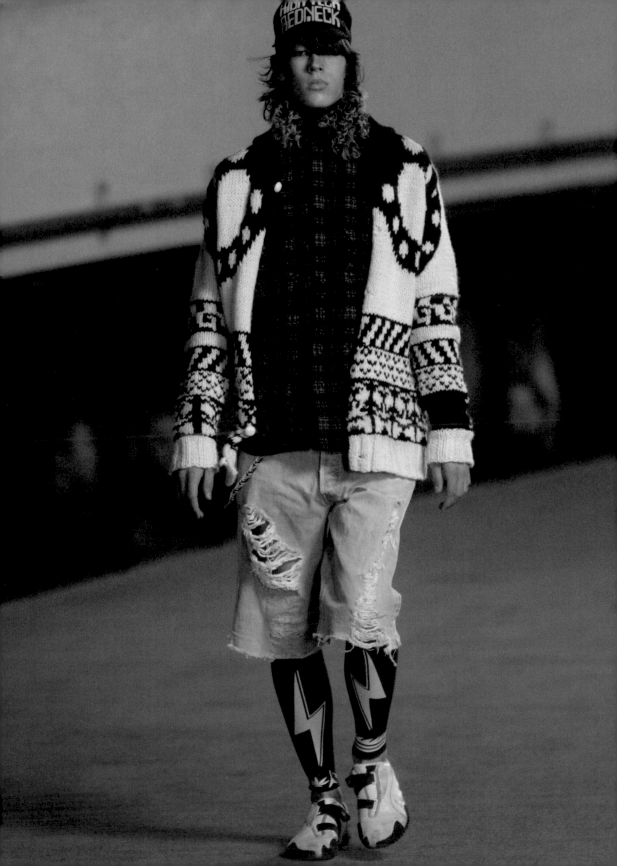

TAISHI NOBUKUNI | TOKYO
Taishi Nobukuni

Two years after graduating in menswear design from London's Central Saint Martins College of Art and Design, Nobukuni, born 1970, established his own label and has been flaunting his I Don't Give a Shit design defiance in his same-name Tokyo boutique since 2000. In 2004, Nobukuni was appointed as the creative director at Takeo Kikuchi—one of Japan's longest-standing and best-known menswear label-label—and immediately helped to thrust the brand back to spotlight with fun and lightness. A year later, Nobukuni debuted his own signature line at the Tokyo Collection, and instantly won the Best Newcomer honor for the respected Mainichi Fashion Awards. Recently, in a bid to re-invent his eponymous brand with eco-friendly concepts, he renamed his label to BOTANIKA/Taishi Nobukuni in 2007.

www.taishi-nobukuni.co.jp

1 fall winter 2005, *Ambiguity*
2 spring summer 2008, *Botanika*
3 fall winter 2006, *Ahimsa*
3 spring summer 2006, *The Village*

Photos: Hiroshi Seo (portrait), Manoru Miyazawa

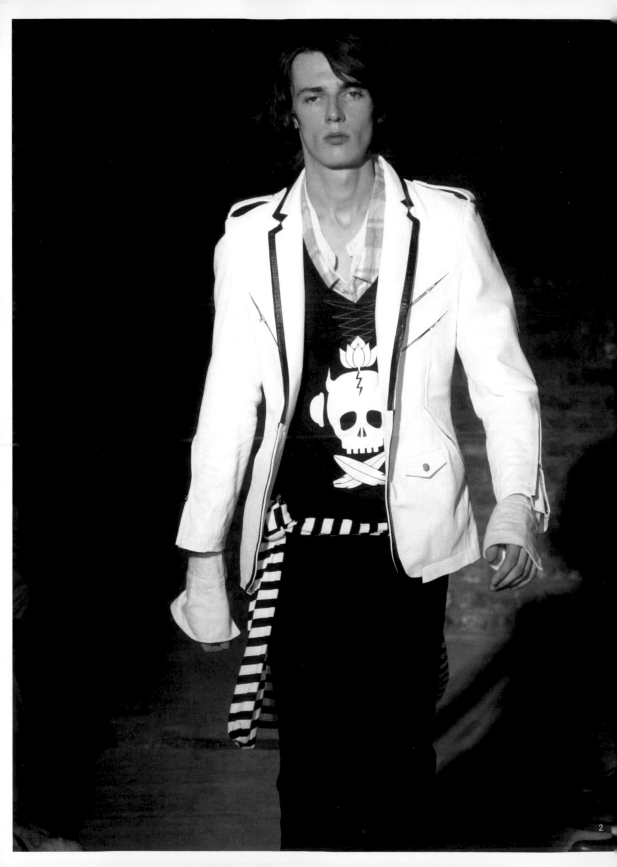

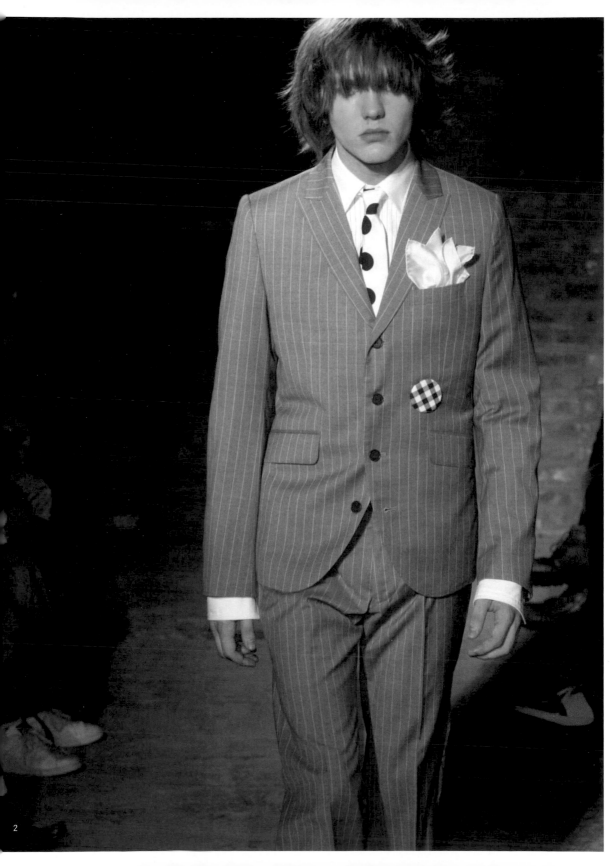

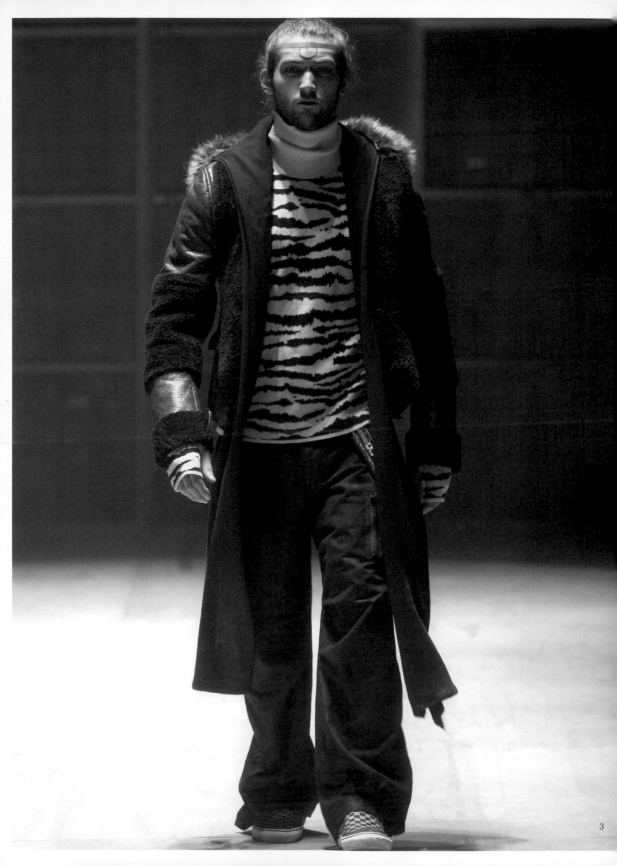

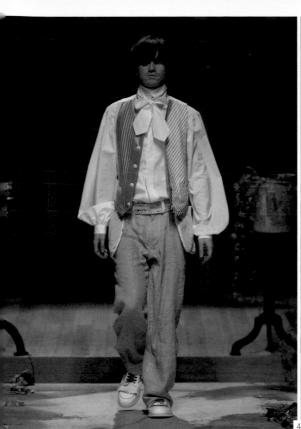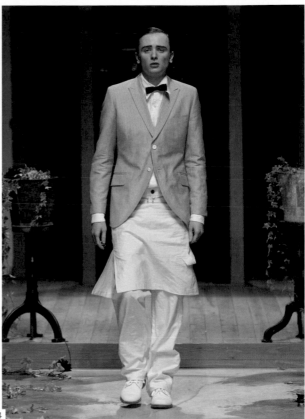

4

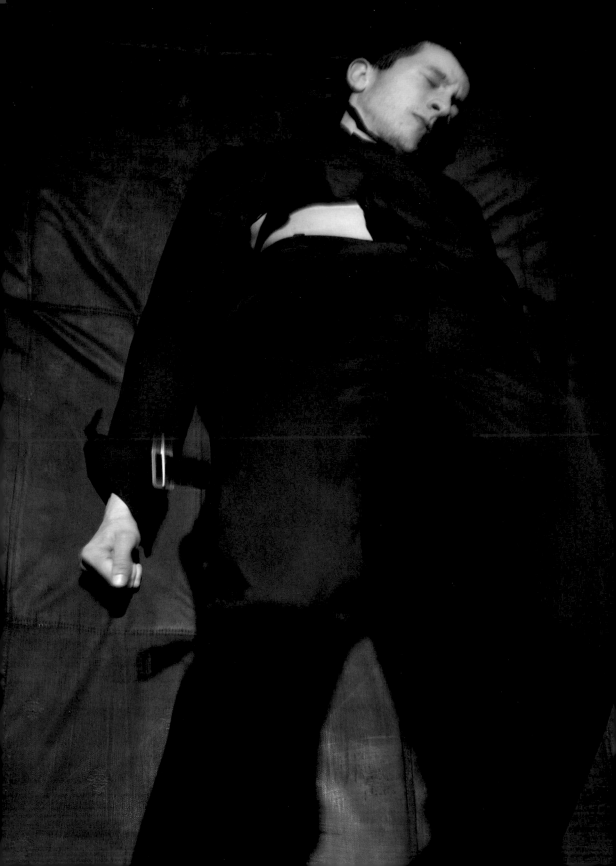

THE ALCHEMISTS | BANGKOK
Seksarit Thanaprasittikul

Understated rebellion is what drives the political science student-turned-fashion designer Seksarit Thanaprasittikul. For the brainchild of The Alchemist, conforming to the rules or breaking them doesn't need to be two extremes. Even a uniform can be worn in a multitude of ways, shirt out or tucked in tight, sleeves turned up or hem unravelled. The love for subtlety is a clear influence of his European fashion training in the Netherlands, where Thanaprasittikul, born 1979, enrolled in a bachelor's degree in fashion design from the Hogeschool voor de kunsten in Arnhem in 2002, two years after graduating from Chulalongkorn University. In between studying, he took up internships with Wim Neels and Ann Demeulemeester in Antwerp and Paris, and entered the 5th International Talent Support (ITS#5) competition in Trieste and won a finalist spot. Returning to Bangkok in 2007 after one last internship with Carol Christian Poell in Milan, he launched The Alchemist with a debut at the Elle Bangkok Fashion Week to much critical acclaims.

www.the-alchemists.in.th

1 collection 2005
2 collection 2006
3 collection 2007

Photos: Ronald Stoops (1, 2 bike), Seksarit (2), thaicatwalk.com (3)

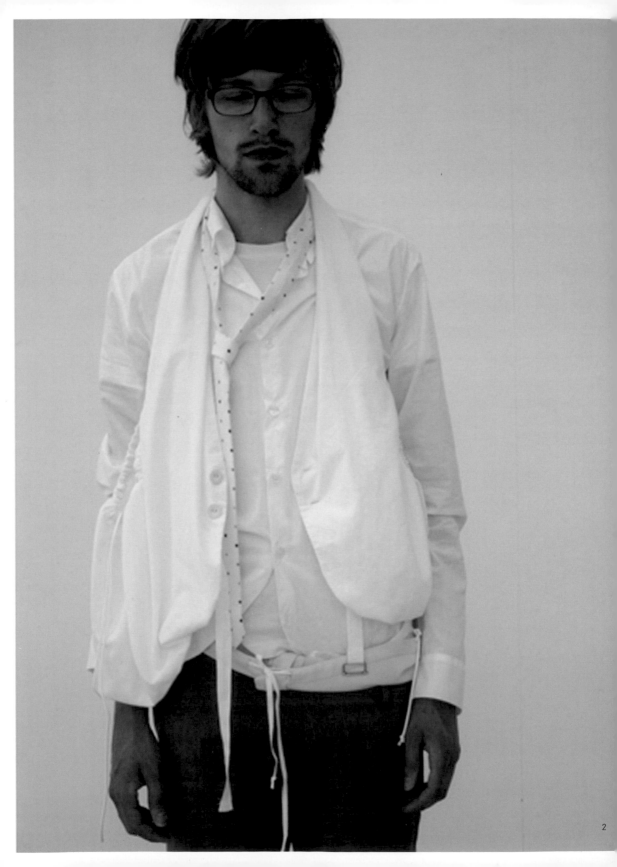

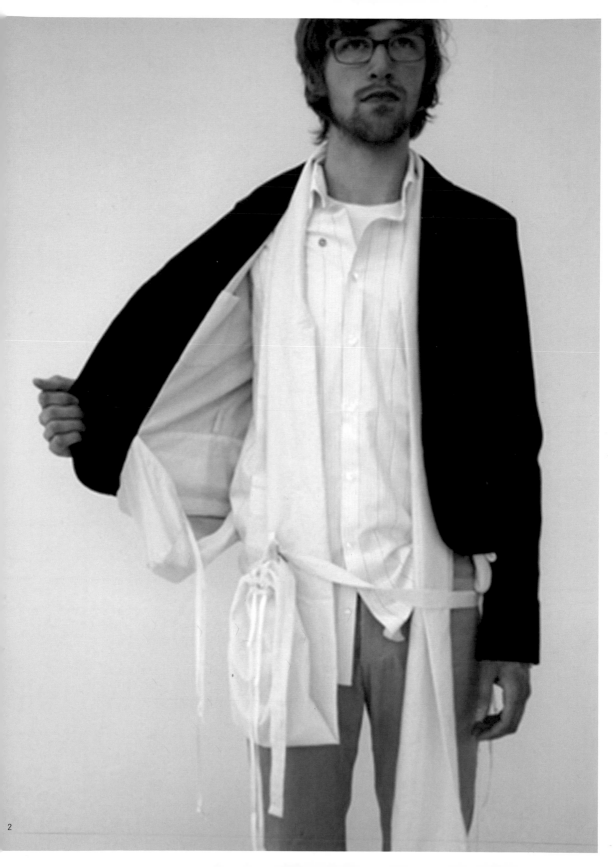

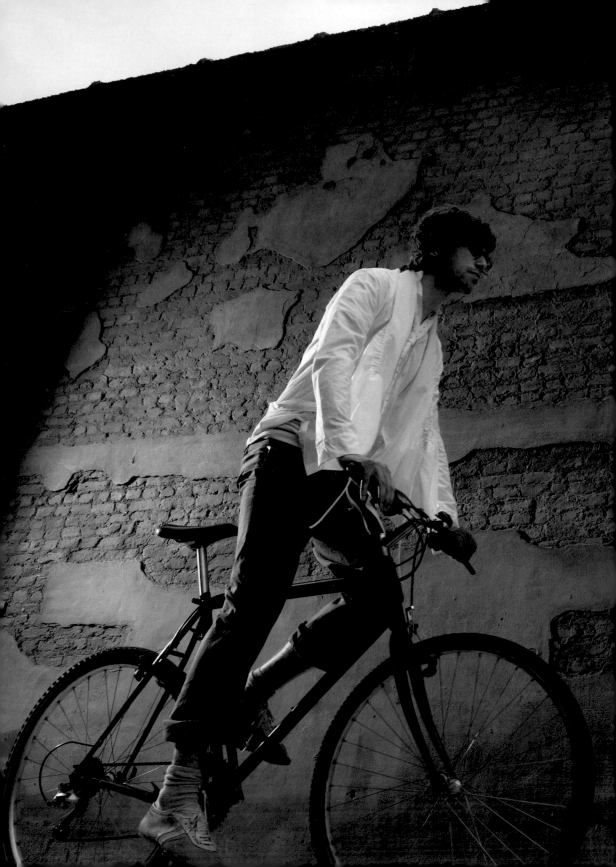

2

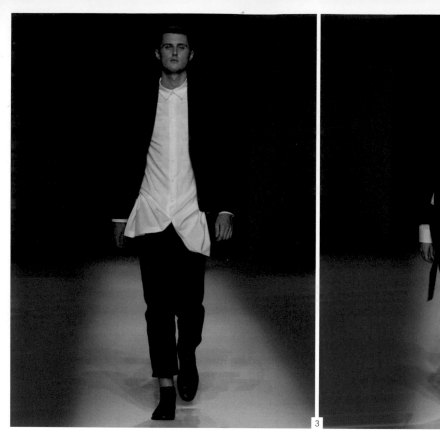

3

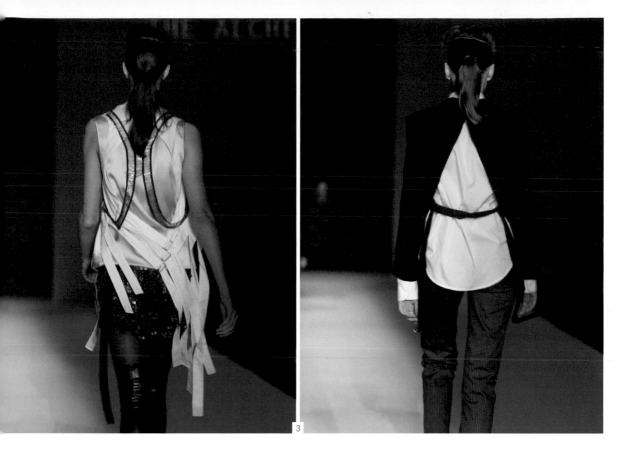

3

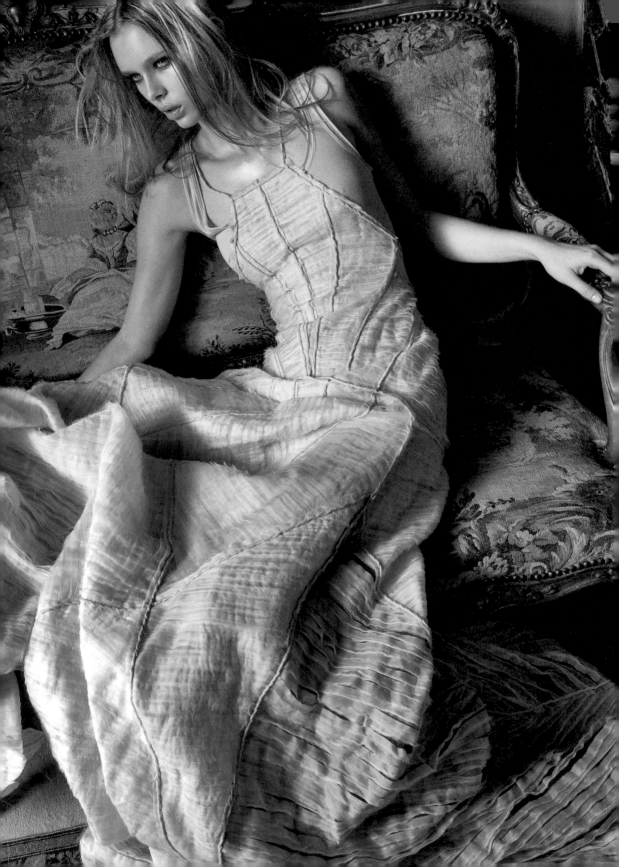

TONI MATICEVSKI | MELBOURNE
Toni Maticevski

Melbourne-based Maticevski graduated at Royal Melbourne Institute of Technology University with honors and an offer of internship at Donna Karan. Instead of taking the job, Maticevski, born 1976, passed on and opted to work for Cerruti in Paris. Two seasons later he returned home to go solo in Melbourne in 1999. In 2002, Maticevski won Best New Designer at the Melbourne Fashion Festival with his debut demi-couture collection, which was followed with another debut at the Mercedes-Benz Australian Fashion Week in Sydney. In September 2006, he was tapped to present his collection for the first time in New York at the UPS Hub at the Tents, where he charmed editors and buyers with his fluid, thoughtful and modern take on classic couture and silhouettes. Drawing on the success of his New York showing, Maticevski was back again in 2007 to show for a second season.

www.tonimaticesvki.com

1 spring summer 2006, *Paris*
2 collection 2008, *catwalk*
3 fall winter 2005/06

Photos: Jean-Francois Campos (1), Justin Edward, John Smith (3)

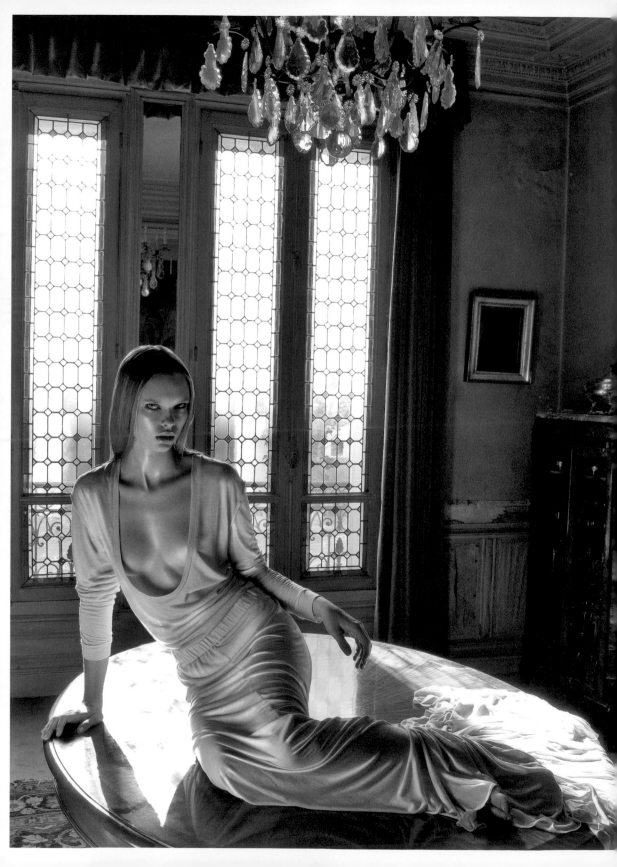

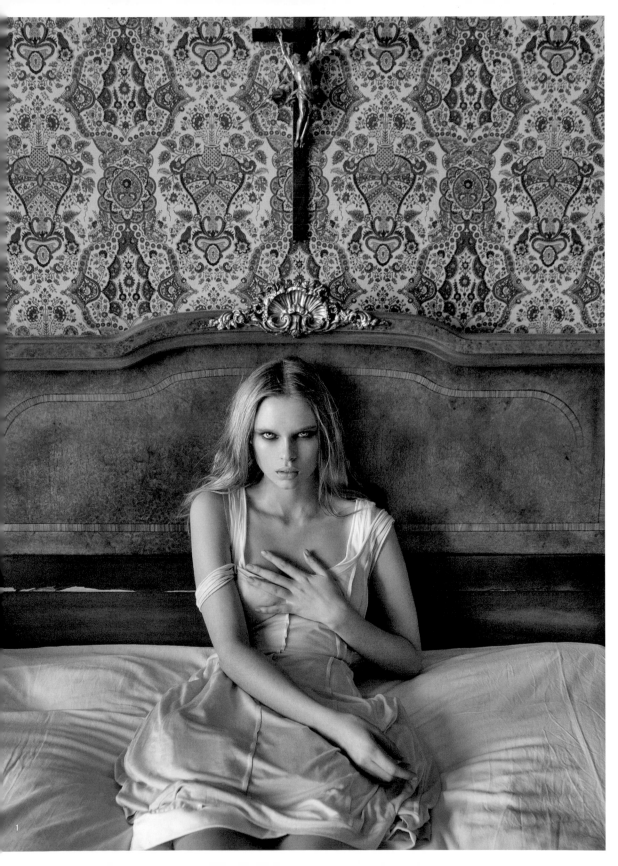

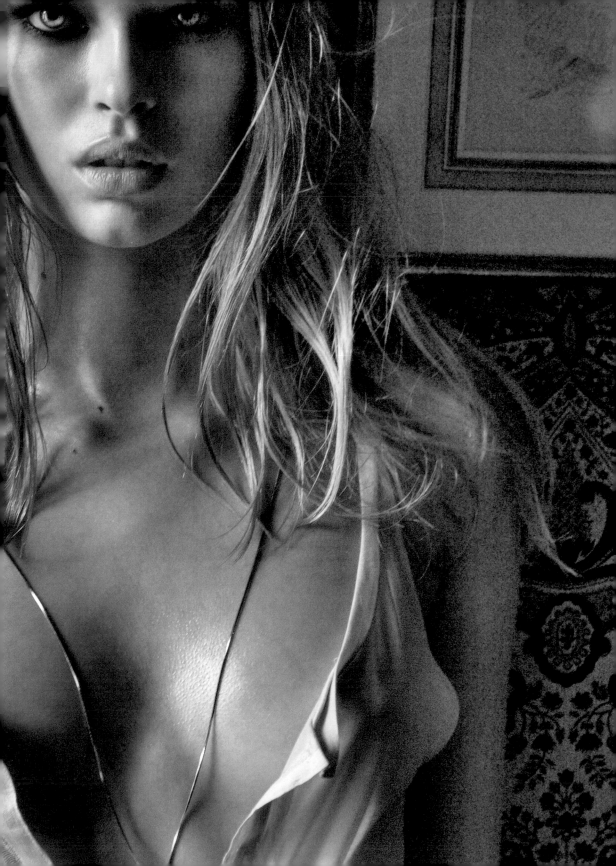

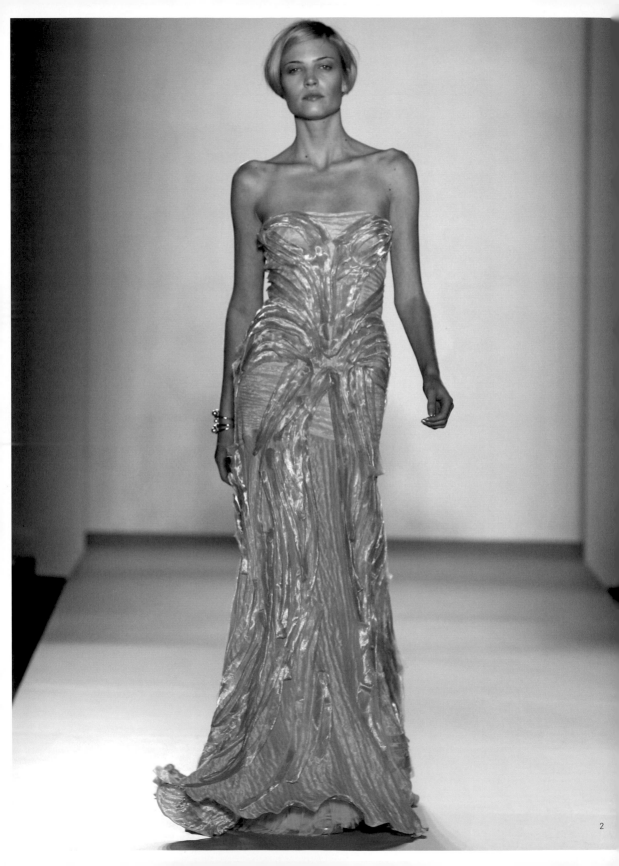

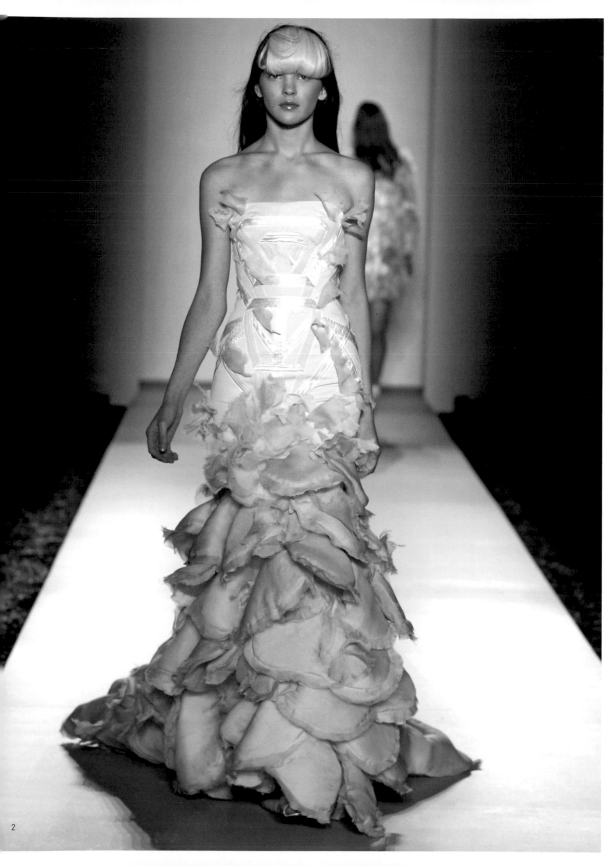

3

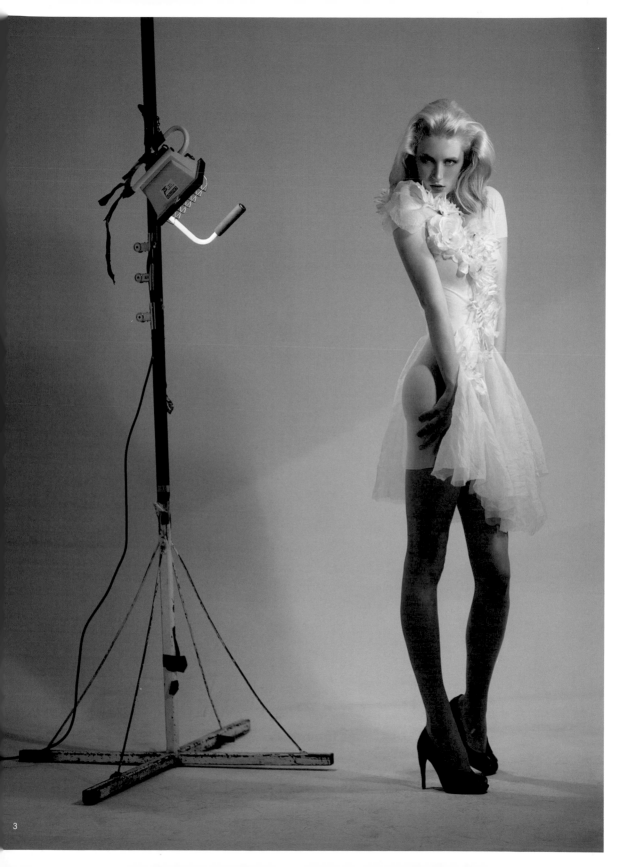

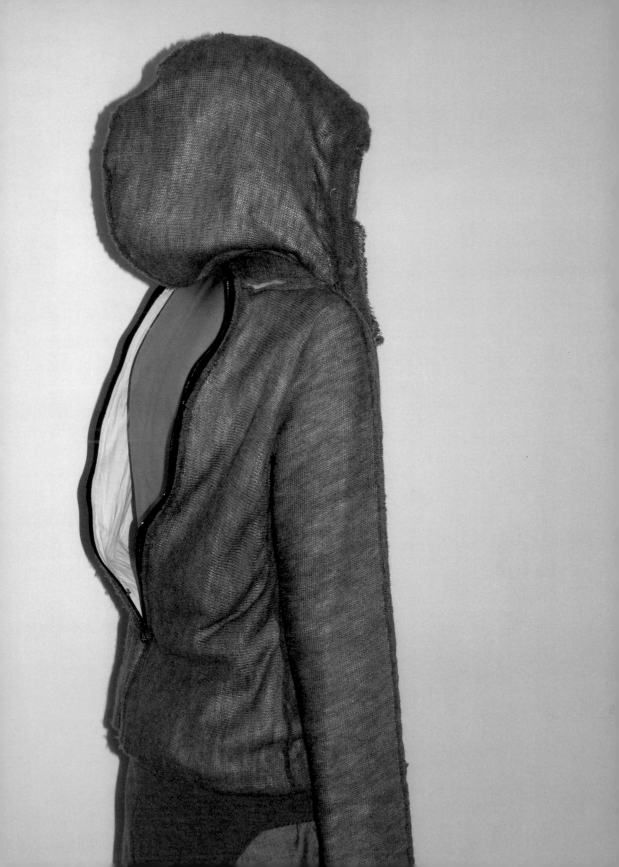

WANG YIYANG | SHANGHAI
Wang Yiyang

Born 1970, Shanghai-based designer Wang Yiyang was quick to make a name for himself with sober, sleek and empathically conceptual designs unseen elsewhere in China. After launching his first brand, ZUCZUG in 2002, Wang received the Changning Sharp New Designer Award in 2004. The same year, Wang's unorthodox aesthetic is taken further with CHA GANG, his second, unisex label meaning container in English. Prior to going solo, the graduate of Fashion Institute of Design at Dong Hua University, Shanghai, spent four years as the chief designer for Layefe's womenswear line.

www.zuczug.com, www.chagang.cn

1 2005, *grey collection*
2 2006, *street collection, performance by Beijing Modern Dance Company, produced by Hong Huang*

Photos: Peng Yangjun

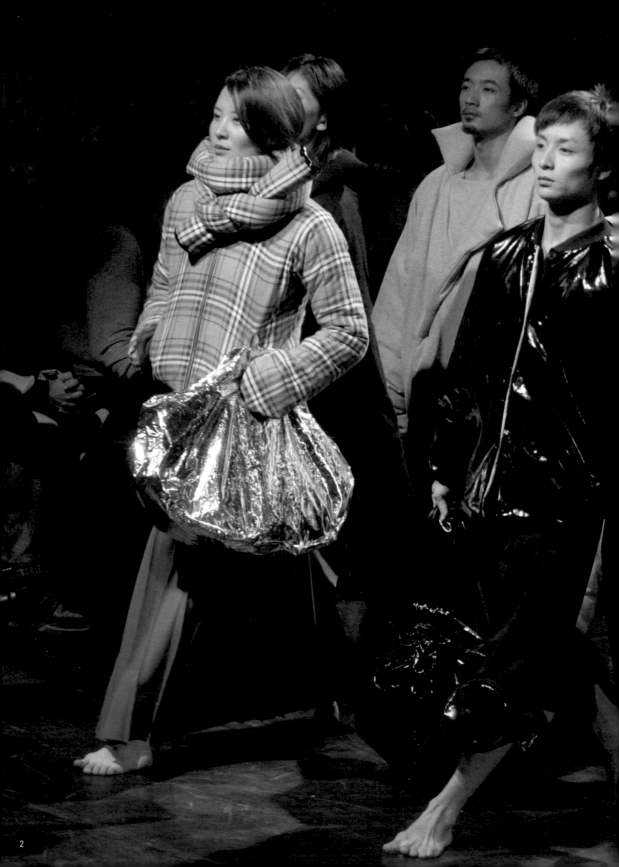

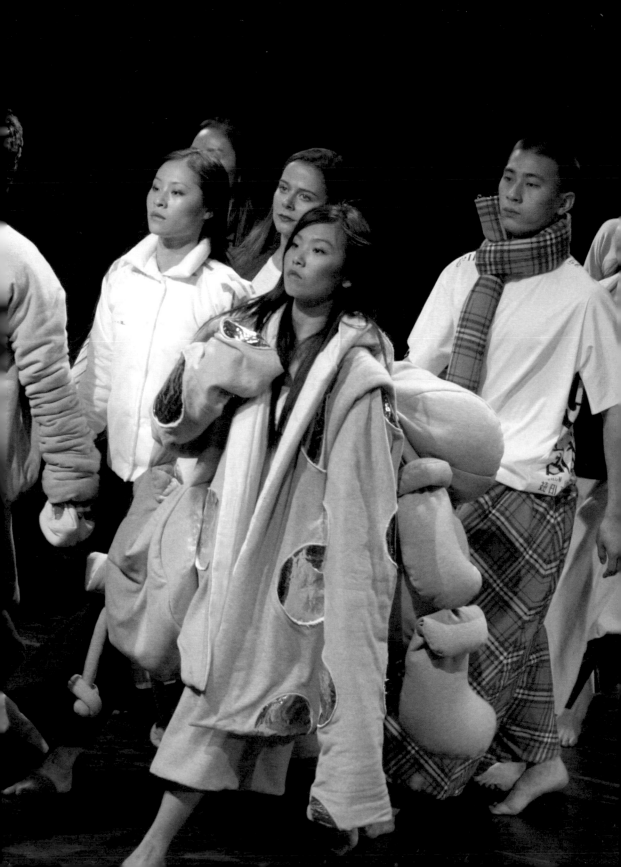

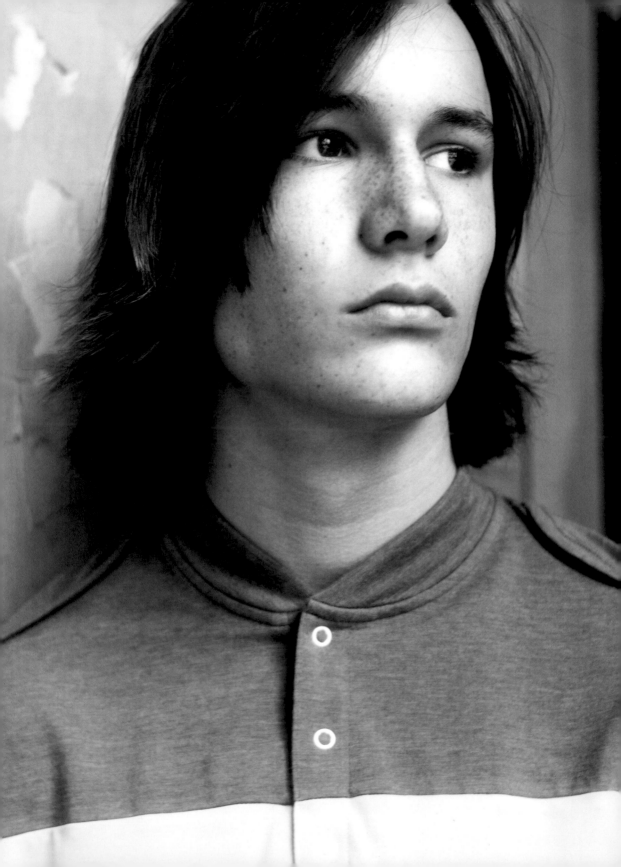

WOODS & WOODS | SINGAPORE
Jonathan Seow

As a top young Singaporean designer to have successfully broken away from the small domestic market, Seow, born 1977, has enjoyed a career fashion dotted with awards. His first, the top prize at the 1995 Smirnoff International Fashion Awards, was won before he even graduated. When he completed his studies at the Raffles LaSalle Institute in 1997, he garnered two more honors as the winners of the Singapore fashion Designer Award and the Asian Fashion Designer Award. In 2001, Seow launched his own label and made a runway debut at the Mercedes Australian Fashion Week in 2002. Two years later, he came second for the best collections at the 12th MittelModa International Awards at Gorizia, Italy. Having been selected as one of five winners of the young designer contest organized by Who's Next Paris in 2005, WOODS & WOODS has since become a regular in Paris Fashion Week showing on the official Men's fashion calendar. Meanwhile, Seow has diverted his originally menswear-only label to include womenswear, which are now sold in top boutiques and department stores worldwide.

www.woods-woods.com

1 spring summer 2008, *men*
2 fall winter 2006/07, *men*
3 fall winter 2007/08, *women*

Photos: Jean Marc Masala (1), Ivanho Harlim (2), Olivier Claisse (3)

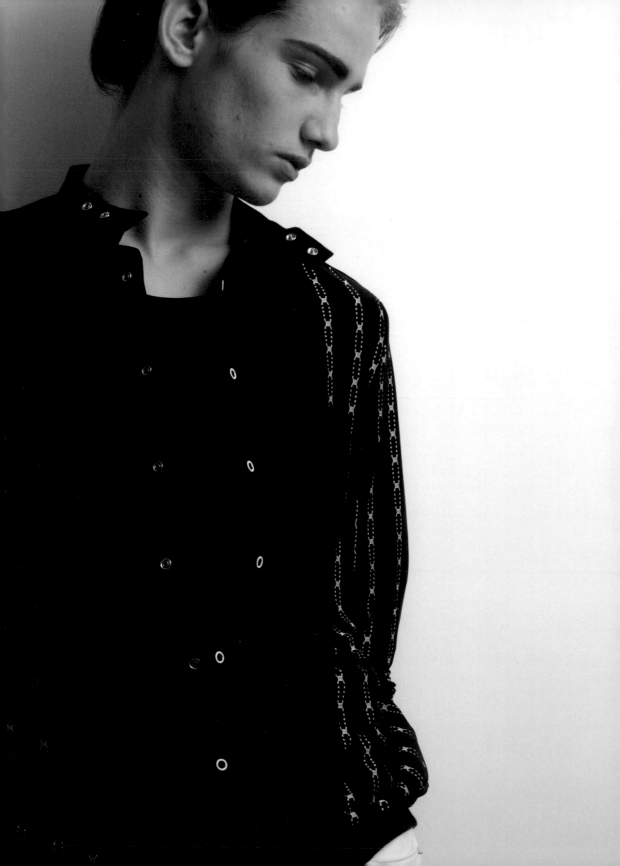

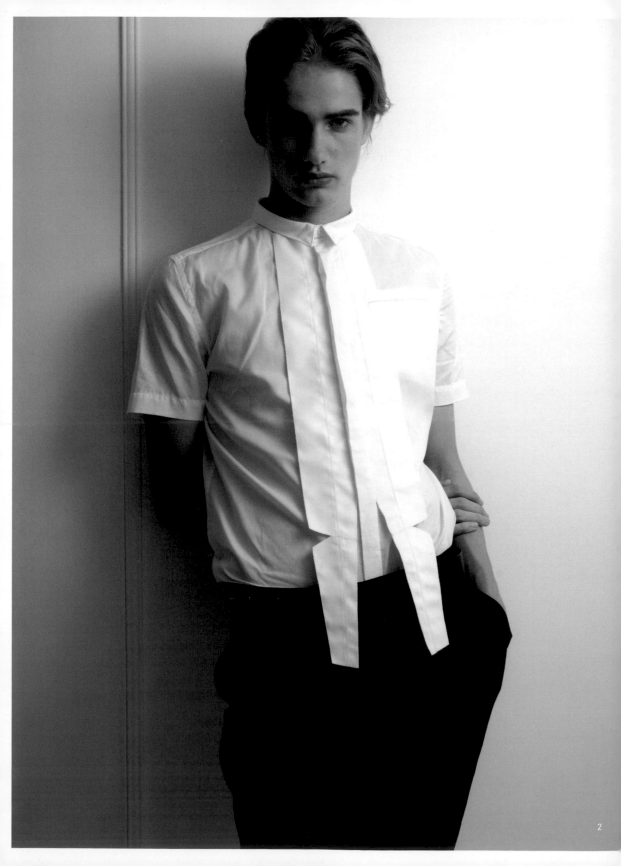

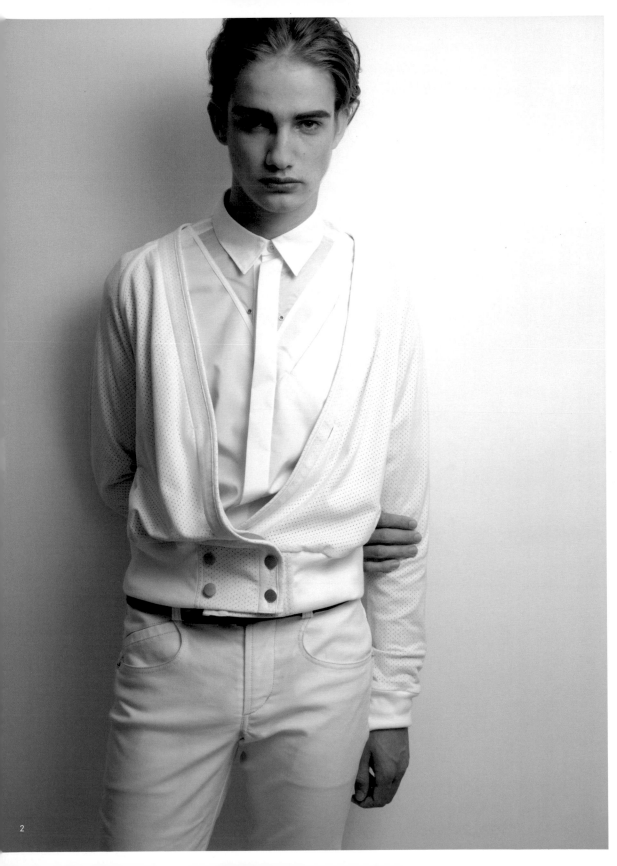

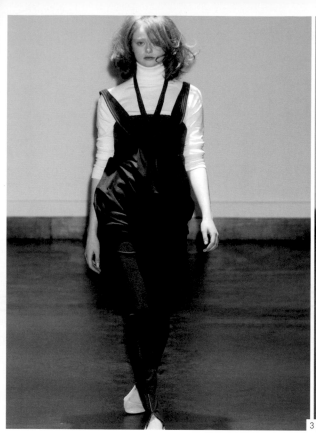
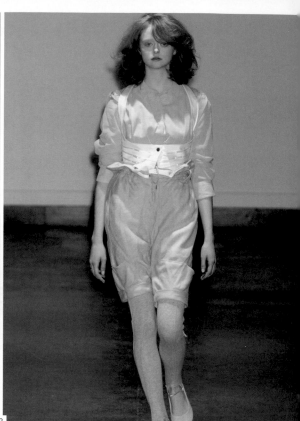

3

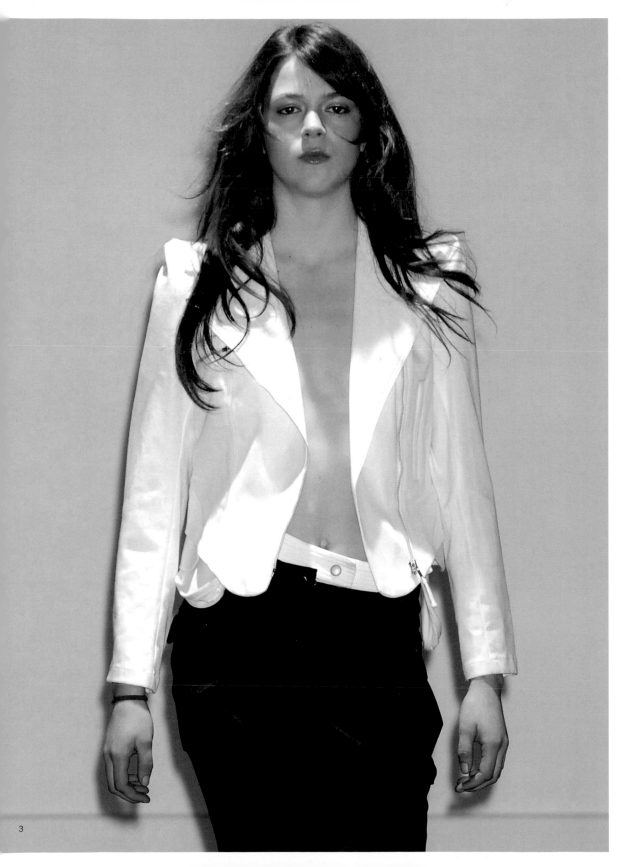

INDEX

published and distributed worldwide by
daab gmbh
friesenstr. 50
d-50670 köln

p + 49 - 221 - 913 927 0
f + 49 - 221 - 913 927 20

mail@daab-online.com
www.daab-online.com

publisher ralf daab

creative director feyyaz

© 2008 edited and produced by fusion publishing gmbh stuttgart . los angeles
www.fusion-publishing.com
team: dora chan (editor, introduction, biographies), katharina feuer (coordination, layout),
jan hausberg (imaging & pre-press), alphagriese (translations)

photo credits
coverphoto © mintdesigns, backcover everywhereweshoot.com
introduction page 7 mixmind, page 9 j.surat, page 11 humio doi, page 13 qui hao,
page 15 nat prakobsantisuk

printed in italy
www.zanardi.it

isbn 978-3-86654-011-8